DIVINE FORCES

Art that Awakens the Soul

by Paul Heussenstamm

Debra,
Sharing the Colors of Love
Heussenstamm
02v

My Spiritual paintings are primarily about the Mandala, which is an ancient symbol, primarily from the East. Mandala means sacred ground, sacred temple, and sacred architecture. The process of painting mandalas brought my eyes and opening heart together to a new, richer way of seeing. The center of the Mandala is located in the center of our hearts. The Mandala is a powerful teacher, teaching us about our Heart Center (anahata). Painting Mandalas symbolically creates the journey of enlightenment. Walking the great Labyrinth Mandala at the cathedral of Chartes, south of Paris, one moves to the center. Circling the great stupa (also a Mandala) at Bodhinath, Nepal is the same as painting a Mandala. The Mandala is a centering and balancing image.

Visit Pauls's website at www.mandalas.com

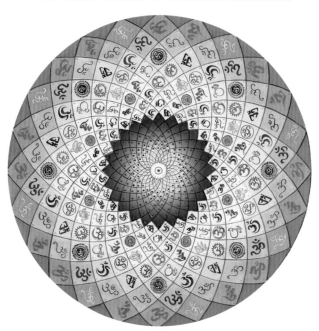

Om Mandala

Library of Congress Control Number: 2009909857
ISBN 978-1-61584-681-8
First Printing 2009
10 9 8 7 6 5 4 3 2 1
Printed in China
For additional copies visit
www.mandalas.com
or email heartcenter@mandalas.com
or request by mail from:
Mandalas.com,
P.O. Box 836,
Laguna Beach, CA 92652
studio (949) 497-2708 / fax (949) 497-2448
For mail orders please enclose $25.00 (check or money order)
for each book payable to: Mandalas.com.
Please allow 10-14 days shipping from California
Shipping by Priority Mail to USA only.
Foreign orders: please inquire first for shipping rates.

Art is a way Spirit shows itself to the world.

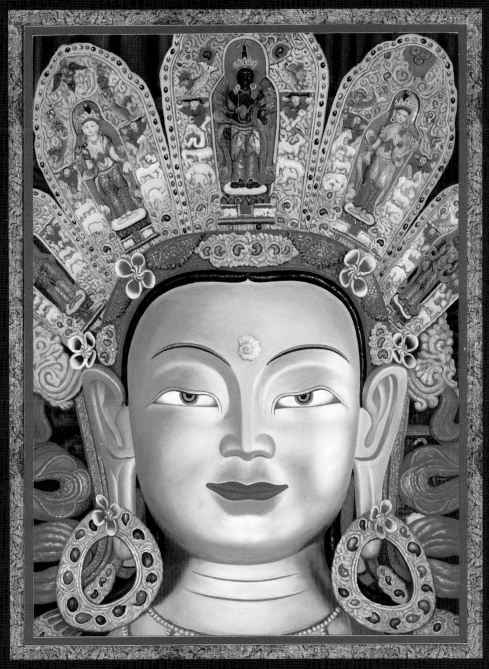

Maha Maitreya

Art releases the feelings and the colors from the sacred chamber of the heart, from the deep infinite well of the body.

Art's essence is a ceremony that reaches for love. Art is rebelling against what has been "tamed" in you. Art, or a painting, is like lightening in a bottle.

Art and creativity are fundamentally and intrinsically an inside map.

An art lover has a "yearning" to see Divine Truth as carried in a particular work of art.

An artist translates his painting from above, from below and from within.

This book is for and from the Soul and dedicated to all women and men throughout time who have sacrificed their entire lives in service of the Soul.

Special thanks to Barbra Streisand who was there along with Carrie Fisher in the mountains of Arizona as my first mandala came into being. Barbra was my first commission.

Special thanks to my major collectors who have supported me in a way that no words could ever express my appreciation for their overwhelming support: Brugh Joy, Lord Vincent from the UK, Viscountess of Windsor, Lane Lowry, Char and Greg Wolf, Kelly Brown and Ann Earhart.

Notable Collections:
Deepak Chopra, Doreen Virtue, Mark Victor Hansen, Eckhart Tolle, Jai Uttal, Annie Lennox, Steven Halpern, Mrs. Dan Ackroyd, Ellen Burstyn, Carl Simington, Anna & Dean Ornish, Mark Foster, Michael Dickerson, Margot Anand, Her Holiness Sai Maa Lakshmi Devi, Adyashanti, Lama Surya Das, Billy Hayes, Lauren Artress, Steven Aizenstat.

Thanks to the Chopra Center for Wellbeing and Deepak Chopra, Dr. David Simon, Max Simon, and David Greenspan for their years of continued support and profound teachings. It's an honor to be part of watching thousands of people learn to meditate, practice yoga, eat correctly and deepen their lives.

Thanks to Agape International Spiritual Center of Los Angeles and Rev. Dr. Michael Beckwith, Rikki Byers-Beckwith, Rev. Eunice, Stephanie Dawn, Valerie Day, Alice and Akili Beckwith for supporting and trusting me with their entire sacred sanctuary. Being part of Agape is a dream come true to an Artist who has spent the better part of his life seeking and searching for spiritual truth… something that is played out every week at this wonderful, multicultural, laughing, singing, dancing, joking, hugging, loving place called Agape.

Thanks to the amazing Esalen for supporting and nourishing my creative painting journey.

Thanks to beloved Inga, Rose, Amana , and Angelica. Without the feminine, the Divine Feminine and my own Soul, none of what appears here would be possible. I trust my Soul fully and completely with my creative exploration, my life and my well-beingness.

Thanks to the people who have supported, nourished, balanced, painted with me and have been an intimate part of all of my painting life: Patricia Wells-Wright, Cynthia Gray, Kristina Clemens, Anthony Rossi, Jason Kowalski, Will Wright, Sean Austin, Chelsea, Rob, Denise Dandolo, and Marty Gray. And my heart goes out to my two amazing artists who have been with me more than a decade and climbed the mountain of creativity, Rampal and Kristi Smith. I love all of you.

In the beginning, I would like to acknowledge those who have contributed and supported the first 20 years of unfolding Spiritual Painting

Grace Love Joy, Doreen Virtue, Marianne Williiams, Angelica Torn, Julie Jones, Antonia Milones, Maddy McNeil, Yuri Murokt, Lynda McHugh, James Poehling, Virginia Weckx, Jill Murray, Georgia Berry, Brenda Lasarzig, Charlene Testa, Jennifer Parker, Carol Parker, Sara Mizen, Kelly Mault, Lynne Smith, Martha Shinizu, Marcia Green, Adrian Hopper, Julie Gomelsky, Kristine Wroblewsla, Fatemah Samuels, Deborah Steffer, Cindy Stoneking, Mary Tessman, Gabrielle Forleo, Adele Swann, Jan Karol Harris, Peggy Cosgrove, Pat Thomas, Betty Eldienberger, Paula Goldman, Charissa Shaw, Vgis Zuina, Janet Morrow, Jeff Simons, John MacDonald, Lucy McCartny, Abigail Samuel Green, Becky Ferrell, Kevin Koon, Maria Candelerio, Sandy Wilkinson, Teena Swift, Smita Bhagat, Debbie Huntington, Domenico Spano, Kathryn Playa, Loretta & Jim Arthur, Linda Wind, Steven Ullman, Christoph Zimmerman, Jane Clayton, Judith Lancaster, Robert Orvis, Robert Wells, Valerie Scruggs, Dr. Frawly, Rajiv Parti, Teryn Guadagnoli, Anna Koo, Sandy Wilkerson, Adaline Cassin, Maria Candelarin, Karen Doshay, Denise Rekstad, Pritesh Patel, Vivian Eisenstadt, Lauren Quick, Yvonne Perkins, Elizabeth Rogers, Beatrice Quntanna, Brooke Vanderuer, Laura Par, Dennis Larkin, Beverlee Sokol, Seanee Emerton, Darren Hensen, Cathy Carlton, Jasmine Kramer, Rae Hipolito, Afshin Fallah, Curtis Paul Chapman, Charlene Gonzola, Diane Ellington, Patricia Selbert, Linda Bender, Jane Sullivan, Jackie Holland, Edna Espanol, Anne Ornish, Sheri Price-Steiner, Caroline Windsor, Karen Schmieder, Ofilia Perez, Erik Rooij, Linda Beckman, Nancy Lashley, Grace Cavanaugh, Craig Lowry & Ximera, Perri Tyler, Anahata, Cheryl Mizradi, Maria Elena Arias, Kyle Robinson, Snezana Stevanoc, Lillian Krueger, Leonard Lumas, Teresa Saguera, Michael Dicerson, Erin Carufel, Terry Ferraro, Susan Travers, Roma Svenson, Tim Lenheim, Donnon Huddalston, Donna Epstein, Frances Bell, Justine Amadeo, Linda Walsh-Joseph, Zorion Zion, Linda Blagman, Danelle Evans, Liz Fortanier, Joan Kaplan, Rita Raja, Sageman, James Phoeling, Sydney Minnerly, Gary Dylewski, Cindy Monohan, Jeff Papineau, Susan Riley, Patrick Brauckman, Wendy Sherry, Lord Vincent Constantine & Mark Foster, Bill Lasarzig, Ana Bustamanta, Fred Damavandi, Joanne Kellert, Laura Nash, Liz Koepke, Manoj Chalam, Roshan Saneii, Susan Rossi, Hisham Ahmed, Andrew Clark, Katy & Al Hardoy, Rick Cabados, Jean Evers, Josephine & Chris Gross, Jane Bolton, Aurora Lemere, Soaring Eagle, Karen Baker, Joni Cass, Scott Hoyt, Virginia & Girish, Kelly Agosta, Ashley Agosta, Mark Hinds, Shari Phelan, Sheree Austin-Gagne, Debbie Dexter, Jennifer Day, Carol Thornton, Jamie & Kim, Susan & George Rydberg, Lynne Marie Alley, Marleeta Burns, Ranjitha Sandeep, Deborah Vince, Patti & Mark Pian, Michael & Marilyn Pooley, Salley Valentine, Harry Hagler, Yuri Zelez, Hallelujah & Blessing, Meena Sharma, Richard Aranow, Alexis Neely, Glenda Thomas, Suzanne Shafer, Donna Haag, Dr. Jarmeth, Deborah Davis, Chris Hogan, Sabina, Esalen, Anne Kingsbury, Patricia Lopez, Carrie McCully, Jorge Zamora, Sudhir Aggaowol, Johanna Perry Holloman, Parker & Ashley Johnson, Klava Cousin, Keith Pilatti, Heidi Leon, Nancy Collins, Suzanne Cole-Kohlberg, Kristin Silva, Claudine Mogg, Lizbeth Michelson, Elizabeth Jo Anderson, Warsonie Locezeno, Mark Schwartz, Gregory DeCarto, Darla Morris, Donna Gilmartin, Anne Kingsberg, Faire Silver, Charlotte Backman, Kathy Masinga, Dee Ann, Gail Hersan, Juan Ortiz, Helene & Sandi, Wendy Cory, Ellen Kabat, Patricia & Camillo McMillen-Florez, Laura & Jade Nizewitz, Terry Wohl, Barnaby & Kathy Barratt, Pat Vieten, Anna Cheung, Peter Bosma, Malina Wakefield, Crystal Morris, Beth Mattei, John & Mary Naughton, Jack Sykes, Kelly Acosta, Susan Dunegani, Dana Dull, Rick McCabe, Sylvia Davis, Joan Pedan, Phyllis Cohen, Lewis Cohen, Susan Korber, Walter Fey, Kathleen Peara, George Trim, Rob Berry, Christina Schiff, Rita McWilliams, Lee Bensen, Sharon Alford, Maxie Robichaux, Emily Rodriguez, Leslie Shade, Peggy Dubois, Patricia Van Essen, Joe Spano, Catherine De Strakosh, Helena & Chris Sangdahi, Beverly Zill, Prue Aunger, Judy Vandergrift, John Richards, Joyce Black, Belicia Govine, Jill Gift, Marea Classen, Alexia Martin, Karin & John Herring, Suzanne Timken, Kent Rossman, Sherry Swan, Ewald Koch, Edward Lewis, Glorya Kaufman, Beth Jarmen, Kulani Kamaha'o, Mary Louise Ruffner, Suzann Amonn, Margaret Jensen, Joseph Heller, Anne Le Croix, Iris Rasmussen, Carina & Andrew Wagner, P & D Kenny, Kim Perkins, Laurine Hodges, Renay Mandell, Tracy Branson, Lyra Shannon, Elizabeth 'Wilo' Edwards, Cherie 'Rose' Hinsely, Linda 'Passha' Williken, Lou Diekemper, Lejune 'Twohearts', Diane Schultz, Steve & Marie Nygren, Cindy Claire, Anne Earhart, Susi Lincoln. Joe Spano, Grant Robinson, Liz Williams, Heidi Hader, Gayle Lukeman, Geneen Whitwer, Len Cohen, Randall Roberts, Eric Toder, Anne Allison, Gaddy Gadebusch, Susan Peterson, Jolie Swann, Patricia Richards, Sharon Whitley, Glenda Menges, Don Doyle, Helen Zuckerman, Steve & Diane Sanders, Bob Strom, Carol Kuzon, Kate Lair, Dr. Laura Paris, Bead Shop, Dr. Mary Farkas, Alex Lukeman, Pacific Institute, Kim Wilson, Shanya & Frank Lester, Sara Brawner, Dr. Frank Stennetti, Sheri Gantman, Jackie McCabe, Patricia Veenkant, Anna Ivara, Joseph Heller, Francesca, Joyce Black, Karen Snyder, Eva Goetz, Amayea Rae, Gailya Morrison, Sierra, Joie Goodkin, Steve & Charlotta Hendler, Ann Postma, Wilhelm H., David Novomiast, Chrysalis House, Holly Carlin, Scott Marr, Gloria Joy, Larry Bressler, Ed Walsh, Ruth Cunningham, Susan Kay, Randy Solomon, Lynn Cappriata, Helmut & Annaleise, Joie Goodkin, Raymond Veenkant, Margaret Jensen, Lynn Capouya, Laraine Barclay, Yoga Center, Rosemary Straley, Elizabeth Arrington, Barbara Bizou, Jane Goldberg, Marsha Donner, Michelle Rivera, Laurie Handler, Terra Wise, Beverly Buchner, Ellen Westcliff Lane, Dr. Lynn Vaughn, Sage Bennet, Renee Overton, Rilla Clark, Barbara Rossman, Janine Wooten, Jean Noll, Holly Ruessing, Hill Harper, Lindsey Sterling, Robert Arnon, Tai-li Wang, Heidi Hadar, Steve Conella, Margaret Jensen, Blue Sky Gallery, Barbara Lyros, John Stewart, Lynne & Trish, Brett Jennings, Sue Marie Connely, Greg Wolf, Robin Mullin, Anne Allisen, Geraldine, Kandis Frank, Bruce Schonfield, Yvonne Hui, Barbara Zilber, Beth Hinkle, Vina Williams, Celeste Wiseblood, Caro Ness, La Rhonda, Upgaya, Joan Hoelscher, Larry Niren, Helene Zuckerman, Champak.... and thousands of others who have participated in the Journey of the Heart. Thank You.

Table of Contents

For your Soul, *opening your heart* is the Beginning; *being creative* Transforms life; *higher consciousness* is the Path; *Divine Manifestation* is the Way; and *union with the Divine* is the Reward.

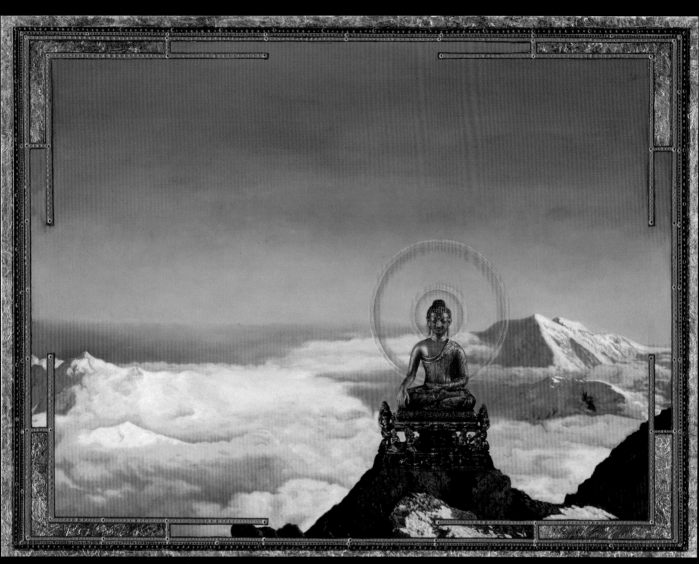

Mount Meru and the Buddha

Artist's Vision

This book is my exploration over the course of some 50 years of life. During that time, much of it spent becoming and being an Artist , I have come to know the Soul, and I have come to understand that the journey of the Artist is the discovery of the Soul.

Finding, facing, and knowing your own Soul is the ultimate purpose in life. This is the foundation of all my teachings, be it through painting, writing, or simply living life. Learning to see with your Heart's Soul, as an Artist, is the result of a long transformation, an evolution from a "business life" to a "creative life." After years of developing and practicing the medium of painting, I now share the path to the heart through the Soul. I am able to communicate the range of feeling and seeing that I experience day by day, both in my artwork and in my life.

Art is Ecstasy to the feeling-oriented Soul

During the 25 years of my business career, I felt that something major, something that lived at a certain depth, was missing from my life. Though I always felt creative, I now realize that I was not consciously connected to my living Soul. This connection developed over time as a result of Artistic exploration, numerous epiphanies, synchronistic events, unexpected pain and loss, and most importantly – through endless hours of painting and exploration in my own studio.

Introduction

by Rev. Michael Beckwith *Founder, Agape International Spiritual Center and author of* <u>*"Fulfilling Our Soul's Potential"*</u>

Paul Heussenstamm's art has graced the walls of the Agape International Spiritual Center, the organization I founded, for three years now. But it is not mere decoration; it is a living Presence. Whether it's a painting of a mandala, a thanka, a deity, an enlightened being or a sacred symbol, Paul's art transmits an energy of aliveness and inspiration.

In my personal and professional contacts with Paul, I can confidently say that it is his spiritual practices which infuse his creative gifts. His theme of art as an integral part of his spiritual path is the direct result of meditating and praying before the shrines of the world's wisdom traditions. From Hindu, Buddhist, Native American, Aboriginal to Christian—the pantheon of deities, icons and sacred symbols Paul transfers to canvas and sculpture symbolize the transcendental qualities of the Ineffable. As Inayat Hazrat Khan wisely observed, "The finer the artist is, the finer the symbols he produces. A real artist expresses his soul in his art."

Divine Passion is exactly what it presents itself to be: an empowering replica of Paul's original art that presents spiritual realities that cannot be expressed in words yet powerfully communicate through artistic expression. His artistic gift is stripped of personal vanity because it originates from within, from his awareness that he is an instrument through which beauty flows. Paul also reminds us of the beauty that lives in our own heart and stirs our yearning to express it in our own unique way.

From every angle Paul opens a window to the depth of being, and through the universality of his art reminds us that we can touch the heights of heaven right on the precious ground of earth.

Art turns the wheels of your everyday life.
My spiritual path is related to art. I can't get to where I'm going without art.

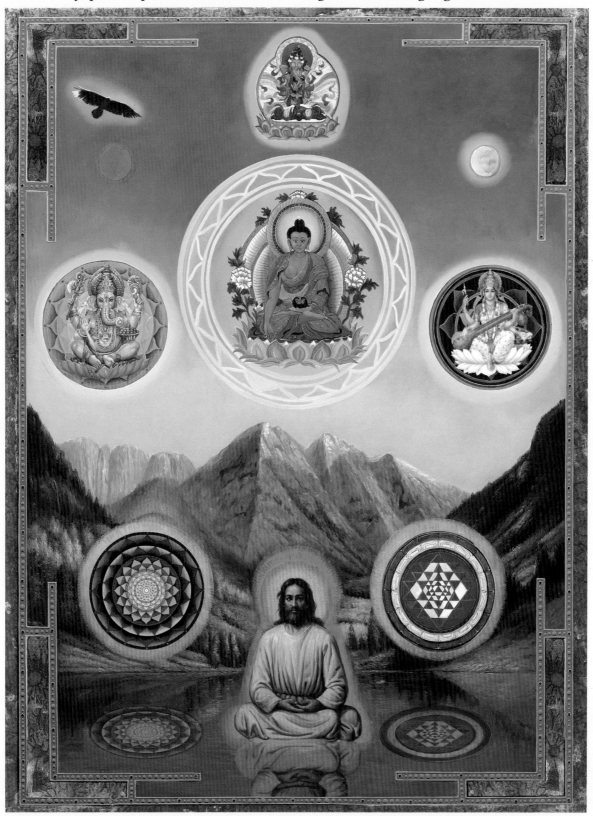

The Soul guides the chariot of an Artist's journey. This painting with the Medicine Buddha, Christ, Ganesh,
Sri Yantra, and Saraswati is a symbolic expression of a higher state of consciousness.

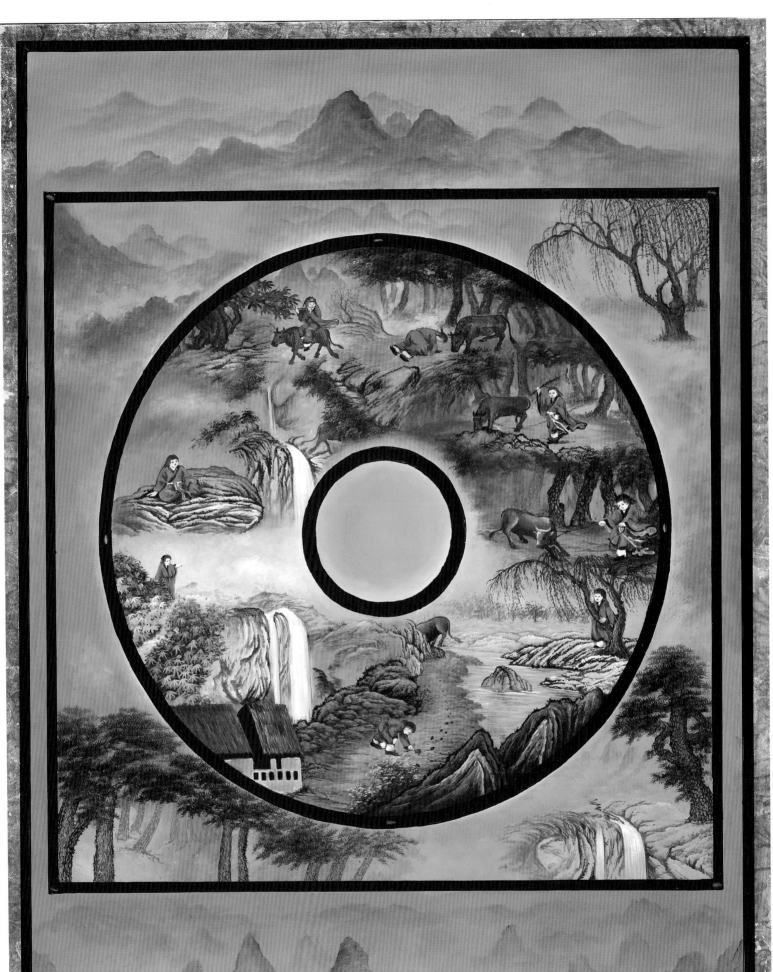

In Art, a teacher's hardest task is removing from each individual a belief :
I'm not creative and I'm not an Artist.

Paul *with Maitreya Buddhas*

An Artist lives the highest Dharma of his creation.

Foreword by Brugh Joy, *author of the "Joy's Way" and "Avalanche"*

To a teacher of life's Mysteries, nothing excites the imagination more than when someone comes along who can illuminate the spiritual forces that underlie an activity. In this book Paul Heussenstamm reveals art as a path into the spiritual realms where the Artist is discovered and where the experiences of the Heart Chakra or fourth state of human consciousness — the Anahata as it is called in the Eastern spiritual traditions — are known, integrated, and become modulating influences in the expression of the Artist through the Artist.

The uninitiated Artist is an individual who has learned and developed certain skills to express a rendering of either the inner or outer world available to him or to her. The initiated Artist knows that the inspiration and the signature expression come through as impulses or as a compulsion from something beyond the personal self. It is as if the person is the living vehicle of expression for a larger and more collective Being. The more the individual surrenders to this Call (transpersonal impulse), the greater is the power and endowment of the creation. The exposure to any work manifesting through this kind of Artist can be enough to induct such a potential in the viewer. An even more powerful way is simply "to hang out" with the Artist whether through classes or as he or she artistically expresses this fascinating grace. It is not a matter of asking questions or of learning technique. It has everything to do with riding along in the radiance of the Artist operating through the person. An individual is indwelled and initiated by the forces moving through the Artist.

The word Artist is being capitalized here to differentiate the technically skilled artist from the person who is a supplicant to and an instrument for a transpersonal mystery that manifests through the individual as artistic expression in life style and in painting. The Artist is then a genie, a daemon, an archetype, or, as in the Eastern experiences, an intermediate Tolku — a Beingness that is the metaphysical quintessence of the action expressed, whose source is beyond the ego structures.

For every great human expression there are transpersonal equivalents that, when accessed, transform the expression from the mundane to the sublime. We could then speak of The Healer, The Warrior, The Mother, The Father, The Teacher, The Child, and so on. In this book Paul is addressing an approach to experience the grace of The Artist. It is a development that transforms the individual from a purely self-centered and egoistic expression and understanding of Life to an individual who sacrifices the personal for the transpersonal awareness. In doing so, the individual is

Working together, Artists can work their way through the valley of the unknown
and together, arrive at the center.

opposite page: Women's Journey to Enlightenment

...raced with resources, senses, and insights that can only be called Awakened. As Paul reveals, the Artist cannot be willed, nor can it be forced into development. This is the mystery.

One can only be Graced by its Presence and then only through a sacrifice of self-centeredness. The action into the Artist involves surrender, letting go, allowing, opening, petitioning, prayer, and inner supplication. Although this is the usual path to prepare for the transformation, there are plenty of examples where the transformation took place spontaneously without conscious participation of the individual. He or she simply wakes up to the fact that something larger than his or her own sense of self is operating inside and expressing itself through action in the world.

It is important to understand the difference between the artist who is occupied with artistic expression and the Artist who is Called, in the spiritual sense, to express a collective and transcendent mystery. The former is an unconscious reflection of the sacred that lies behind the artistic expression. The works are technically and skillfully expressed and meet, to a large measure, what we usually call art. The Artist who is Called enters the vocation (this word means to be called by divine inspiration) of the Artist. It is not a choice, nor is it a willed expression. The individual is truly an instrument and realizes such.

What does the spiritual path of the Artist have to do with such an esoteric realization as the experience of the transpersonal through the Heart Center or Chakra?

First, the definition of the state of consciousness as experienced through the transpersonal forces of the Heart Center needs to be considered.

Thousands of years ago, the Eastern approach to spirituality differentiated the several states of awareness available to the individual in his or her path of spiritual realization. Each of the levels or aspects of consciousness are distinct and quite beyond the surface of ordinary human awareness. To achieve realization of any of these states of consciousness is a lifetime discipline, requiring enormous sacrifice of one's ordinary human expression. The states of awareness are associated with radiant forces emanating from different levels of the physical body. The Root Chakra, for instance, is connected to the elemental aspects of manifestation and is located between the anus and the genitals. This state of consciousness would best be described as the path of the Shaman. The Sexual Chakra or second chakra radiance is discovered between the genitals and the lower abdomen just above the pubic bone. The Sexual Chakra state of consciousness is expressed in procreative forces of all kinds. The best examples of individuals who are masters of this realm are Tantric Masters and the Dakinis of the East. There is the Solar

Plexus Chakra, the Splenic Chakra, the Heart Chakra, the Throat Chakra, the Third-Eye Chakra, and the Crown Chakra. Each has a radiate vortex of energy at a specific location in the body and each is associated with a distinct state of consciousness. Again, each of the states of awareness associated with the energy centers of the body is transpersonal — beyond the ordinary consciousness and operates independently of the surface consciousness.

The Heart Chakra or center forces are, for Paul and many others, a profoundly moving and appropriate preparation to becoming an "instrument" or a living incarnation of the Artist. The ego undergoes a change from the "me and mine" centered awareness to the "us and ours" dimensionality of being. The ego suffers a deflation yet in doing so becomes a much larger carrier of the deeper mysteries of life. The Heart Center experience is therefore a development where the surface consciousness becomes aware of the larger more transcendental aspects of life and places its resources in service to this large mystery. The Heart Center is not a personal state of consciousness; it is impersonal, yet deeply feeling.

Of the two transcendent or spiritual states of awareness available to most Westerners — The Mind and The Heart — the Heart expresses in the reality of relationships rather than in differentiation and discernment realities. The Artist knows innately the relationship of color, form, composition, feeling, and meaning without the need for words or concepts. It is through the whole that the experience comes and not through its parts. In Paul's case, the Artist's Eye becomes available. The larger dimensional relationships of life and objects are seen in new ways completely unavailable to the surface eye.

All anyone has to do to experience the power of creative genius is to enter Paul Heussenstamm's home. On wall after wall are the products of his vocation – his Call into being a vehicle through which the Artist expresses. These are not works of art that Paul possesses. Rather they possess him. It is in this sense that the capital "A" of the Artist as discussed in this introduction and in this book, is to be understood. To capitalize the word Artist is to reveal its spiritual basis. Again, the Artist refers to the daemon or genie — a transcendental over-arching influence — to which any great Artist surrenders and which guides the unfolding and development of the expression. It does not refer to the person that submits to such forces. The person as vehicle is the Artist but is not the Artist. It is the spiritual aspect, the transcendent aspect, of being an Artist that Paul so richly explores in his book. In our culture we speak of those individuals who are inspired beyond the ordinary as masters. Paul is an unfolding master.

I am a very appreciative witness of Paul's path of artistic

spiritual expression. His creative flow expressed in his paintings has augmented most of my conferences the past 25 years constantly inducting and communicating the deeper Soul mysteries to the attending participants. His famous mandalas — uniquely conceived Soul portraits of individuals grace many homes throughout the country. The essential nature of a mandala is to express the core (French Coeur) or heart of the matter in question. Paul lets go of his head and moves to his Heart Center for the images that will become that person's mandala. He is given the Artist's Eye to know the individual on a transcendent level. Again, this is where the forces of Heart Centering become important in the initiation into the Artist. The Heart Center's ability to be in a feeling relationship to the observed allows the Artist to express the Soul or essence. The Divinity of the Mind would reach the core of anything it puts its "mind" to and will see the essential nature yet be unable to flesh out or humanize the realization. It would express in descriptions and concepts what the Artist can and does express in images (relationship of forces that appear as images). Ah, the truth of "a picture can express a thousand words."

And what I most appreciate about Paul, more than the paintings themselves, is his Beingness — an extremely fertile, dynamic and living Artistic rendering, an actual incarnation of the Artist who inspires and inducts through color, passion, word and body, love-making, touch, dress, and physical presence. The Artist makes love to the world through Paul. And we, including Paul, are Its lovers.

W. Brugh Joy

Life Teacher and author of "Joy's Way" and "Avalanche – Heretical Reflections on the Dark and the Light"

Papaya Mandala

The creatives of the world make a huge difference in life and in the planet's wisdom.

Your Soul has miraculous creative abilities and capacities.

∞ TEACHINGS FROM MY SOUL ∞

When we learn how to open the Soul, we begin to feel connected with it, like a Buddhist practicing non-duality. First, we connect in our painting; and then we connect to life. This is the beginning of hearing a deeper language that leads toward a far greater insight into life and expands our conscious awareness. Soul connects one to all reality, to eternity, and is the fundamental teaching of my creative sharing. Similarly, a true Artist connects every stroke of painting to every other stroke to mirror the Soul's connected reality.

Art is the seed of all that is.
Art is a bridge between the mind and the Soul.

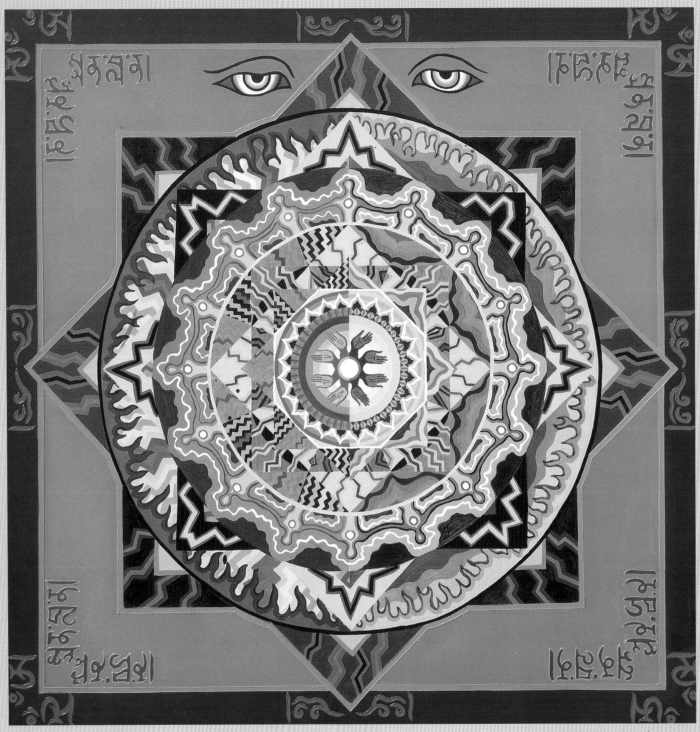

Awakening

Awakening was my first Mandala:
When my heart opened, the feminine side got larger and larger; and other relationships came into clearer perspective.

When you change your relationship with the heart, you change the way you live in the world.

Through painting and my Spritual-Creative practice, I have learned that the language I see is a universal language.

This is readily visible in sacred art in the West as well as in the sacred temples and monasteries of the East.

My teaching is about integrating Western and Eastern art from

a place that sees beneath the surface into the mysteries found in all ' sacred' paintings.

True art is a sensitive balance between tangible external reality and intangible inner reality.

We must learn to listen to our Soul to connect directly to our paintings (all art), our Spiritual life, and to the Divine.

Balance Mandala

Surfing the Cosmic Seas of the Mandala as printed in Awareness Magazine

P-s-s-s-s-st! There's a Shangri-La hiding in Orange County! When the door to Paul Heussenstamm's home and art studio opens, we are transported to Tibet, Indonesia and India by the beauty of the sculpted deities and art objects brought back from his extensive travels. Once inside, Heussenstamm's stunning paintings, covering every inch of wall space in this Laguna Beach sanctuary, are mesmerizing. His artwork immediately resonates on a deep level, stirring the Soul.

Paul's paintings depict many aspects of the Sacred: multitudes of hands bestowing blessings, all-seeing Buddha eyes radiating light, lotus reflections dancing in ponds, and Tantric lovers embracing for eternity. The artwork seems to be enveloped by the sounds of the ocean rushing through the open windows and blessed by the goddess statues in the magical gardens.

Most of Heussenstamm's art is in the form of mandalas, an ancient and archetypal image based on a series of circular shapes. As Paul shares the stories behind the images in each breathtaking painting, he gently entices us toward a closer connection with the Divine. For him it's all about "exploring the Sacred through seeing the beauty."

But before Paul created his mandalas, he was seduced by

the sea. A youthful 57, Paul has been a passionate surfer for 45 years. When asked how often he surfs, he smiles, "Every day that the surf is good," and that's been true for him since the age of 12. He laughs as he fondly recounts the many times his father allowed him to skip school so that he wouldn't miss a perfect wave.

And even now Paul admits that looking for him at his studio in the early morning is fruitless if there is a wave to be found on the coast.

Paul opened a surf shop in Newport Beach in 1974. It was not long before it evolved into a successful, award-winning, multi-million dollar chain of shops. Life was good. Looking back, he describes himself then as a "golden boy," successful in business and enjoying life as father, husband, and provider while living in a magnificent home in Emerald Bay – all without ever having to miss a day of surfing!

Then suddenly Paul's life crumbled around him. Everything he valued as part of himself began to crumble – home, relationships, business, lifestyle. He was imploding, and would later discover that the psychological terminology for this classic, archetypal experience was "the dark night of the Soul." What he knew in that moment was that he was in hell.

In his struggle to heal his heartbreak, Paul sought out spiritual teachers, therapists and art classes. One day, while attending a workshop facilitated by Brugh Joy, a mandala emerged spontaneously from Paul's brush. At the time he didn't know what it was, but it spiraled him toward a deep relationship with his Soul.

One of the great primordial symbols of humankind, the mandala has its foundations in Eastern cultures. In Sanskrit the word means both circle and center, and the art form generally includes a center, radial symmetry and cardinal points. Just as they have done for many hundreds of years, today's Buddhist monks still "paint" traditional mandalas with carefully placed colored sand. One particularly intricate pattern called the Kalachakra Mandala portrays 722 separate deities within the design! After days or weeks of meticulous work by a team of monks, these extraordinarily complex mandalas are used in Buddhist religious ceremonies, and are often also available for viewing. After the events have concluded, the sand mandala is ritually swept up and the grains of sand dispersed into a river during a sacred rite to honor nature. According to the Buddhist tradition, sand mandala painting was first taught by the historical Buddha in the 6th Century in India, and the continuous lineage of these teachings extends through to the current, exiled Dalai Lama.

Carl Jung is credited with introducing this ancient symbol to Western consciousness. His classic Man and His Symbols memorably featured a mandala on the cover. Jung called it a "…cryptogram (encoded message) concerning the state of the self." In Mandala, a multicultural exploration of the art form, authors Jose and Miriam Arguelles say the mandala "…symbolizes the various levels of awareness within the individual as well as the energy that unifies and heals. Making a mandala is a universal activity, a self-integrating ritual."

As a portal to the Soul, the mandala represents the center from which we all came, and to which we shall return, the alpha and the omega. And through connecting with the Soul, making mandalas can heal the broken heart. Joseph Campbell tells us, "Making a mandala is a discipline for pulling all those scattered aspects of your life together.."

Communing with the Soul requires learning its language — the wordless song of color, creativity, images and textures. The subconscious mind responds powerfully to the compelling language of imagery. In the blockbuster DVD movie, The Secret, a boy manifests a bicycle through focusing on photos of the bike he wants, and a bachelor Artist manifests a relationship by painting a picture of himself alongside the woman he desires. In a similar way, qualities of the Soul, such as peace, love and joy, can be invited into our experience through their symbolic representation in a mandala.

Paul later realized that the spontaneous mandala that emerged during the workshop was a lifeline tossed to him by his own Soul. Just as cutting through a tree reveals the concentric rings of growth, Paul had sliced through himself to find his own mandala within. And when that dam broke open, his mandala paintings flooded forth.

Paul's first two stunning mandala paintings were purchased immediately by Brugh Joy and Barbra Streisand. Now, nearly 1,000 paintings later, he is still mesmerized with the mandala, and with surfing the inner waters of its meaning. And he discovers more to delight his Soul in the curl of every wave.

It is from his own experience that he tells his Mandala Workshop students, "If you paint and surround yourself with sacred art, it will change your life. You will find out that you are not alone in your body; there is a Soul in there with you!" In his workshops in California and around

Orange Blue Mandala

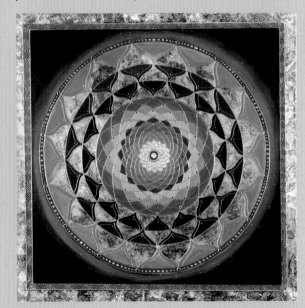

Malaysian Fire Mandala

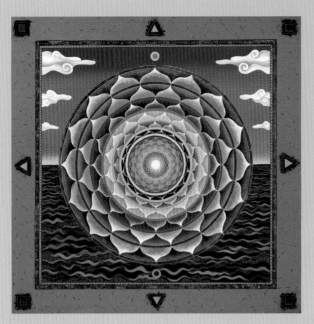

Inner Balance Mandala

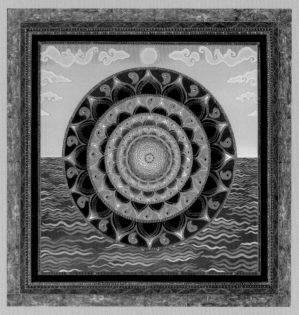

Oceans of Change Mandala

the world, Paul invites his students, many of whom have never taken an art class before, to a love affair with their own Soul. As one self-proclaimed "reluctant Artist" reported, "Somehow — magic occurs."

In Paul's Mandala Studio, a team of painters contributes to each piece of art created there. Paul's philosophy contrasts with the prevailing Western view that an Artist's work should be created from his own distinct and individual personality. Paul's point of view springs from the Eastern perspective that the various aspects of divinity can best participate in the creation of artwork through a variety of painters. This practice of co-creation was common in the traditional art world of many of the Old Masters. Rembrandt, Rubens and Raphael all ran studios with scores, even hundreds of painters, communally creating each work of art. Even contemporary Artists like renowned glass maker Dale Chihuly employ this type of communal method when creating their masterpieces.

Unlike the Old Masters, however, Paul does not sign his name on the front of the painting. He bases this preference on the Eastern philosophy of remaining anonymous in order to honor the Divine Artist. And he notes that "Georgia O'Keefe never signed her paintings, saying that 'the flower should stand in its own beauty.'"

In a compromise with Western sensitivities, however, Paul does sign the paintings on the back. And each piece of art that emerges from his Mandala Studio has his unmistakable fingerprint: his invitation to discover the ultimate love affair with the Soul.

Paul's mandalas and other sacred artwork have been in books, magazines, and movies. Various forms of his mandala painting, Sri Yantra Magic, were featured in several scenes of the metaphysical sci-fi movie "The Last Mimzy", though viewing the credit listings won't reward the attentive reader with a mention of Paul's name.

A number of Paul's paintings will be featured in the upcoming TV movie "Holidays in Handcuffs" starring Melissa Joan Hart and Mario Lopez, and directed by Ron Underwood, which will air as part of ABC Family's annual 25 Days of Christmas programming event in December.

Heussenstamm's work is in the collections of many notables, including Margot Anand, Deepak Chopra, Ram Dass, Mark Victor Hansen, Eckhart Tolle and Doreen Virtue. Collectors also include entertainers Mr. and Mrs. Dan Aykroyd and Annie Lennox, and Olympian Mark Foster. His work is also in the royal collections of both Lord Constantine of Stanmore and the Viscountess of Windsor.

"Higher Consciousness," a rotating exhibit of over two dozen major pieces of Paul's work, is currently on exhibit at the Agape International Spiritual Center in Culver City, California.

All of the magnificent art in the exhibition was painted in Paul's Laguna Beach studio – his lagoon of creativity, the watery temple from which his extraordinary mandalas are born. Heussenstamm's art rises in sacred celebration from the pools of the unconscious, bestowing blessings of the heart upon all who experience it. —Meryl Ann Butler

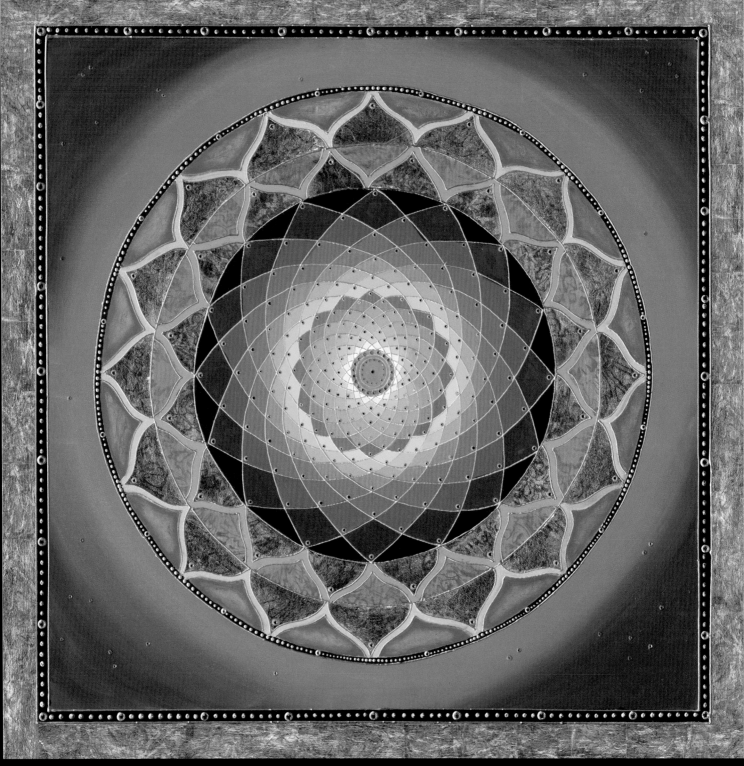

Blue Heaven Mandala

For the Artist, exploring the boundaries of consciousness creates a path through life that awakens the Soul. Also, in a Soul sense, a Mandala is always a door into the unconsciousness; an 'eye' into the Soul. Brugh Joy feels that: "The Mandala is another eye of God or Goddess. It is the mystery of the totality that moves outside of time and space. It can be experienced in all dimensions, and we catch a glimpse of the deity itself, whether the Mandala is personal or collective."

As I began my journey, the very act of being creative transformed me into a heart-centered being.
Exploring first as an expressionist and then discovering the teachings of the Mandala,
my life was fundamentally changed!

I soon found that painting Mandalas (sacred temples)
began to integrate my spiritual life with my paintings.
I realized that art had become my spiritual path and my guru!

Paul with Countess Elizabeth Heussenstamm
Heussenstamm Castle, Vienna, Austria

Personal Mandalas as printed in Vision Magazine

Perhaps the most recurrent piece of advice present in both Western and Eastern philosophy is "Know Thyself." From Plato, the Greek Classical philosopher, to the Tibetan "Book of Living and Dying," this dictum echoes throughout. Certainly, many schools of psychology view self-knowledge as basic to a healthy psychology.

Paul Heussenstamm has found his artistic home in artwork that seeks and accomplishes this objective. The specific composition, which has facilitated his exploration of the spirit, is the ancient form of the mandala. A mandala is a complex form that begins with concentric circles. These layers are filled with specific symbols and patterns with symbolic representations. That fact that the overall composition is circular is meaningful, as the circle symbolized the infinite, completion, as well as continuum.

Brugh Joy, Heussenstamm's spiritual teacher of fifteen years, has stated that the mandala is another eye of God. Or Goddess. It is the mystery of the totality that moves outside of time and space.

Joseph Campbell, in his "Power of Myth" series, stated that the mandala indicates the cosmic images that are operating in our lives.

Carl Jung, the eminent psychologist and mandala painter,

both rediscovered and introduced the mandala to the West. He felt that the most powerful religious form within the mandala was the circle, and particularly the circle manifest as the rounded square. The circle is one of the great primordial images of mankind; and in this consideration of the circle, we are analyzing the self. So great was his faith in the healing power of mandalas, that he employed them frequently as a therapy technique. On mandala symbolism, Jung writes, "There is no linear evolution; there is only circumambulation of the self. Uniform development exists, at most, only at the beginning; later, everything points to a center. This insight gave me stability, and gradually my inner peace returned. I knew that in finding the mandala as an expression of the self I had attained what was, for me, the ultimate. Perhaps someone else knows more, but not I."

Some time ago, after exploring various forms of Artistic expression, Heussenstamm recognized himself as uniquely sensitive to the spirit of others, and the mandala was uniquely expressive of the quality of those spirits. He has done, and continues to do, workshops as well as readings of other's Souls. After using his intuitive capacity to remove the veils of the superficial, he is able to produce a "map" of the psyche. By studying this map, the subject is able to see further into his/her own life, relationships, and motivations. He teaches and inspires his students to create revealing, personal Soul mandalas.

"First, we have to talk a little bit about the Soul. All of us believe that we have a Soul. We have faith in it. But do we really understand how the Soul is a part of our lives? That is what I have dedicated my life to, and what I have discovered in the mandala is a way to see the Soul, and create a direct relationship with your Soul," says Heussenstamm.

Continuing, Heussenstamm states, "In my life, I left a 27-year professional career to pursue teaching and sharing this perspective. Nothing is as valuable as the relationship I have discovered with my Soul. That is what my paintings are about the Soul and its language. However, you first have to be aware that there is a Soul that lives in you and is active in your life. But how do we begin to see its language?"

"When I first started painting mandalas, I didn't know any of this. This is all self-taught, all self-discovery. I began to see things I couldn't see before. I began feeling things I couldn't feel before. My awareness expanded greatly. I started when I was painting and then began looking at people and different cultures. I began to see that there is a whole invisible world that we in the West don't usually see. If you study Aborigines, Native Americans, Tibetan cultures, they know this language; we don't. We are learning, although we don't have many Soul teachers in this culture. I began to feel and see the "Soul" in painting and then began to see it in people. The Soul does not work in the same realm that we work and live in. We have to understand its language."

Mayan Mandala

"What do I mean by that? We live in a world of time and space, day-to-day, where everything is linear and logical. That is not the world of the Soul. The Soul sees differently. The Soul (I discovered in my experience) is in the body, in the Earth, and in the Mother. It was as though new eyes had opened for me to see with. In Tibetan painting, they add extra eyes in places other than just on the forehead."

"The key is to discover ways to access the Soul. There are vision quests. Some people take drugs, yet I don't recommend that avenue. The mandala is a portal, a door and entry point, a way to access the Soul and reveal

its language. The way to contact the Soul is to begin to learn its language; we begin to see the living Soul or what I see as the Divine."

"The mandala, for me, more than any other teacher in my lifetime, has opened the doorway into the symbolic language of the Soul. Once this language is known, once the doorway into the unconscious has been opened, once the dynamism of the intuitive pattern reading is known, changes occur suddenly and dramatically."

Inspirations for Heussenstamm's work range from Gauguin, Van Gogh, Cezanne, O'Keefe, and Kahlo, to the Tibetan masters and Native Americans. These Artists all share the ability to capture a raw, primal truth about the human character, and to open deep motivational centers (within the individual). The Tibetans and Native Americans are known for their devotion to a higher being, and to higher values. Their object is that of the sacred. Together, humanity is reflected in both of its aspects, as a physical being and as a spiritual being; and through the mandala, these aspects become one.

Paul Heussenstamm is an Artist, yet offers much more. He is a teacher and healer. His art, although decorative, can be used as therapy, in other cases, guidance toward self-realization, and in all cases, a sharing. To be sure, each mandala is a portrait of the psyche of its creator. The object is to help others progress to a stage that Heussenstamm has experienced, to inspire them "to find the spark that moves them deep into their own creative universe."

Call of the Soul

Heussenstamm operates and works from his studio in Laguna Beach where he conducts workshops on Discovering Your Soul Mandala. This weekend (2-day) introduction to the inner Artist is an opportunity to creatively explore the mystery the Soul and the mandala. Each individual finishes and completes a wondrously colorful mandala as a symbol to live with, study and begin a process of learning, growing, healing and Artistic development.

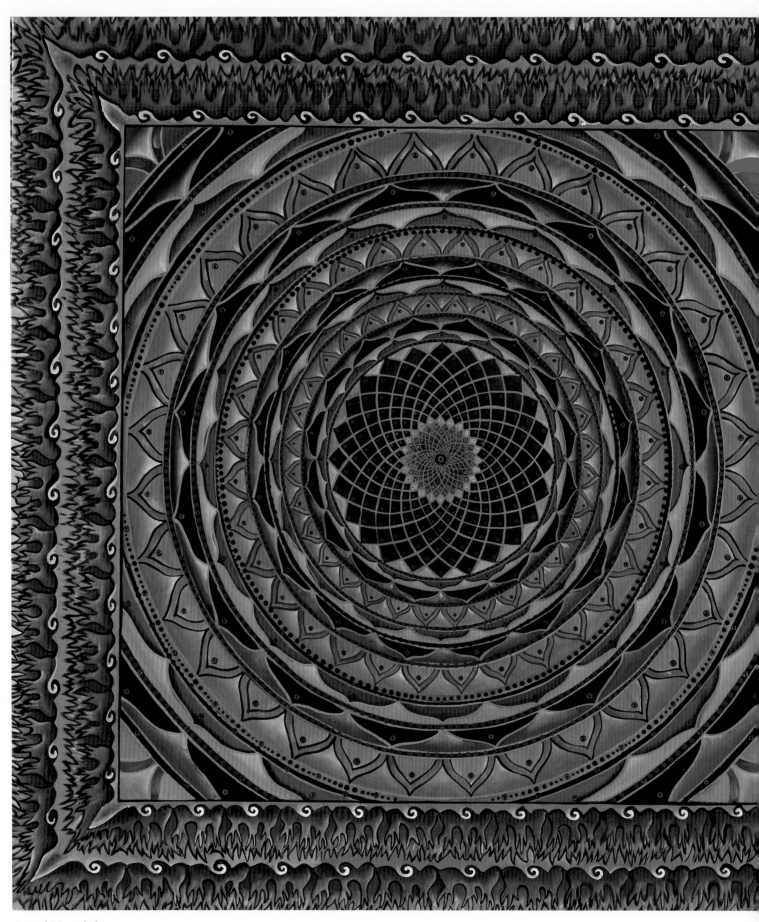

Jewel Mandala

The vehicle of the Mandala clarifies your vision, clarifies your mission; and the quality of life depends upon the quality of your relationship with your Soul.

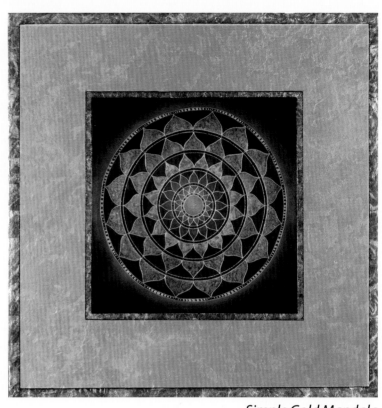

Painting from your Soul is the ultimate component that provides much more information than you had ever imagined.

Simple Gold Mandala

Painting from the heart is allowing the painting to paint itself.

All the paintings you have made in life have been orchestrated by your Soul with the Soul's deep desires to transform your life into a more passionate existence.

The Soul/Spirit is so near, you can't see it, although through art, we ready ourselves for joining with the Soul/Spirit.

Butterfly Mandala

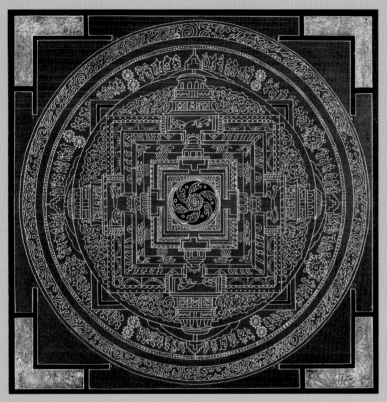

Red Temple Mandala
An Artist imagines a painting into existence.

Dance Mandala
A Mandala is where the inside and outside meet.

Heart Center Pastel Mandala
The Mandala has infinite capacity to deepen consciousness.

Maha Om Mandala
Om has carried me through my life; I remember my father chanting.

Art is a place between biology and consciousness.

"We are all circles on the great mandala; and by changing the intensity of color, we clarify the fullness of each circle. Every Soul is a circle with a unique combinationof color and intensity. Each circle contains two individual circles with a delicate membrane between them."

-Voice of Spirit

Language of the Soul as printed in Tantra Magazine

This powerful dream voice came through me in 1992 while I was painting in Hawaii, and it clearly symbolizes the essence of my work as a painter where Soul patterns are colorfully manifested through the ancient symbol of the mandala. "Mandala" means circle or center and has literally been around for thousands of years, although not well known here in the West. The mandala, for me, more than any other teacher in this lifetime, has opened the doorway into the symbolic language of the Soul. Once this language is known, once the doorway into the unconscious has been opened, once the dynamism of intuitive pattern reading is understood, then life as it is known changes suddenly and dramatically.

As I began to open up this ancient doorway, I received access to an understanding of a Soul language that has powerfully changed my life and the lives of all those who come into contact with this level of intuitive knowing. One of the true gifts of this language is a deep understanding of the patterns, symbols, and currents in Nature and how they relate to my own Soul's unfolding and development. These insights highlight my journey into the potential of full radiance of the Soul. As I look into my own Soul's pattern, I have come to see the "long body" (a way of seeing the past) of my own Soul's unfolding. My life as an Artist truly began the moment the sperm hit the egg. I now understand that a pattern was struck within the core of my psyche, or Soul, at the moment of conception. Of course, it took thirty-seven years and numerous life experiences before the pattern of an Artist fully manifested in my conscious awareness.

I came into being as the genetic combination of a Jewish mother and a German father. My parents were both studying art and met at the easel. The dynamism of the postwar Jewish-German mixture created the possibility of both tension and the union of opposites. This was the beginning of the pattern of my life as an Artist. My mother was an art teacher; my father a highly spiritual man, venturing into meditation and Eastern religion. Our home was constantly filled with unusual and deeply sensitive people like Sufi Master Pir Vilayat Inayat Khan, actor Gig Young, transcendental painter Emil Bistram, and health guru Gypsy Boots. Art and books were everywhere in our home. It was impossible for me to appreciate at the time the open and creative environment in which I had been born.

Next among my seminal influences was travel. Travel has filled my palette with colors, my mind with images. Travel has shown me the broad diversity of places and people, as well as the subtle inner unity. In South Africa, I visited the immense game preserves and the vastness of the wild African plain. I stood in the presence of lions and felt their overwhelming power and majesty. While I collected multicolored shells, flocks of pink flamingos flew overhead. Throughout Africa and the Middle East, I saw snake charmers, shamans and fakirs. Guatemala, El Salvador, Mexico and other tropical venues filled me with intense hues and a deep respect for the dignity of native peoples for their beauty and their strength. The works of the great masters of Europe filled me with reverence and awe.

The South Pacific, Samoa, Tahiti, and Fiji were places I walked for miles on tropical reefs alive with fish, turtles, and dolphin. The fern forests of New Zealand taught me a thousand variations of green I had never imagined, much less seen. In Australia, caught in a storm of inconceivable fury, we were forced to stay indoors for days. In Malaysia and Indonesia, there were miles of terraced hills planted with rice. The deeply spiritual people of Bali expressed a vital creativity — the arts of woodcarving and silversmithing being passed down from generation to generation. Hong

Kong and Singapore were charged with excitement and intrigue. Finally, the colorful memories of almost forty trips to Hawaii were most instrumental in my growth toward the Artist I was to become. The tropical plants and birds, the ocean, and the people still beckon me.

These adventures were times of ritual and deep purpose. It was an epoch of exploring, experiencing, and freely living life to the fullest. I was alive, awake, sexual, in tune with Nature, and vigorously healthy. I see now that being aligned with your Soul creates vitality and ecstasy. The role of this vitality, as well as the inventory of sights, sounds, tastes, feelings, and ideas is clear as it manifests in my Artistic vision. In my Soul's journey, travel initiated a rite of passage, all part of the path that led me inexorably to my life as an Artist. As we all must pass through the stages of development, I see my own period of travel as one that broadened my vision and prepared me for the life to come.

In the next stage of my life came marriage, children, and a successful business career. After falling in love and being married, I opened a surf shop. With my dedication, the small shop grew to a corporation grossing over a million dollars per year. Eventually, the store was nominated for a Marty Award, a prestigious award for retailers. I was deeply honored even to be nominated, which meant that the store was one of the most influential retailers in the Western United States. When we won, I was genuinely shocked. I realize now that this honor was the pinnacle of my life as a surfing businessman. It truly was the beginning of the end and signaled the conclusion of that phase of my life. I was about to enter the mystery of transformation.

Soon thereafter, I was picking up one of my sons at his painting class, and I asked the teacher if she gave lessons to adults. She said, "Yes," and I immediately began to paint. Years earlier, I had taken lessons from Gloria Joy, a transformational painter, although I really never made a full commitment. I was just thirty-seven. I began painting three hours a week with a hilarious bunch of wonderful, elderly ladies. It soon extended to two classes and six hours per week. Within a year, I was painting three days a week, and I began to genuinely be involved in learning to paint. By the second year, I was semi-retired from my business and was actively studying with several very famous Artists. I was dreaming of being one of those plein air painters, such as Gauguin, Van Gogh or O'Keefe. I was falling in love again with Nature, color, the outdoors; and deep inside

there was a growing fire of creative expression that was crying out to be expressed through painting.

As this process deepened, my paintings began to transform into the expression of this creative passion that was welling up from my unconscious. I was now painting my visions and dreams, and right before my eyes, the whole nature of my work and life was transforming. My art was pulling me into the exploration of deeper dimensions and the beginnings of the experience and expression of the Soul. A new voice had come into being, and I merely began listening and responding to this growing call of the unconscious. Little did I understand, and never would I have guessed, that this voice that had come into my awareness would change, expand, and transform my entire life. As I now understand this process, this was the turning point, where I was "called" into service by my Soul to contribute to life and meet my destiny. This voice would also carry me into a deep exploration of the unconscious, connect me with my ancestors, and radically shift my life. The creative spirit began teaching me the language of the Soul.

As I continued to study my visions and dreams, my artwork began to transform. One form of expression that came into being was very large and voluptuous flower paintings. Through the long body, I now see that these paintings forecast the end of my marriage. My increasing sexuality erupted into the paintings and I found myself moving away from my relationship. I was painting life-size. My growing, almost exploding, feelings were bursting into existence in these large and wildly sexual paintings. What I have come to know is that my art, all art, is a litmus test of the Soul. From the ego-mind level, paintings and art are beautiful and moving. From the perspective of the Soul or the mind's eye, paintings reveal the energy currents and symbols of the painter's unconscious, and in many cases the collective unconscious. I use the word 'unconscious' to mean that which we carry intrinsically as human beings but do not know consciously. Therefore, the unconscious is limitless, vast and a lifelong journey of exploration.

The amazing thing about the unconscious is that it is known by few here in the West. Once you have discovered your unconscious, it is the beginning of the great journey of Soul alignment and development. Through this work of exploring the Soul, I have realized the essence of measuring the Soul: the range of feelings and the sense of presence you carry. Paintings contain the intrinsic

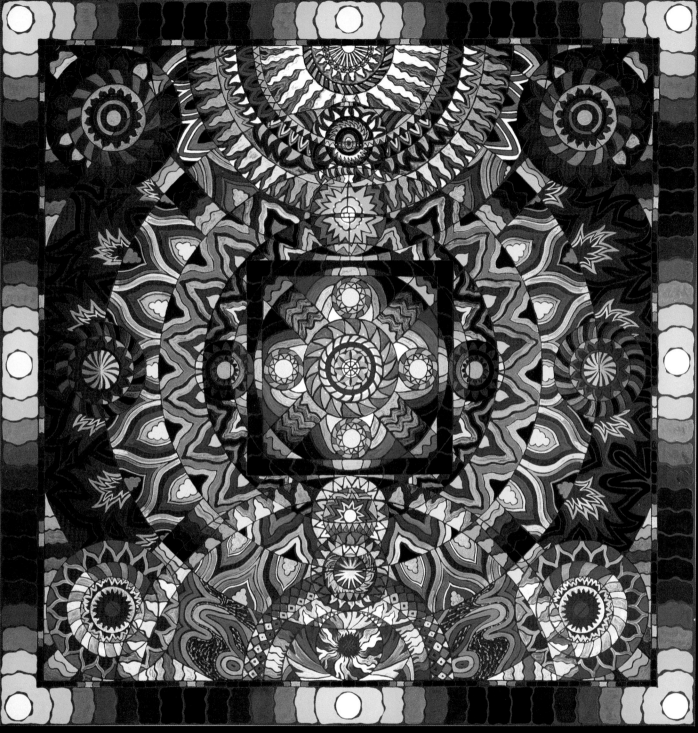

Anahata Mandala

Art has an infinite capacity to deepen consciousness.

How do you access the Soul? As I travel around, I ask people, 'Tell me about your Soul and how you relate to her.' Naively, we may feel it is in us, but I found that, instead, it is we who are in the Soul. "She" is all around us. Soul's location is not the question; but the experience of Soul (wherever she is), as something powerful to see and to hear. When I began to paint, I began to see new things, feel new colors, and experience a myriad of new feelings. I was seeing and hearing the Soul.

Blue Cosmos Mandala
Painting is intimacy between you and your Soul.

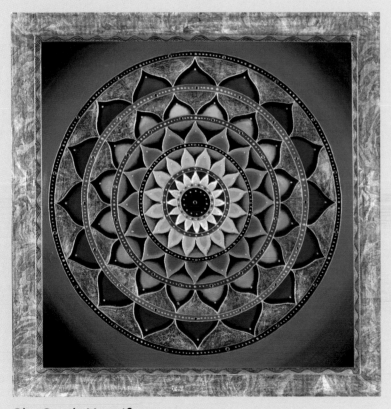

Blue Purple Magnificent
Art comes from the Soul's journey through Cosmic time.

Soul quality of the Artist and intrinsic patterns of our collective intelligence. This is why art has such great value. Art reveals that which cannot be said and it makes visible the invisible. From the Soul's perspective, all paintings are alive, breathing, pulsating, dancing, glowing, and carrying the forces of the unconscious.

In addition to the sexual flower paintings, the inner voice was directing me to explore the painting of my dreams. This moved me into the exploration of the deeper mysteries of the unconscious. As I look back into this evolution, I can now see the Soul was speaking through all the paintings. I had no idea of its voice at the time in my development. Yet, the mysteries of the unconscious, as Carl Jung correctly named it, were being revealed in my paintings. My work began to take on a new level of energy. As my life rapidly changed, I became conscious and aware of my own Soul expressing a major influence on my life as a painter..

For a time I voraciously read everything I could find on the mandala. Reading Dr. Beverly Sheiffer's master's thesis, entitled "Mandalas and Icons," proved to be a significant event on my path. At the end of the book was her phone number, which I called. I was granted a meeting with her. Her home was beautiful, a feminine temple. There were art treasures on every wall. After our talk, she accepted me as a student. Here, I came to know the mandala as a psychic map and a symbol of wholeness that can center us through difficult times. Indeed, Dr. Sheiffer at that time was dealing with the loss of her husband and her son. The mandala was essential in her process of healing. After about three months, I knew our work together was finished, and I asked her if it would be permissible to create mandalas using these techniques. She thought about it for a moment, then stated, "You're the only one who has taken this kind of an interest in my work. I'm gifting you with this process." After thanking her, I soon began to enter fully and explore the mandala. My second, third, and fourth paintings all sold immediately. I realized that I enjoyed and was energized by painting mandalas. Little did I know that four years later the mandala and the great mysteries it contains would become my life's work. This whole form of Soul destiny was validated when I discovered one of my drawings from childhood. I found a powerful mandala that I had created when

I was about seven. Within this drawing were all of the mysteries that I was now exploring almost thirty years later.

One begins to know his or her own Soul and opens to the capacity of intuitive knowing through the long body, the mystery of one's own unfolding. It is an awesome journey and truly the essence of all of our paths into the spiritual dimensions. Art is the visual entrance into the mystery of creation. Once the inner eyes of the Soul are opened, then you have access to experience of this mystery. You can walk into a museum and see the living presence of immortality as presented by the great Artists. To our Souls, all of their paintings are fully alive, charged with energy. They are visual expressions of the painter's Soul, our Soul, and the mystery and essence of life. This is why art is so valuable. It is the mystery revealed. This is the reason we build museums housing the works of great Artists. When you stand in front of a great painting, you have an opportunity to feel the radiance of the Soul of the Artist and his or her connection to the eternal currents of creativity. To the Soul, there is no comprehension of time and space. Paintings are in the eternal now; they are alive. The discovery of this mystery was the end of my twenty-seven-year career in the surfing and clothing industry, and the beginning of seeing life through the eyes of the Soul.

Not long into this process, people began to feel and respond to my paintings in a much deeper way. They began to ask for specific commissions; for instance, mandalas for meditation rooms, altars, or for astrology or therapy practices. I returned to Brugh Joy and showed him several of these commissioned paintings. He suggested that at a very deep level I was tapping into the client's personal mandala. My response was, "What's a personal mandala?" He laughed and said, "One day you'll know."

His teaching and my own realizations of this mystery in mid-1991 have carried me into my present path of creative development. The mandala, whether it is personal or collective, is a magnificent teacher. It is truly the doorway, or portal, into the well of the Soul. It is an "eye" into one's unconscious, revealing the language of the Soul. Once you intuitively understand this visual dynamism, then you enter the eternal mystery of

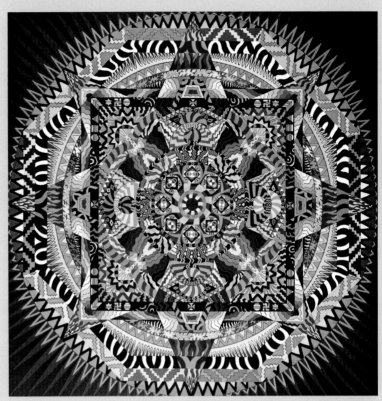

MINDala
You must learn to yield to the paint.

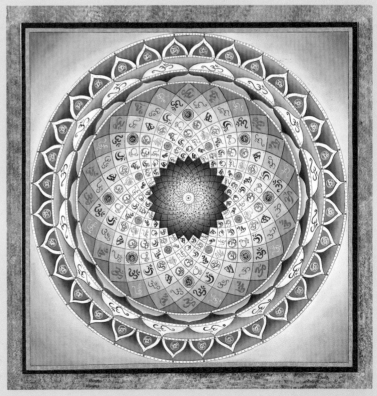

Om Mandala
Painting is about sitting and listening to your Soul.

the divine, and you have the divine gift of feeling and seeing the mystery. This has long been understood by various cultures around the world, but it is only reappearing here in the West due to the great changes in our culture today.

The wisdom of the mandala has taken me into many aspects of the mystery of my own Soul. One of these is teaching and traveling around the country this past year sharing the wisdom of the mandala. I call my teaching "Art as a Spiritual Path." This is the sharing of the deep colors of love. In lectures or workshops, we begin to work with mandala symbolism. When you stare at the center of the mandala, which is called tresspasso in the Eastern traditions, you begin to see with your peripheral vision. Immediately you see, maybe for the very first time, the patterns and movements in Nature. As you are staring at the center, the painting comes to life. You see breathing, movement, spirals, colors expanding, wheels turning, and a glimpse of the cosmic mysteries. The beauty of this technique is that after a while you can move your eyes and see the dance of the cosmic patterns throughout Nature, which can also be seen in holographic posters. Taken a step further, this visual dynamism can be applied to all seeing in manifest reality. This is a great entry or path of induction into the language of the Soul. From the very thrilling moment you first see the mystery, much of what you thought was real begins to collapse or fade away; and a whole new level of reality opens up, the drawing of the veil of "Maya". You walk through space and see a profound dance of patterns, color, movement, and the connectedness of the universe.

At this point there is no more boredom in life; any walk can be a journey into the mystery of the universe. When the eyes of the Souls have opened, you can see what the great Artists, poets, and composers have been moved by. This reality is the very essence of their Souls. Seeing another human being as a Soul with these eyes fills you with profound compassion. You will witness in front of your very eyes the deity itself. It is an awesome experience, and one that has powerfully affected my work as a painter, my relationships, my workshops, and my life. This Soul seeing, and sharing the Soul's language is the dedication of my life and my painting. The Soul sees, feels, and hears only the present. It knows no past or future. It looks into and through Nature, and reveals its range of sensitivities through deep feeling.

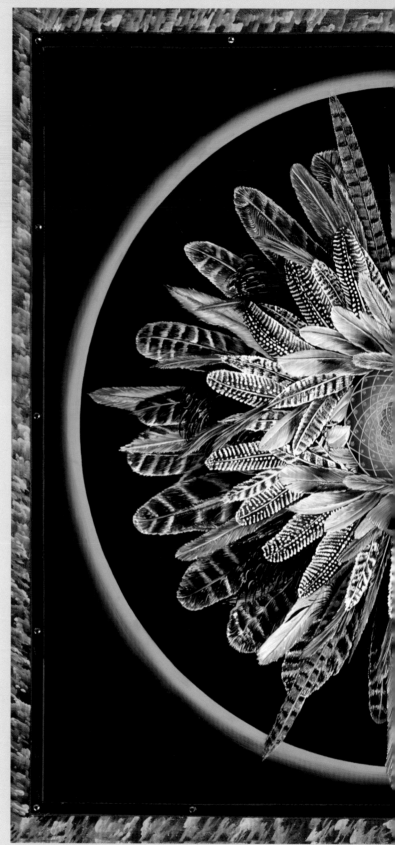

Feather Mandala

Paint with your heart, not your head,
for your head will lead you astray.

Its center is the heart and the Heart Chakra. When viewing life through the eyes of the heart, you look into a wilderness of experiences that are hidden from everyday awareness. There comes an intuitive knowing that you are no longer reading about life or the spiritual journey; you are the mystery. As you move, the whole universe moves with you. This is the place of oneness with life, with Nature, and with the eternal dance of the divine. The Soul and its vitality, is the entrance into the mystery of existence. Art is a direct form of truth and it visually reveals this mystery. While much of the world is into television, inside our very home is the greatest mystery of life in living, vibrant, dancing and cosmic color.

The mandala looks into the wholeness of life. This means what you see and know, and what you can't see or know with the outer awareness. When this is applied to people, you begin to see the patterns of the unconscious. In the unconscious, we enter the mystery of the dark side, or parts about ourselves that we haven't either known about or integrated. I mention this because it is of great value to uncover the mysteries of the shadow side of the unconscious. I hasten to add here that much of my own journey has been one of falling into the dark side and having to survive very difficult circumstances in order to have an understanding of the powerful focus contained in this part of our psyche. I have had three great descents, of which two have been painted in mandala form. One is called "Descent into Fire; the other "The breath of Fire: the Feminine Crucifixion". These experiences were incredibly painful at that time, but I have come to trust fully and respect the workings of our own unconscious or Soul. My experience of life is that it is such a profound mystery, and that life itself as an expression of our Soul is fully in charge of who we are at the core level. When you begin to recognize this, you can't help but pray, for through prayer and grace we are given this gift of life. Life is the greatest gift you can have in this universe. Life has called us all into existence, and it is life we shall serve. When you know this, you listen to the call of service and you transform to a place where you can make your Soul's contribution. You also realize that in the second half of life there is no greater joy than making a form of contribution of whatever you are called to contribute. Your responsibility is simply to be fully present in who you are, the rest will happen by grace. The more you are radiant in yourself, the more others around you will radiate in themselves.

The heart is what desires the highest values.

The heart always sides with the truth.

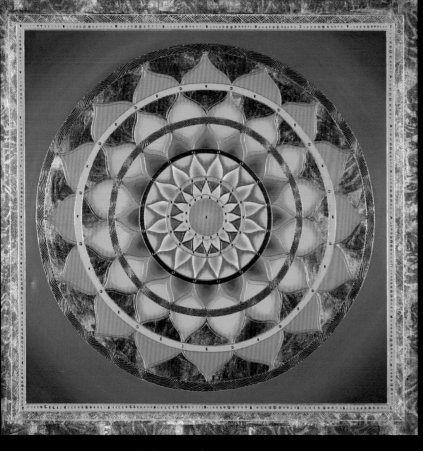

Turquoise Center Mandala

The door to your heart opens, and life as you have known it, changes... and changes radically forever. This is when I began to learn to step in front of my canvas and surrender to the Soul. The Soul overrode my own awareness, and I began to experience a much vaster and deeper range of feelings.

Commit yourself to earth while on earth. Commit yourself to the heart while you have a heart. Commit yourself to paint while you can paint.

This is the mystery of induction and why we all seek out teachers and gurus to facilitate our journeys. The mandala symbolically integrates the dark side in a safe, balanced, and deep way.

You do have to balance the deeper forces, but the mandala gives the psyche a valuable symbol of wholeness. According to Jung, the mandala is the ultimate symbol of well-being and wholeness. In my teaching, I have come to know that we are all right! In other words, the Soul has organized our unfolding in such a way that when you realize who you are and what you are, you immediately drop and kiss the Earth. You look back through the long body of your life and you would not change one second. You would pick the same parents in an instant, and you become eternally grateful for all your teachers, both of the light and of the dark. I know how painful this may be, but the teachers of the dark are quintessential to the process of the Soul's journey. The universe is a "cosmos" in the original Greek sense, an ordered, purposeful whole.

To see beyond the manifest is to grasp the pattern. All of reality has a pattern, and the patterns are ours to understand if we have the courage and insight to open up and look. All we seek: peace, love, health, and happiness, and in sum all that is real; and can be ours through this understanding. The chief blessing of my life is that these patterns have come to be expressed through me in the form of the mandala. My life's journey has come clear to me through this ancient symbol, and through it, I have been able to show others their paths. This is a great blessing. In my exploration, the mandala is the doorway into the language of the Soul. As you learn this language, you gain access to the eternal wisdom and mystery of the Soul. Your life will be altered, expanded, graced, and deepened forever!
Blessings and Namaste

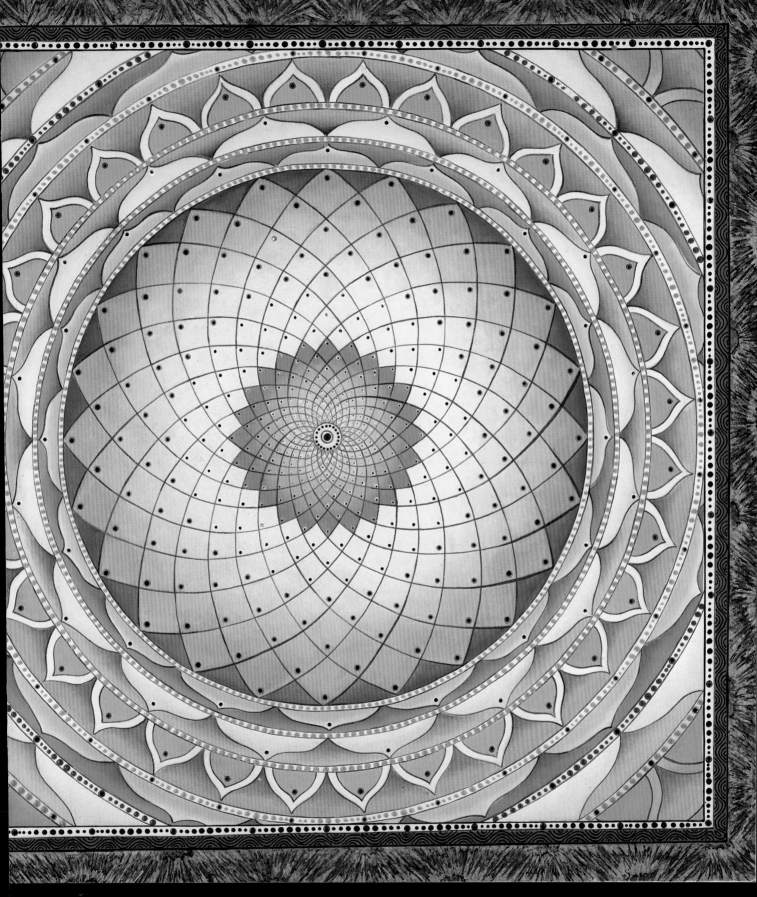

White Mandala

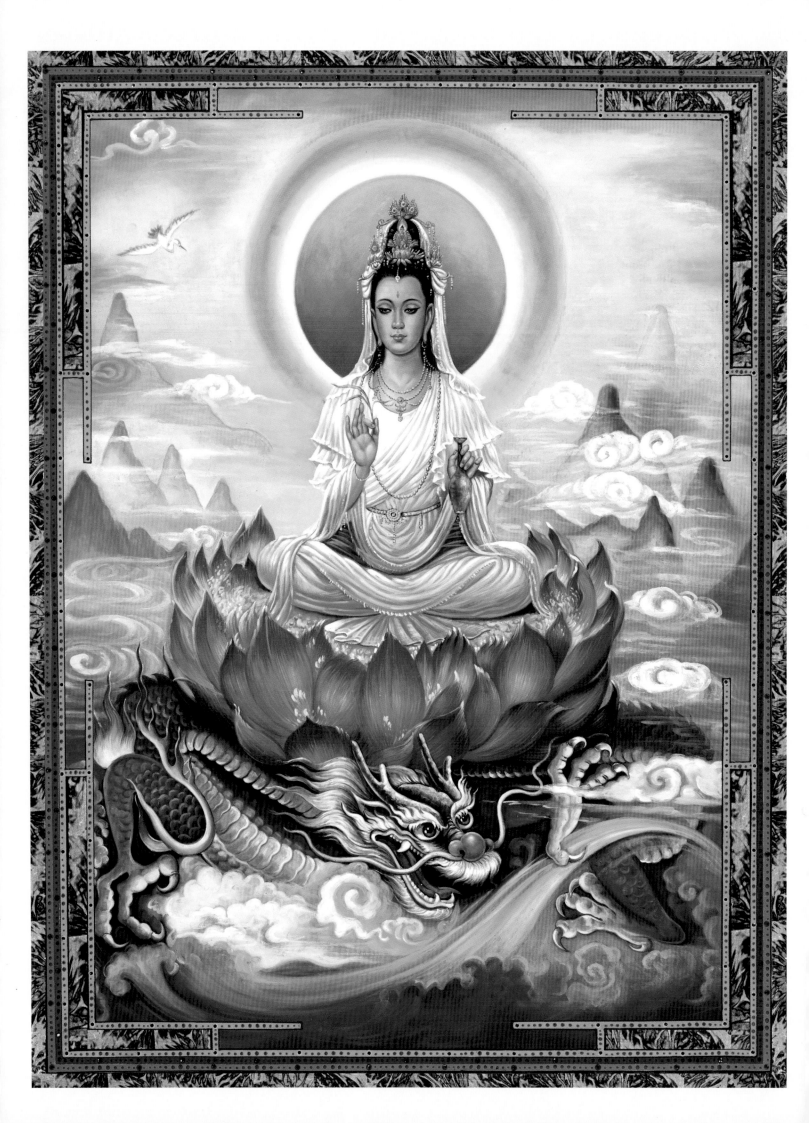

Once in my experience, I went alone to meditate in the desert. There were no hills on which to fix my vision. I was startled to realize that I was at the very center of a giant circle, and that the horizon was no longer flat. As I turned slowly around, I felt connected to the circle around me. As I moved the whole circle moved with me. In Buddhism, we are at the 'center' of the Mandala; and this was my experience. This experience immediately impacted my art because I realized I had found the Heart Center of the circle within myself. This is well-known and practiced by Tibetan Buddhists.

The impressions we take in from birth to the day we pick up the brush... every moment of memory from agony to ecstasy now comes into play in the forces of creation.

Buddhism: Creativity and Spirituality

by Lama Surya Das, *author of "The Buddha Is As Buddha Does"*

Who or what is the creative genie? One could say that it is the natural mind open to itself. One could call it natural spirit, heart and Soul as well. It is open, vividly present without being overly self-aware, and without constraint or expectation of outcome. Open, and full up with delight and innocent, childlike grace. Beyond poetry, beyond music, painting, sculpture — one could also say that the greatest art form of all is the fine art of living. Living day to day, moment to moment is the most basic, even authentic art medium we have: It is the means for allowing the creative genie out from inside us. When we create our experiences, ourselves, through every moment — isn't that art? And who doesn't participate in that?

One could even say that this is how God creates the universe. The fine arts have always been connected with mysticism. Prayer and contemplation have always been in themselves art. Artful. Reclaiming the sacred in our lives naturally draws us closer to the wellspring, the source of creativity. Many American churches today hold open-mike poetry readings, often outside. They recognize the unity of faith and culture.

Van Gogh thought that the best way to love life was to love many things. Ram Dass says that the best form in which to love God is in every form. My dog claims that god is dog spelled backwards, and most religions mistakenly have it all back to front and inside out—the tail wagging the dog. She bow wows to everyone and makes me want to be the man she thinks I am.

Authentic creativity is the art of freedom. It is pro-activity, like Buddha activity, which selflessly and spontaneously occurs according to needs, conditions and circumstances; not mere karmic reactivity based on egocentric conditioning and habitual patterns. Beyond effort or nondoing — Wu-wei in Chinese — authentic presence or enlightened activity — pure, uncreated creativity —

expresses the Taoist notion of nonstriving, of going with the flow, oneness. It expresses effortlessness, rather than over-doing, which is so unlike our ordinary conditioned reactivity, the totally predictable and conditioned stimulus response known in Asia as karma. Creativity is pro-activity. It comes forth freely and fearlessly, impeccably, as we must respond. Not simply in reaction to what others think and do, or what the circumstances around us seem to call for, but freely, according to whatever arises. Enlightenment embodied means unobstructed, uninhibited, spontaneous Buddha activity — the ultimate creativity.

Everyone today knows the use of usefulness, but who except the true Artist knows the use of uselessness? And yet, done must be what needs to be done—no more and no less. This is the great middle way of moderation and balance, implying an uncommon common sense, simplicity and straightforward naturalness, rich with discerning wisdom.

We may feel in the thrall of others; we may go through life with a victim-like mentality. But it's really a matter of following, or not, our own creativity and accepting responsibility for our own karma, our own character and destiny. Finding our own love path and following our joy, our bliss, as Joseph Campbell would have it. Not fooling ourselves about this. We don't benefit by editing out this scene, that memory; we don't benefit when we deny the truth, and pretend even to ourselves. We may blame others for our problems; but if they obstruct us, it's because we empower them to do so. There have been realized masters in prison, such as Sri Aurobindo and Mahatma Gandhi, who said, "The British can imprison my body, but they can't imprison my mind." Genuinely being our Selves is freeing ourselves. This is how we find freedom amidst bondage and within our entanglements and difficulties, not freedom from them by avoidance, denial, or getting away from it all.

opposite page: Quan Yin's Elegance — a tribute to the great painters of Asia... all of our teachers.

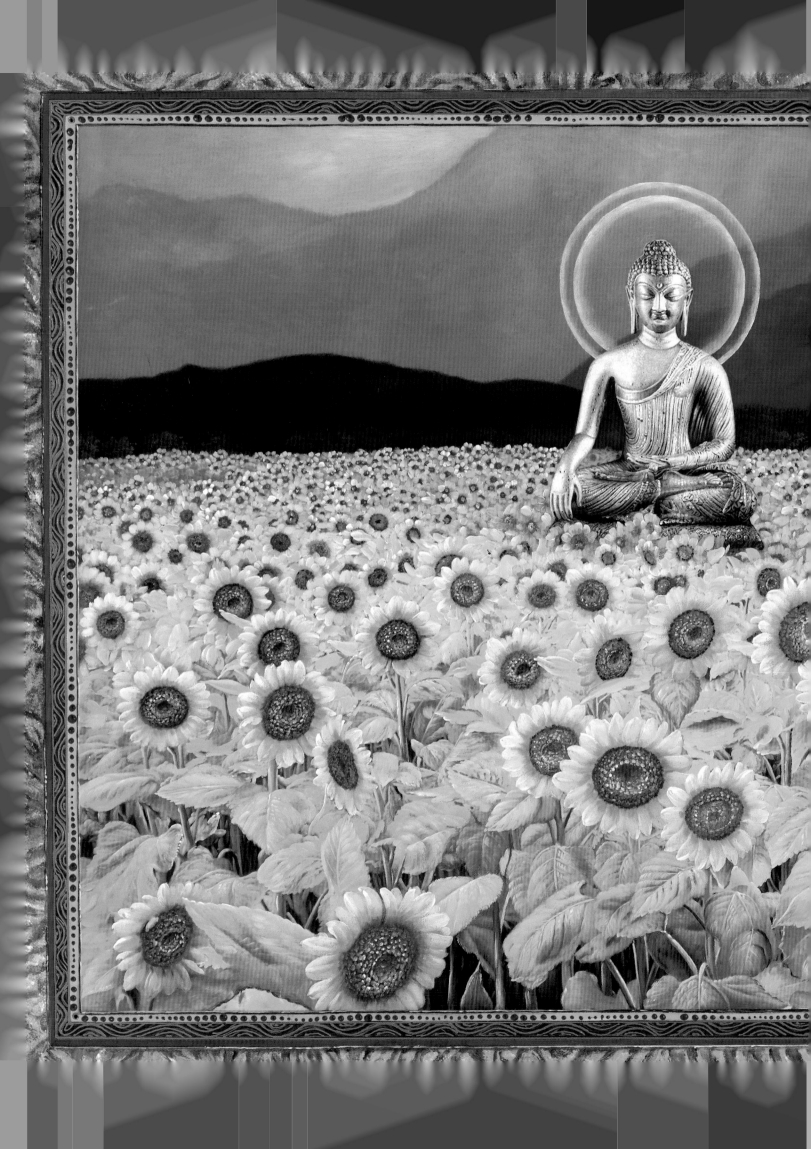

My experience is that an Artist must be initiated either from a teacher or from life. In Buddhism, the term for initiation and for the one who is being initiated is Srotapanna, one who has come into the current. Great Art is flowering just like an enlightened Buddha and carries the same form of currents or energies. One who has been initiated and surrenders fully to it, falls into the current and starts flowering. You have only to find a favorite Artist, such as Monet, and you can easily see through your heart that he carried unquestionably this current. I recommend spending a day at Giverny where Monet created his true altar to the Divine goddess of beauty.

Art is outside of time and space and always will be. One of the great problems and really diseases of our modern society is a mind that is in a hurry. The new phenomenon of our society is time-consciousness, which has radically changed our awareness and our lives. We have become so time-conscious that not for a single moment can we wait, stay in the moment. It seems impossible these days. Therefore, art that is timeless is separated from our world, it's out of reach. This isn't so when you go to an ancient temple in India where the art has been meditated on and prayed to for thousands of years. In the Ellora temples, just a few kilometers from Bombay, you can experience sacred paintings and stone carvings, meditated and prayed on for more than 1,500 years. The whole place is consecrated to the Divine through the Spiritual values of beauty and Artistic creations .

If you find any Artist or any art, just surrender to the universe. And the awakening may happen. The Artist in you may appear. When you are fully open, fully vacant, totally more or less empty, then the spiritual force rushes toward you and fills you. So always remember that whenever you feel like surrendering, do not lose the moment. It may never come again. Surrender to art and art will become a teacher to you. Many things will be revealed to you from art that no book or scripture can reveal to you. Surrender to a color, and the color may become a God to you; or the color will reveal things that no God can reveal to you. The Ultimate is surrender, which is the spiritual path of the Artist. This is the initiation and entry into the spiritual life through the creative process.

Unfortunately, so many of our responses today are aggressive, neurotic and violent — just like eruptions of the unconscious in dreams. There is an outpouring of aggression. And basic aggression is the incessant desire for things to be other than they are. Creativity is a natural outpouring of reality from the real to the real. Everything is subjective; this is truth, the way and the light. In this light all and everything is possible and just happens. The whole moves, yet every single pixel is still. From the Musely point of view, when nothing is done; nothing is left undone. Yet don't mistake this supreme serenity and centeredness for mere inaction; creativity is incandescent dynamic energy and like true spirit, ecstatic and not static.

We can see the confusion in some modern art. Natural creativity is spontaneous: There's joy in it, the joy of mind untrammeled by limitation. But what we think of as spontaneous may well be nothing more than the knee-jerk spasm of conditioning. Karmic reactivity. Unkindness toward another, trashing the immediate environment like a child in a tantrum, or even the smearing of neurosis on canvas: all this an expression of egotism, of self-preoccupation. Sometimes I can see the difference between neurosis being splashed around — on canvas, in print, through sound waves or words and actions — and spontaneous, selfless Buddha-like activity, free from self and dualism.

The total attention, precision, and discipline required for true creativity to blossom through craft we've developed requires fully inhabiting the present moment, getting out of our own way, and letting the light come through. We can widen our inner aperture and — free of dualities such as inside and outside, self and other, past and future; in a nonconceptual state of wakefulness — be free of fabrication, unadulterated by artifice. As with meditation practice, one just is.

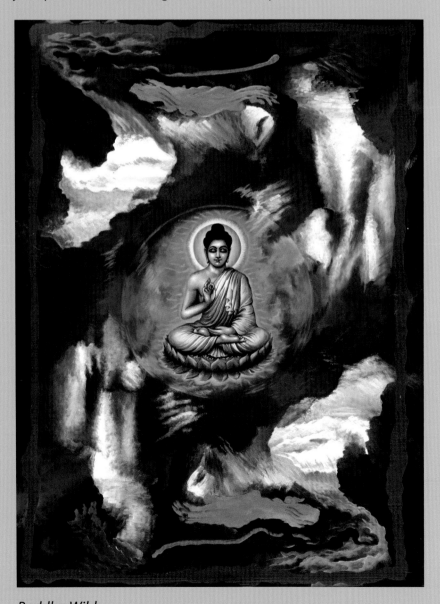

Buddha Wild

After seeing my paintings at the Agape International Spiritual Center, Tenzin Robert Thurman said : "Great art is Bliss to Buddha."

Great Art resolves the ego's problem of what to do with Death because Art goes beyond Death.

Sacred images are a form of energy... beginningless, endless, and timeless.

Vajrayogini (opposite page) is the feminine side of Buddhahood... Her brightly colored body is ablaze with the heat of her sacred tantric fire and is encircled with the flames of her wisdom.

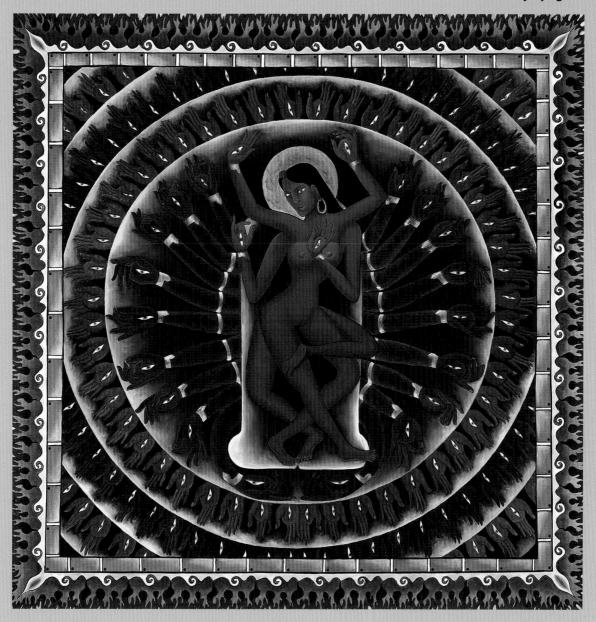

Chogyam Trungpa Rinpoche titled a book of poetry "First Thought, Best Thought", a Mahamudra slogan that embodies the notion that raw unedited isness is the real stuff of poetry. Allen Ginsberg said, "Ordinary Mind includes eternal perceptions." The unedited expression of what emerges before we have a chance to remake it is the primal stuff of art. I love haiku poetry and the intuitive flashes of one-stroke Zen black ink on white rice paper sumi-ye painting for this brand of elegant simplicity and radiant nowness.

The more that comes up from our unconscious mind, the better we get to know ourselves; and the more primal stuff, the more raw material there is for us as Artists to explore. Awareness practice implies familiarization, with ourselves and with reality, through cultivating the heart-mind transparent to ourselves — through meditative mindfulness, introspection and self-inquiry — the staple of Buddhist Artist-practitioners throughout time. It's not a matter of repressing anything — thoughts, emotions, sensations, perceptions — but of becoming more aware of all that there is within us. This is how we can directly experience reality as it is, not as we would like it to be. Buddhism calls it clear seeing. To approach and enter this luminous state, some form of meditation — classic or spontaneous, such as nature-gazing — is usually required. To see things just as they are, without the tinted glasses that distort our perception, is a form of transcendental wisdom.

Medicine Buddhas

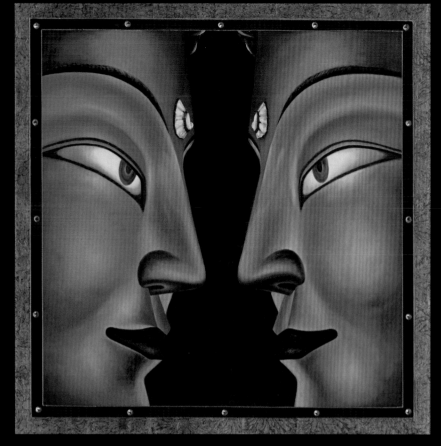

Art can end the war of opposites, opening a door leading to love of the unknown... when the door opens, you must take courage and enter the light.

You can see the Soul when the inner and outer worlds meet as one. Learn to see 'Deeply'... Art is a path to the Deep.

In our culture, here in the West, we are discouraged against identifying with the Deities. An Artist must learn to see into his Soul.

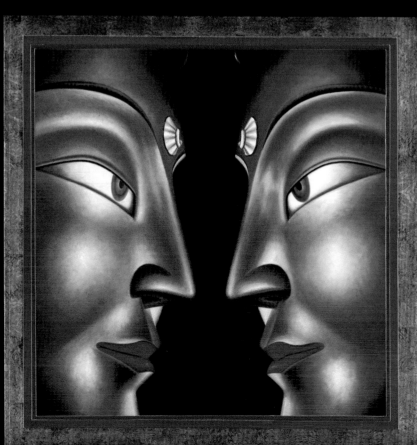

This powerful and influential realization allowed me to apply a Soul view to life, to relationships, to painting, to work, to Spirituality.

The Soul births us into life for a second time. We are reborn, and we see with new eyes.

The Artist's life is based on seeing and revealing this Divine world.

Maitreya Face to Face

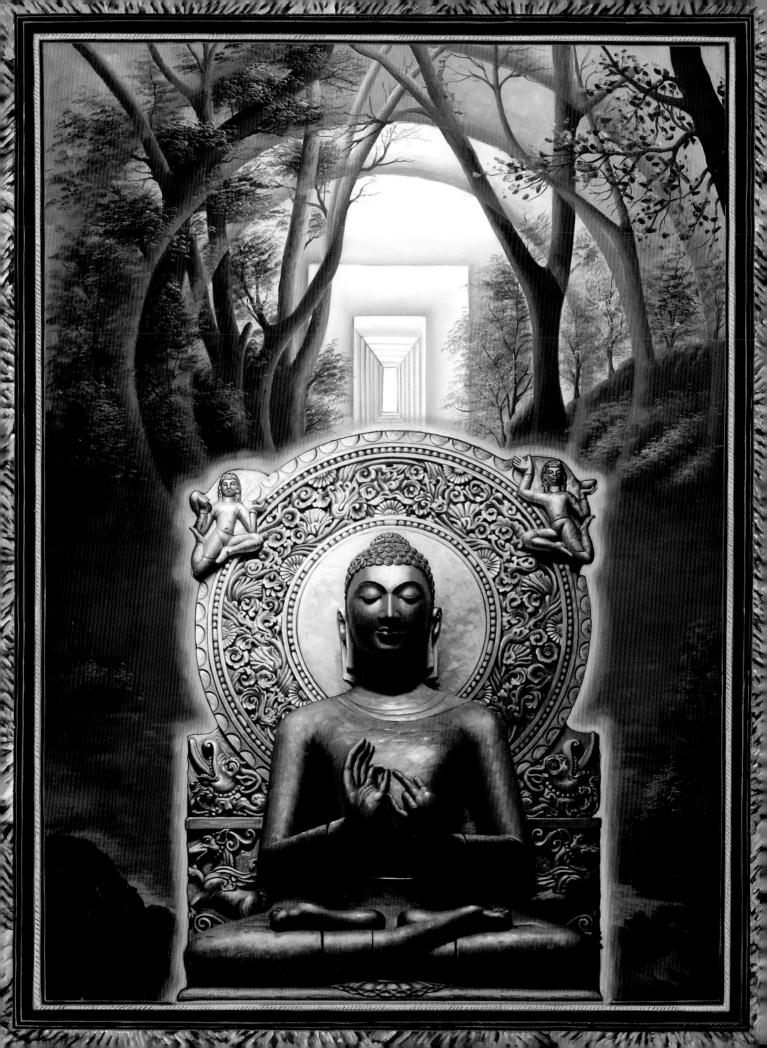

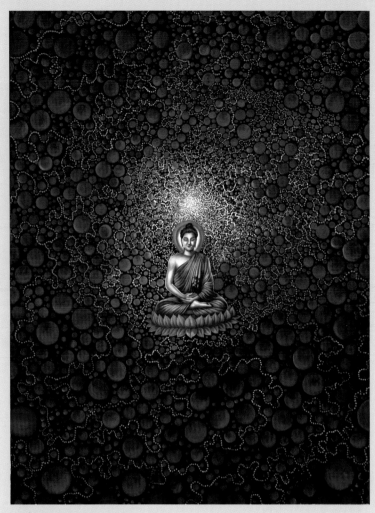

Buddha in the Veins

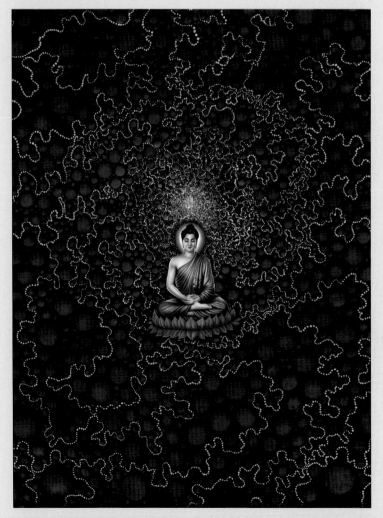

Buddha in the Bloodstream

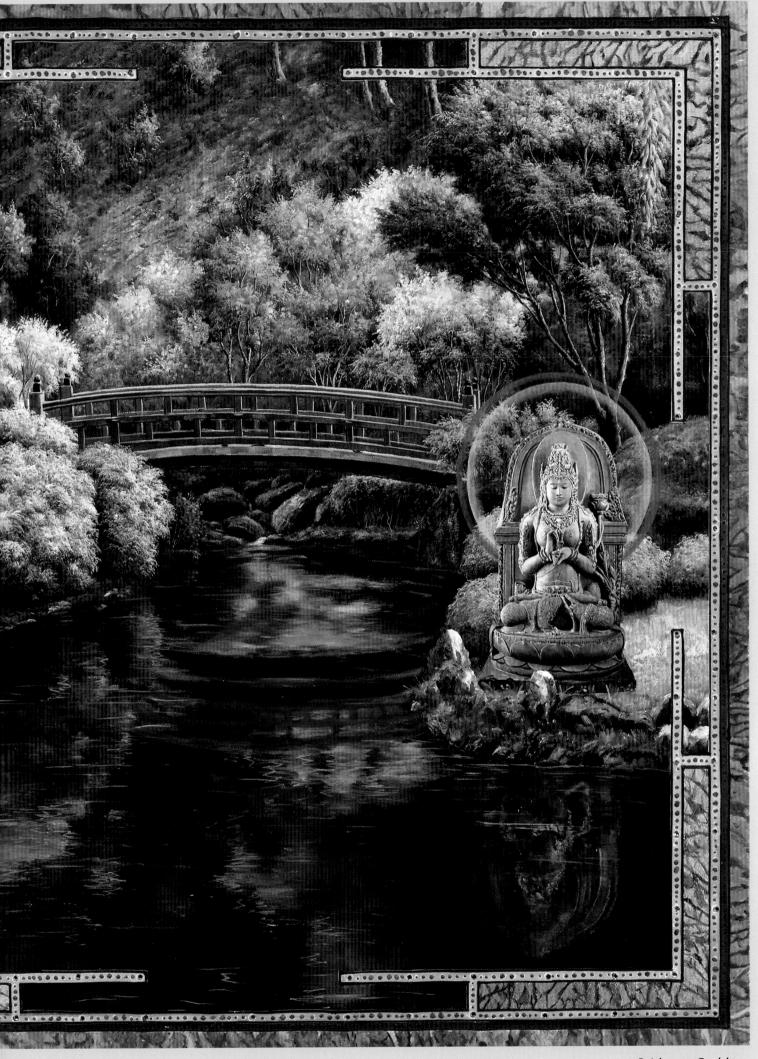

Bridge to Goddess

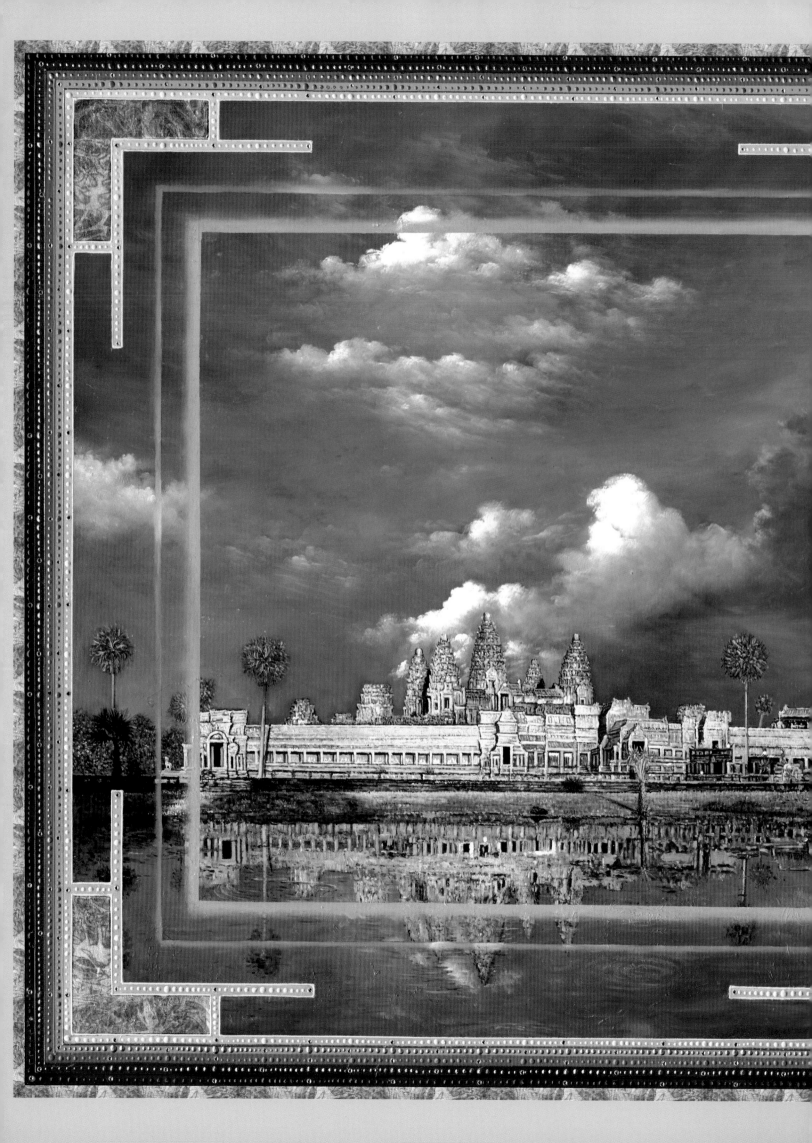

Art is a place where we learn to see deeper and deeper... an Artist's job is to deepen the mystery of creation.

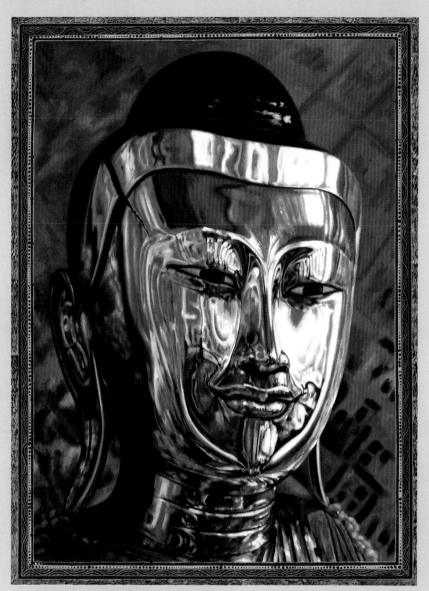

Golden Face Buddha

The Artist's gift to the world — especially the Impressionists — is that clear picture of exactly what the Artist was feeling and seeing deep within. They're seeing a world in union. This is why the Soul is available, shining through their work. It reveals the union of the individual and nature, of heart and mind. William Blake discovered "that we could see the whole world in one grain of sand." Monet saw his ultimate truth in a yellow flower. Michelangelo saw it in stone, Van Gogh in the night sky, Picasso in the abstract lover's face, Rodin in the body, Renoir in the women of Paris, O'Keefe in flowers, Seurat in the science of dots, Gauguin in dark Tahitian women; and Leonardo saw both Truth and his own Soul in Mona Lisa. Yes, the true Artist lives to manifest the Soul. His relationship with Soul is the fundamental foundation of his art and his life.

opposite page: Ankgor Wat Temple

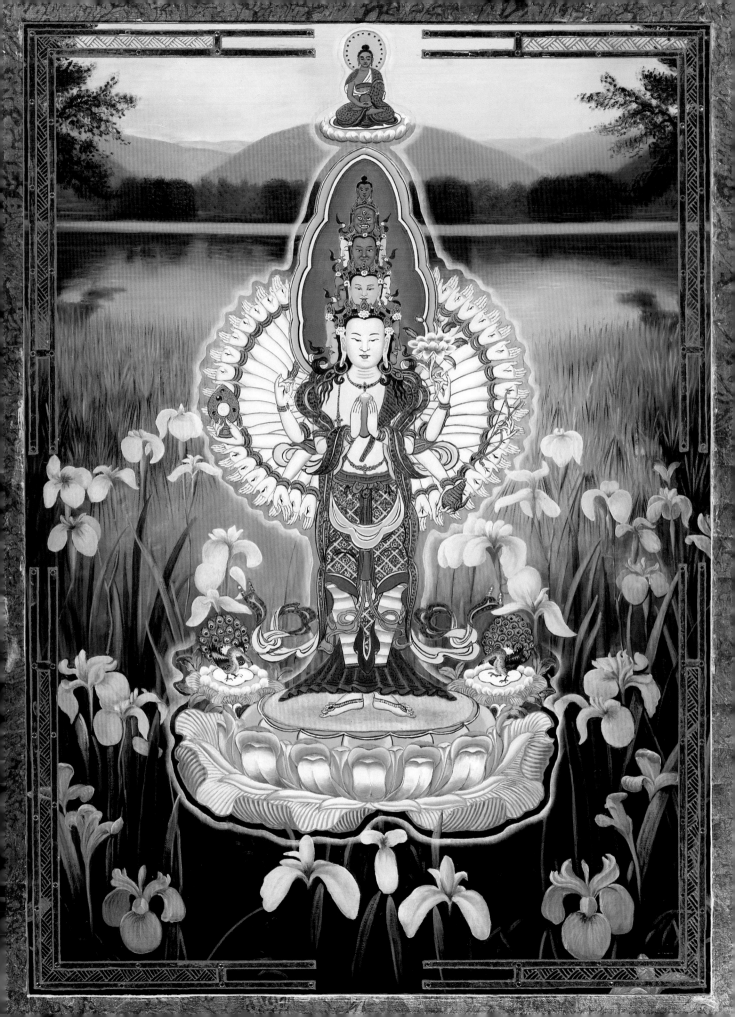

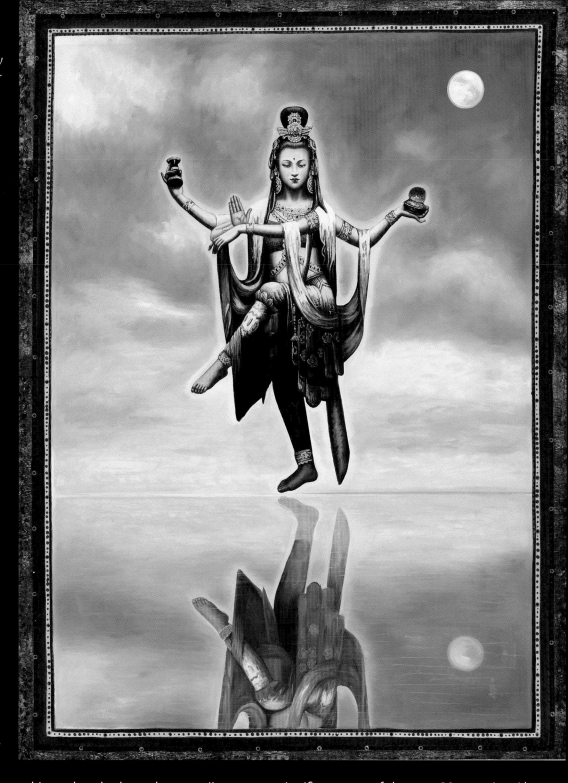

To see Divinity moving through our world, you have to see the collective body of all Artists working on every level, from children to art schools to masters.

Following the Heart Chakra transforms the life of the Artist.

Grace Tara

I know the Soul is centered in and at the heart because I've spent a significant part of the past 20 years in a 'descent journey.' descending from the mind to the heart; learning to listen to my heart first, rather than my mind, which is the basis of our 'surface' society. My friend, elder and Jungian psychologist, Robert Johnson, said he has great sadness for our 'literal-bound' society, which lacks the capacity to feel the depths of our lives and dreams. The Soul sees and feels differently from what we normally experience. Actually, by descending to the heart, we are simultaneously lifting to a higher consciousness. The Soul is working on a different level. She doesn't comprehend time and space. She is outside of it. Once you experience this, then all your previous ways of being more or less collapse, and you transcend your familiar state and shift to a more awakened consciousness.

*An Artist creates a piece of work that is equally personal and transpersonal,
individual and collective, temporal and eternal — it reveals that individual
consciousness is equal to eternal consciousness.*

*A creative person carries the God-given privilege of creating
those symbols that re-create the journey itself.*

*An Artist must, while he is here, learn to dance his own dance, If you attune your
dance to your Soul's pattern, then you dance "the Eternal" with all Artists from
all time.*

Buddha in the Vines

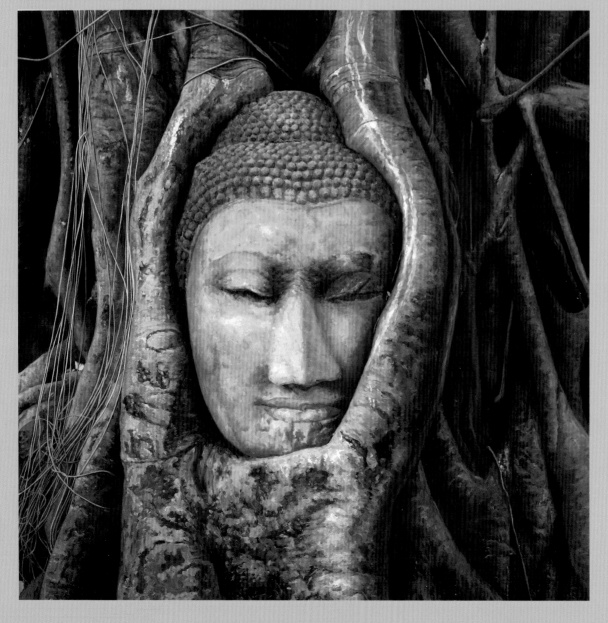

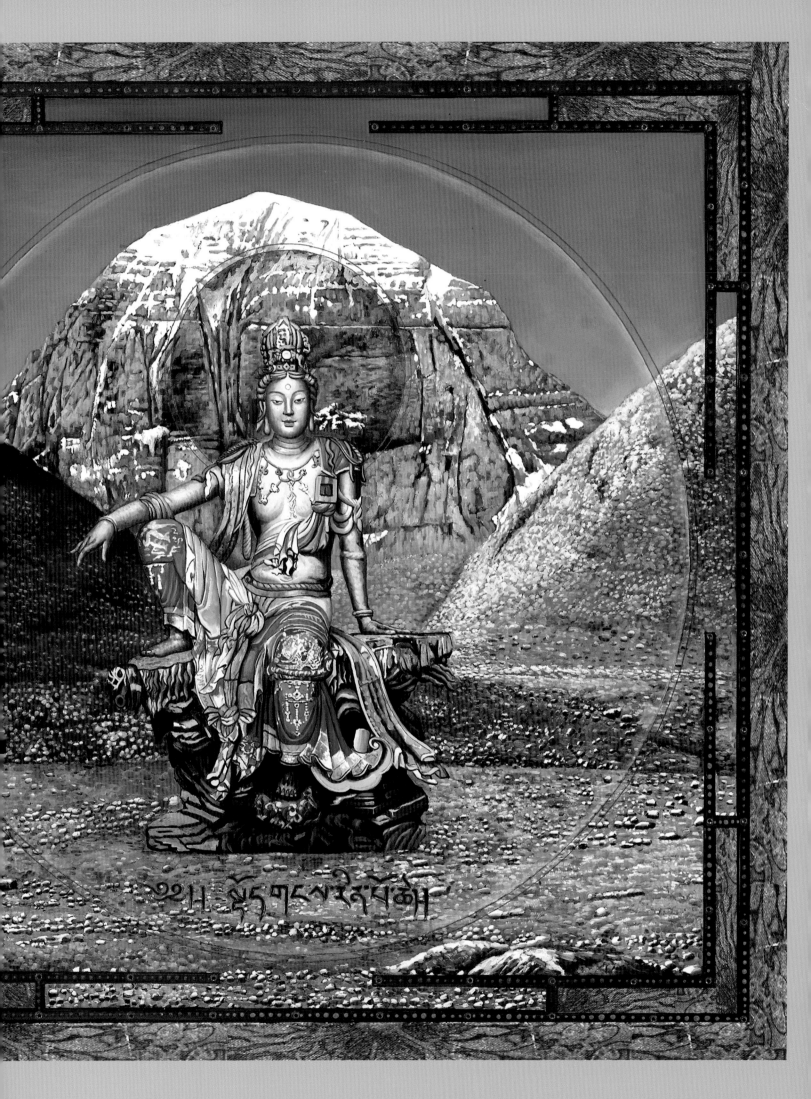

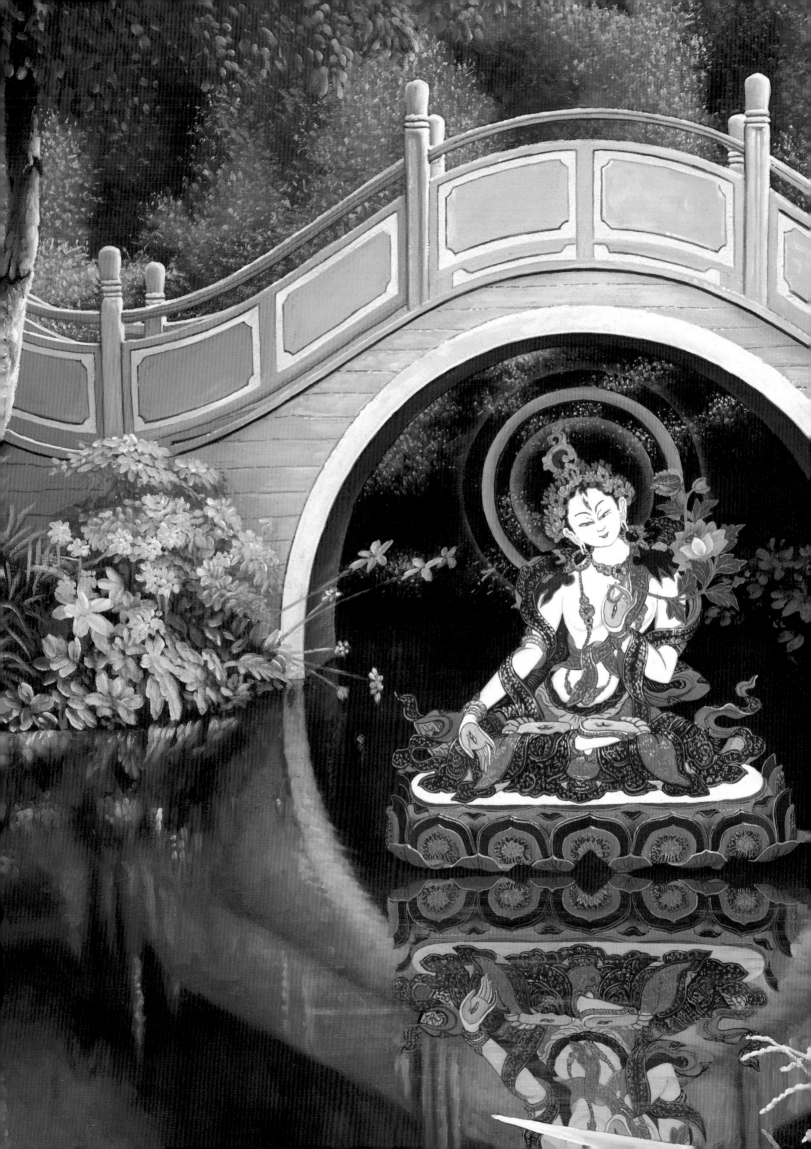

Pro-activity isn't relational; it's non-reactive. It's like unconditional love, openness. More than simply creative, it is creating. The process itself — spontaneous, uninhibited — arises from this. It takes time and practice to get out of one's own way enough for such art to emerge.

Dharma Artists, including Barbara Dilley, Kaz Tanahashi, Paul Heussenstamm, Mary Oliver, Rick Fields, Allen Ginsberg, Philip Glass, John Daido Loori, Meredith Monk, and Kate Wheeler have all spoken of how their art is an expression of spiritual practice. Writing teacher Natalie Goldberg was told by her Zen master, Katagiri Roshi, that as she was having so much trouble sitting in meditation, she would do better simply writing. It was her own creative process that loosened her up, her own natural meditation that freed her from the constraints of self-consciousness. One's art is ones natural meditation, an intimate mysticism deeply connecting to our innate true nature, divine nature, Buddha-nature.

Rumi, the great 13th century Sufi saint and mystic, is surprisingly a best-selling poet in America today. But saints have always loomed large among the giants of literature and mysticism. Basho, Hildegard of Bingen, Blake, Tolstoy, St. John of the Cross, St. Francis, Milarepa, Han Shan, Sengai, Wang Wei and Wordsworth — all expressed their spirituality through art and art through their spirituality. In the Zen Buddhist tradition, poetry, painting, gardening, tea ceremony, calligraphy, and the other arts are considered ways to meditate in action; they engender the same results, it is believed, as sitting meditation, as zazen. Creativity and spirituality are related, intimately, inseparably.

Divine creativity flows through us when we learn to tap into our inner natural resources. That's why it can be extraordinarily helpful and inspiring to find one's own natural meditation through what most passionately enlivens. This is congruent with the principles of tantra, which teach us that every aspect of life is sacred; such principles can provide access to the awakened state. It may seem purely accidental when creative grace moves through us, but practicing one's craft definitely makes us, in this sense, more accident prone. As we learn to get out of our own way, the inner light show becomes ever more visible.

God's playing field awaits our discovery and exploration. If we want to think of ourselves a

White Tara Bridge

An Artists' prayer is becoming the "Eye of Divinity."

imprisoned, enslaved, helpless, we're free to do that. And so we do, often — so we might as well enjoy it! However, the door of our interior prison is always open. Have we become so used to cowering in the corner that we're afraid to step out? Long-time prisoners are afraid to leave the prison they know: They feel lost. The wide unstructured world seems too free to cope with, too open. Not for the Artist, though, no matter how the world might seem. In every moment there are infinite possibilities. The Muse finds him, and maybe more. Dencombe, the writer in Henry James' story "The Middle Years," said, "We work in the dark — we do what we can — we give what we have. Our doubt is our passion, and our passion is our task."

Like the spiritual seeker the Artist is always searching. And yet the Artist is never really lost, no matter how she may occasionally feel. It's not so much a matter of choosing the right muse or art form, as whichever form one chooses is the right one. Creative people find every opportunity to step out; they enjoy exploiting their own innate natural resources, and in the most unexpected ways.

There is no such thing as art except what we invent. Who saw a Campbell's soup can as art before Warhol saw it in new light? That's called fresh seeing. When we can see freshly in every moment – and actually we do, but don't notice — that is art, which is creating life anew. Not caught by conditioning, by our illusion of a limited and finite self, we can reinvent ourselves, in every moment. True art introduces a new way of seeing; it introduces a new way of being.

If we're caught up in a self-concept, such as, "I'm an Artist," or for that matter, "I'm a lover," we're not really an Artist; and we're not really in love — there isn't unconditional non-dual divine love in it. There's only fixation, self-love, a kind of narcissism. It's the same with art. Art, like love, truly flows when it's allowed to flow unimpeded. Art flows when it's not even tinged by the color of our own prescriptive lens. Of course, color can be part of the art; but it's more transpersonal than that. We have to step out of our own way so that the greater selfless self, the greater vision, can emerge. That's pro-activity; that's freedom.

You've heard about channeling? Think of it as channeling. Get out of your own way, and let the Muse speak.

Walking around Bodhinath and saying "Om Mani Padme Hum" alters
your consciousness; and the prayer flags release winged horses to fly.
The horses gallop with the wind and encircle the globe.

An Artist creates as if he is looking through many gardens as well as
kneeling by many temples... An Artist must create toward fulfilling
her/his purpose as well as understanding the Artist's mission. An
Artist must explore the abyss of the unknown or unmanifested.

opposite page: Stupa Bodhinath

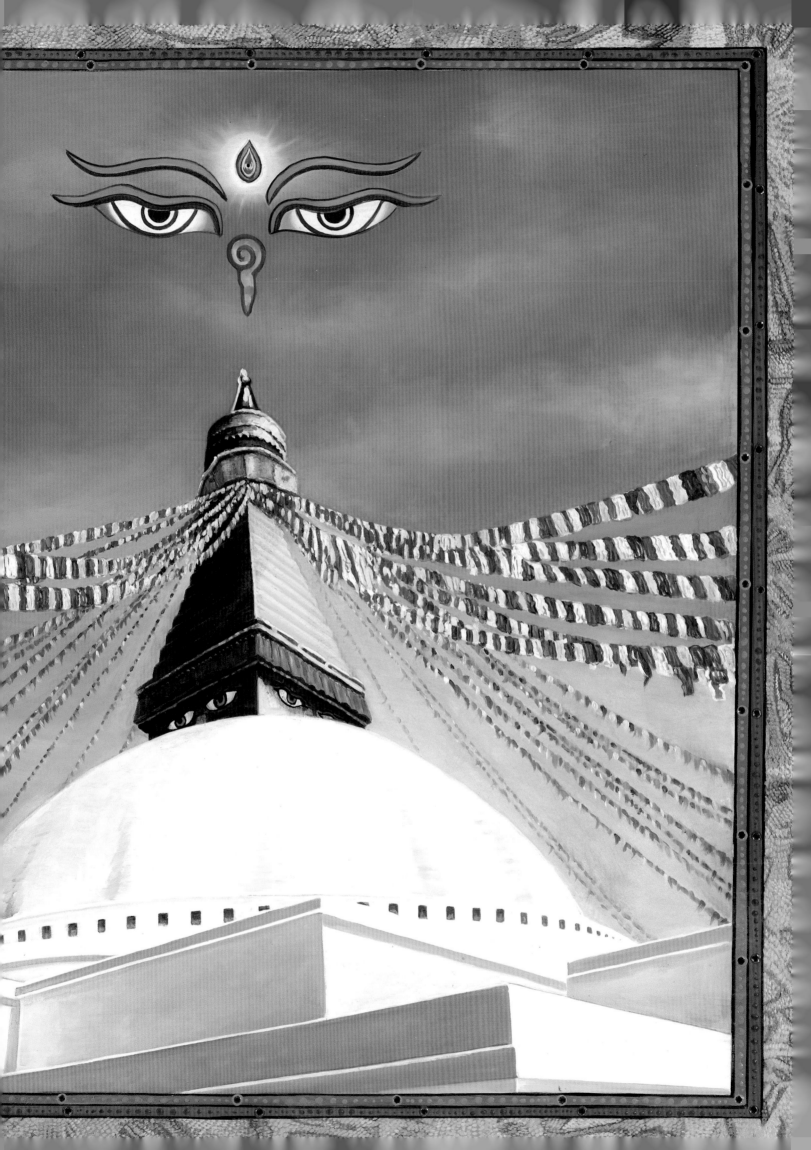

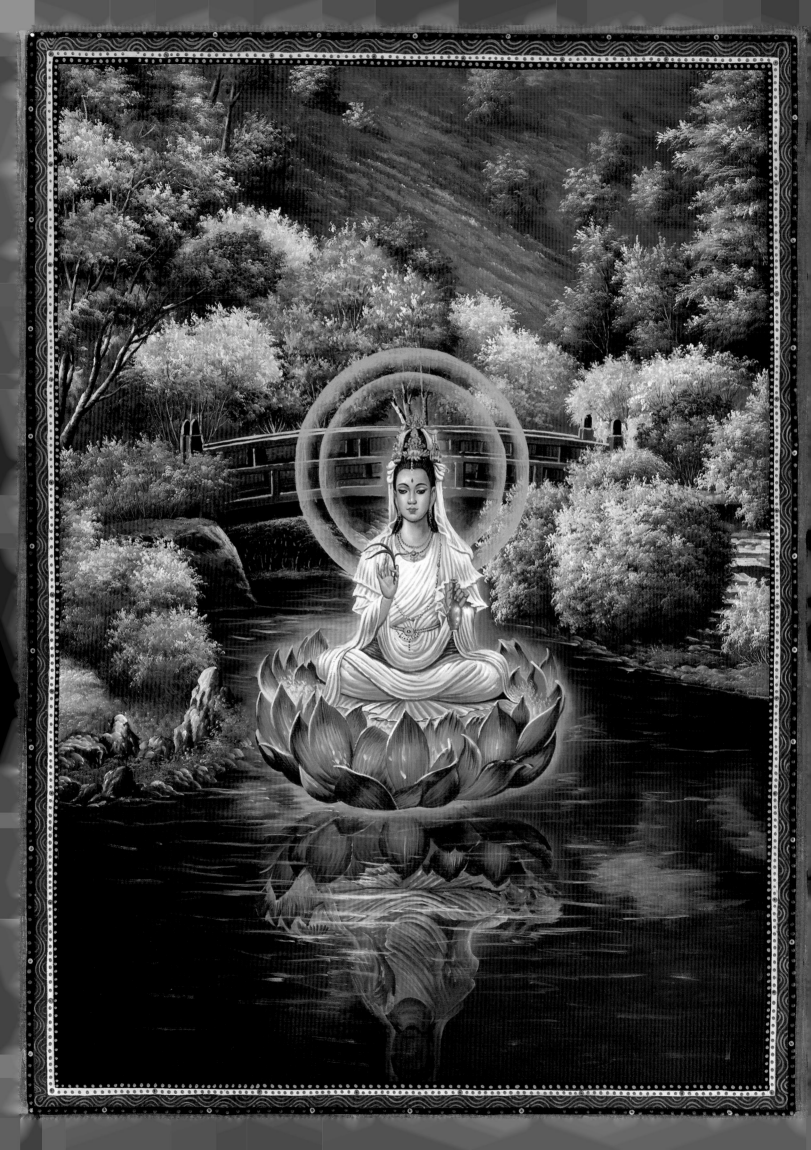

Art is learning to manage the power of Soul/Spirit.

When we formally practice meditation and other contemplative practices, we're as a monk in robes. The robes, the shaven head, the mala beads remind the monk that all he has to do is sit through it, through all the weather, with his eyes wide open. (Gaze upon Van Gogh's self-portrait of himself as a Zen monk, and most of his self-portraits). Likewise, making a sacred space for ourselves can help us through the chaos without looking out. If we cut off the chaos too soon, if we're unwilling to really hang in the void and dance in the openness of craziness before contracting back into our socialized lives again, back into the gilded cage of egotism and normality, our breakthroughs are limited. One can go further.

Many, like R.D. Laing, for instance, have spoken of the benefits and insights that madness can provide; they've spoken of the value of integrating these experiences within our lives. Even in my lineage of the tantric Tibetan Vajrayana tradition, we speak of crazy wisdom. Another fine book by Chogyam Trungpa Rinpoche is entitled exactly this.

The struggle to open the inner doors and windows can precipitate psychological breakdown as well as breakthrough: Psychosis such as Van Gogh's can give birth to beautiful forms, feelings, and perceptions. Artists and mystics plumbing the source of vision tear off the inner blinders: They open to the infinite effulgence of Being. Spiritual madmen and holy fools, such as Kabir, Mirabai, Nasruddin, Han Shan, and so many others exemplify that kind of craziness. As Tibet's great poet and saint, Milarepa, sang: "My lineage is crazy; I am crazy — crazy for Dharma, for enlightenment!"

The irrational, the intuitive so-called other side of the brain can set us free. Not just mind, but heart-mind, the total embodiment of being on all levels, not just the mental, intellectual, psychological levels, but deeper, deeper than psychology and personality — beyond person and individual. The Be-ing level.

Beyond concepts, intellectual judgments, beyond the rational mind, there is tremendous innate natural wisdom.

Socrates, regarded as the wisest man of his time in Athens, said "If I am the wisest, it is only in that I know how little I know." So let's not fool ourselves. Do we know where we're going tomorrow, really? We may think we're headed somewhere, but how to be sure until we get there? If we want to face the existential facts, we'd face the openness of everything. Anything can happen. If we create our life tomorrow in a familiar way, it is because it's all we care to do. Decidedly, it's not because that's all there is.

Concepts are embedded within the limitations we've constructed around ourselves. Maybe the kindergarten teacher, or in my case, the third grade teacher, told us we can't sing. When everyone else sings, just mouth the words. Don't ruin the harmony, Jeffrey. And for a long time after, I was afraid to sing. "I can't sing," I'd tell myself. "I can't." Until I heard Bob Dylan and Leonard Cohen, their gravelly voices, whereupon it became instantly clear that anyone can sing. I picked up a guitar, and began writing my own tunes, singing them in my own voice.

Making music isn't just for musicians.

Who can keep us from recreating our life as we would like it to be — as it could, and should be? No one but ourselves can keep us from being Artists, rather than marching forward like mere consumers, corporate robots, sheep. No one but ourselves can keep us from dancing with life instead of goose stepping. In every moment recognizing our own creative imagination, the living picture we paint on the canvas of our lives. But how we interpret the world colors it, isn't that so? These colors, these interpretations determine our experiences. It's not what happens to us so much as how we respond that makes for the quality of our lives. Right now, some people are hot and others cold. That's visualization. It's like a painting, a concept.

Everything is imagination. And imagination is freedom, but it can also be conditioning — bondage. What I learned training in the Zen arts is very different from what I learned of writing and the other arts within the halls of the American Academy.

Garden Buddha

Quan Yin's name means 'She who harkens to the cries of the world.' She is a Goddess who represents compassion, love, hope, transformation and service. She represents the most beautiful aspects of God, and it's a Spiritual practice to paint her.

opposite page: Quan Yin Red Bridge

In Kyoto the first thing I had to do in my calligraphy class, before even making a single stroke with the brush, was devote an hour to rubbing the ink stone in water for the ink. On my knees in a meditative posture, relaxed, I'd breathe in and out, slowly: all this in preparation. The rub of stone; the dark ink. Only then, only through and after, could I make the stroke for One. You know — big deal! – a single stroke, Bloop! Three hours later, maybe, I'd be allowed to make the strike for Two. As you slow down, slow down — slower, after a while the inconceivable opens. You begin to realize that art doesn't happen in just the way you had believed before, the way you'd framed it. And it has nothing to do with imitation.

The Zen arts are a total, inclusive training in focused attention and spontaneous expression. We're all spontaneous all of the time, naturally, whether we know it or not. We need but to recover that faculty, so we may better recognize and actualize it within our own life.

Have you ever seen the famous Zen painting of a single stroke, the sword stroke? Five hundred years later it still arrests the viewer. It has so much chi in it, so much energy. It's alive with non-conceptual directness. No one knows what to do with it, or how to interpret or imitate it; the stroke boggles the mind. That's art — a fresh way of seeing, of being.

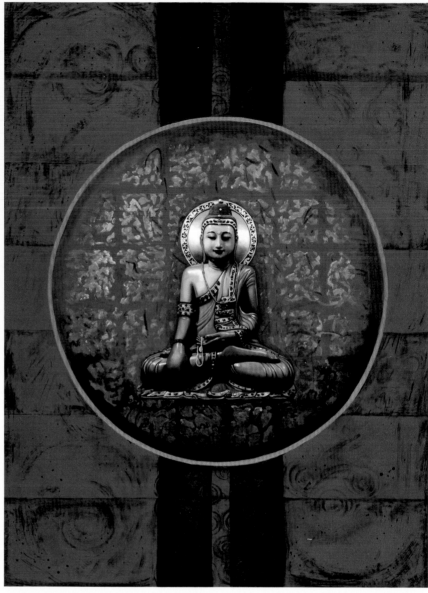

Art isn't only about daubing color on paper. This moment we create is inexpressibly precious. Let's not ruin it, crumple it, and throw it away too quickly while we seek elsewhere. The art of living demands a certain degree of freedom from conditioning. But even being one with conditioning is freedom. Not trying to get away is freedom. Not having to deny or suppress is freedom.

Freedom is in the dancing, in the aliveness, not in the struggle to find the right place, only to remain stuck there forever.

Are we lost, gone to past or future? Or can we tune in to presence of mind? Becoming aware of such distinction can help us to abide in the now, though we don't live just for the now.

Are we living in a way conducive to dance, moving with whatever tune the band is playing? Or do we know just a few steps, the same old steps? Do we really want to be a wallflower the whole of our life rather than enjoy the bash? What are we afraid of? Let's allow for the pure joy of creativity, the joy of no standards to worry over other than the wish to excel within ourselves, to act impeccably. No one is watching the dance. No one is telling us we may or may not dance this way, or that way. But fear and hesitation can hold us up; they can inhibit us. Courage, confidence, fearlessness — all enter in. We can't pretend to be fearless, but we can learn to notice how fear holds us back — fear and doubt, hesitation and anxiety. Noticing that, better learning ourselves, we can let go a little, more. We can walk through the walls of fear, dance through them.

See through them.

opposite page: Quan Yin Light

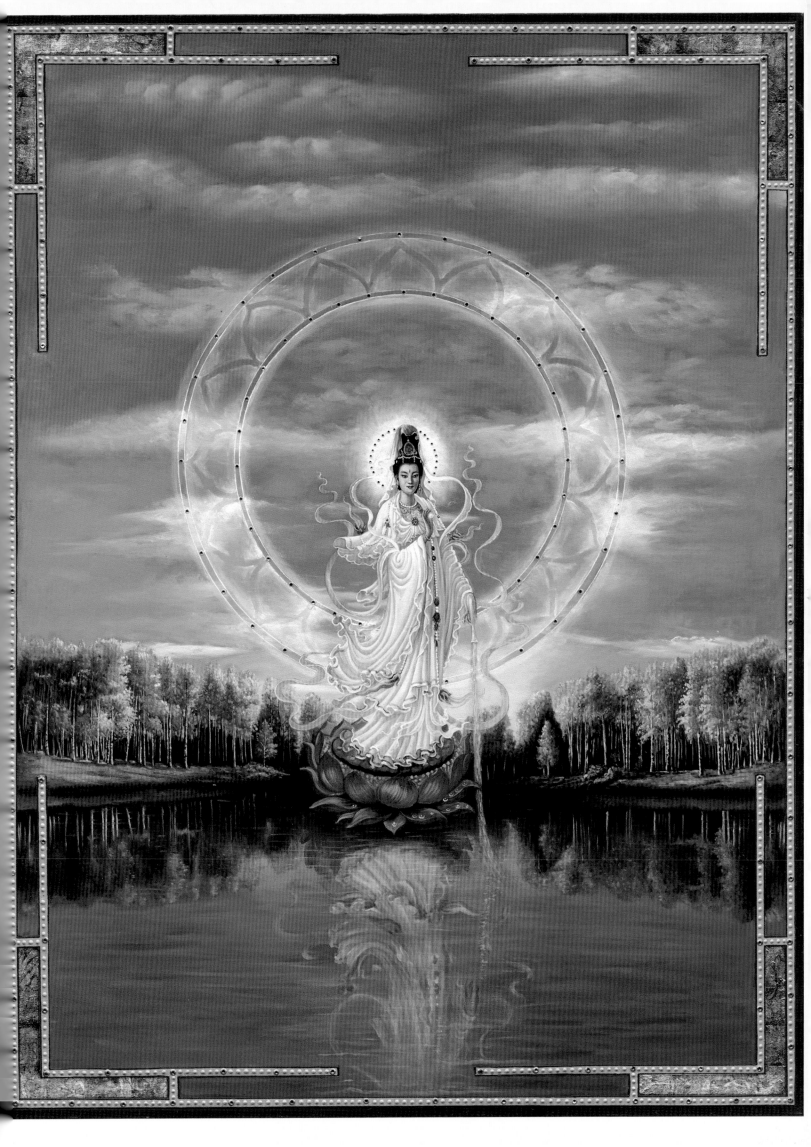

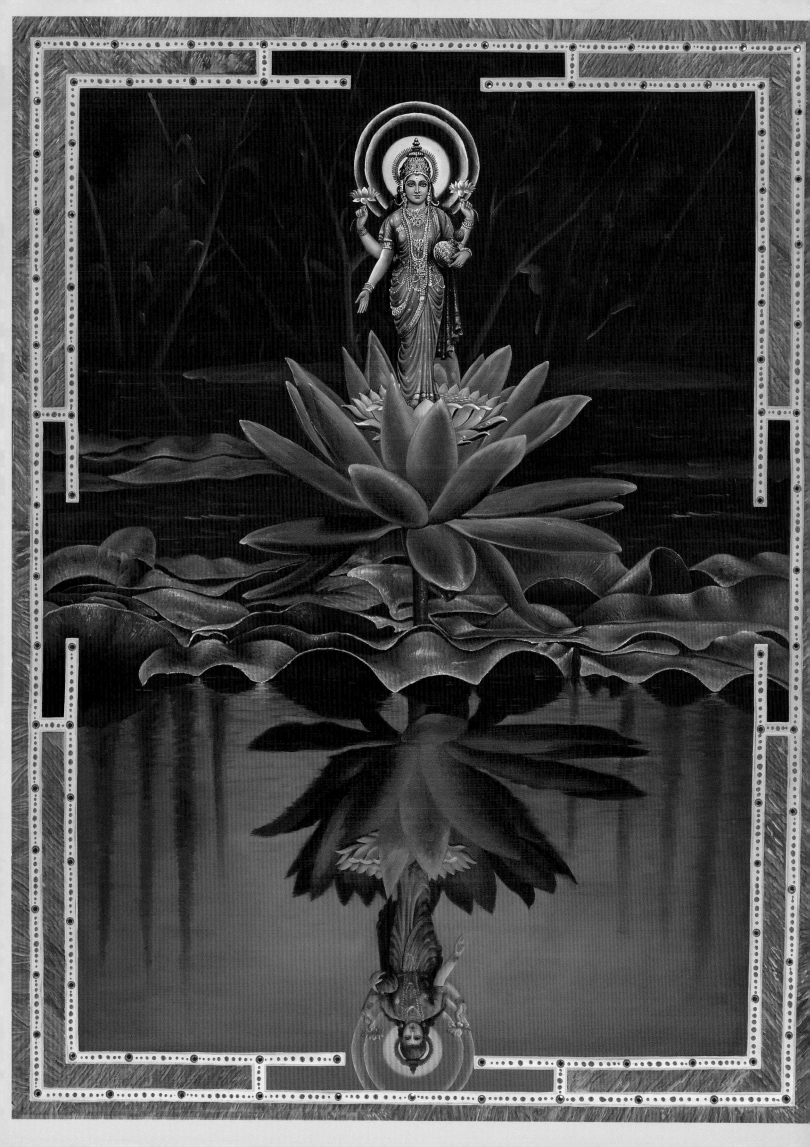

*In our modern culture, most of us have very well-developed minds, well-developed intellects,
which, in fact, none of us can actually see. When I asked my teacher, Brugh Joy, about the location of the mind,
he said, "Here's my phone number. When you find the mind, give me a call."
We know it's there, and we know it functions through the brain, and we know how the brain functions,
so we can use our mind. But we can't see it.*

*The Soul is like the mind in that, at first, you cannot see it. However, I have discovered that Soul functions
through my "heart." The heart is the sense organ of the Soul.
Our question should be, "How do I access my heart?"*

*You will be on your way to accessing your Soul at the same time, because the Soul's language begins at the center
of the Heart Chakra (the Heart Chakra is the energy center of the heart, named Anahata in Sanskrit).
Therefore, an Artist's life is a path opening the heart.
First the heart feels the colors you are painting, and then it feels the hidden energy of the painting.*

Hinduism

It's natural for an Artist to explore the ancient Hindu tradition for you must see (like a Hindu) behind the impermanent material world, like a face behind a mask. A Hindu meditates to find the invisible source of bits and pieces of life and all living things... which is the pure and eternal Spirit.

Like a Hindu, the Artist's sublime objective is to achieve union with God, which they call Brahma, or we call the Goddess. For a painter, this union comes through ritual and a total devotion to your Soul, or muse, while for the Hindu, it develops through purity, self-control, detachment, truth, non-violence, charity and the deepest compassion toward all living creatures. As an Artist, my work is to reveal the Hindu ideal of 'Ultimate Reality" and as an Artist, our paintings are a vast effort to explore the Divine and her relationship to the world. Hinduism requires every man to cultivate life's mystery until he reaches the highest revelation and offers a fellowship of all those who seek for the truth. Ancient teachings have been a guiding light in my own search for Art as A Spiritual Path. Rather than being literal and seeing gender differences, what we're talking about are symbolic qualities of masculinity and femininity. We're not saying that only men have mind or that only women carry the heart. The classic universal symbol of the yin/yang has the circle of masculine within the feminine and the circle of feminine within the masculine. Also, the ancient symbol of the goddess, the Sri Yantra, is centrically composed of white triangles representing sperm (masculine) combining with red triangles symbolizing blood (feminine).

There are multiple levels of perspective, illustrated most notably perhaps by "the separated view" and "the connected view." When we're in the connecting view, not only do we see woman and man as two images of wholeness; but inside each man I see a female presence, and inside each woman I feel a male presence. Jung called the internal female anima and the internal male 'animus.' We often meet them in dreams or combined in hermaphrodite patterns, perhaps of men with vaginas or of women with penises. From the Soul level, in my experience, the Artist is a hermaphrodite, both male and female. I see this as a thread that connects Artists across time. Renoir observed that, "If God had not created woman [Eve], I am not sure I would have become a painter." I agree. Without Renior's relationship to the Soul (women), he would never have become a painter. Nearly 40, Rodin realized that an Artist "brings a thousand unsuspected shades of feeling…giving us…new inner lights to guide us." The feminine Soul is, for the Artist, a thousand shades of feeling.

The Soul of a woman contains both the masculine and the feminine, and the Soul of a man contains both the masculine and the feminine. That is why so many Spiritual paths require deep Spiritual commitment. For example, to truly become a priest or a monk, it is necessary to create a ritual marriage inside the self. There is no need for a physical partner. The disciple undertakes an inner journey to enlightenment, through a sacred marriage. A monk falls in love with the Beloved [Soul] inside himself.

Michelangelo refused to marry; he explained that he was already wed to the Mistress Art within — his Soul. Van Gogh took on the "character of a monk worshipping the eternal Buddha."

This is Soul work., learning to know your muse.

opposite page: Lakshmi on Red Lotus

"Always side with the truth."
-Krishna

Krishna has inspired my creative imagination and is considered a vibrant, high manifestation of the Divine.

Love is the highest Dharma of all. -Rama

The heart, the feminine ultimately, is the experience that directly connects us with nature; it is also a connection to our ancestors and to the Divine. It is one of the universe's great secrets, especially for men — to surrender to the feminine. (By the way, men, this is the ultimate in a relationship … just ask the woman in your life.) Symbolically, this means one has surrendered the mind (masculine) in favor of the heart (feminine); and as a result your Soul will shine forth. Once Gauguin found Tahiti (his Soul), he realized that going "to our island where we can live like savages … I shall be able to enjoy the silence of the beautiful tropic nights, listen to sweet murmuring movements of my heart, in loving harmony with mysterious beings surrounding me … free at last."

Here Gauguin had crossed a threshold with Soul, plumbed deep feelings, and eventually found eternity. If you study his paintings in France and then in Tahiti, you will see a powerful difference between mind (Europe) and Soul (Tahiti). All Artists are searching for eternity. Paintings are eternal moments reflected by the Artist, whose creation is merely a supersensitive mirror of what he sees and feels. When you look at a great painting from the Soul, you are looking through the Artist's eyes at that moment, feeling what the Artist is feeling, which the painting has captured for all eternity.

Art and all Spiritual paths lead towards self-realization. In discussing the necessity of descending to heart, (to the feminine), we are not denigrating the masculine. The mind is an awesome creation! The masculine, the part of us that discriminates, is critical and essential to our development. Mind can help us recognize that we've been separated from something, and that we have an opportunity to reintegrate, to unite, and thus gain the opportunity to become whole. This is the beginning of becoming an Artist … after awakening the eyes of your Soul … integrating heart and the mind. This is at the essence of Mandala painting, in which the heart (Soul, feminine, feeling, nature) is integrated with the mind (spirit, masculine, thinking, separation).

Just say 'Yes' to your heart. Hidden within the heart is the treasure that each individual is seeking. Being creative opens a door into a new inner world, which is really your own Soul. Therefore, on our path, we will not destroy anything except the images and illusions that we have feared… things like "I am afraid to be an Artist!" The reason we remain rooted in the mind in our society is that it appears to be much safer. However, the danger of playing it safe is that we become separated from the fullness of life. Imprisoned in mind, we will never come to know the treasures, the passionate fire, that lies within ourselves, and we will never know the wisdom of the heart, which is feminine. Krishna is the ultimate lover of the feminine.

opposite page: Krishna Walks on Water

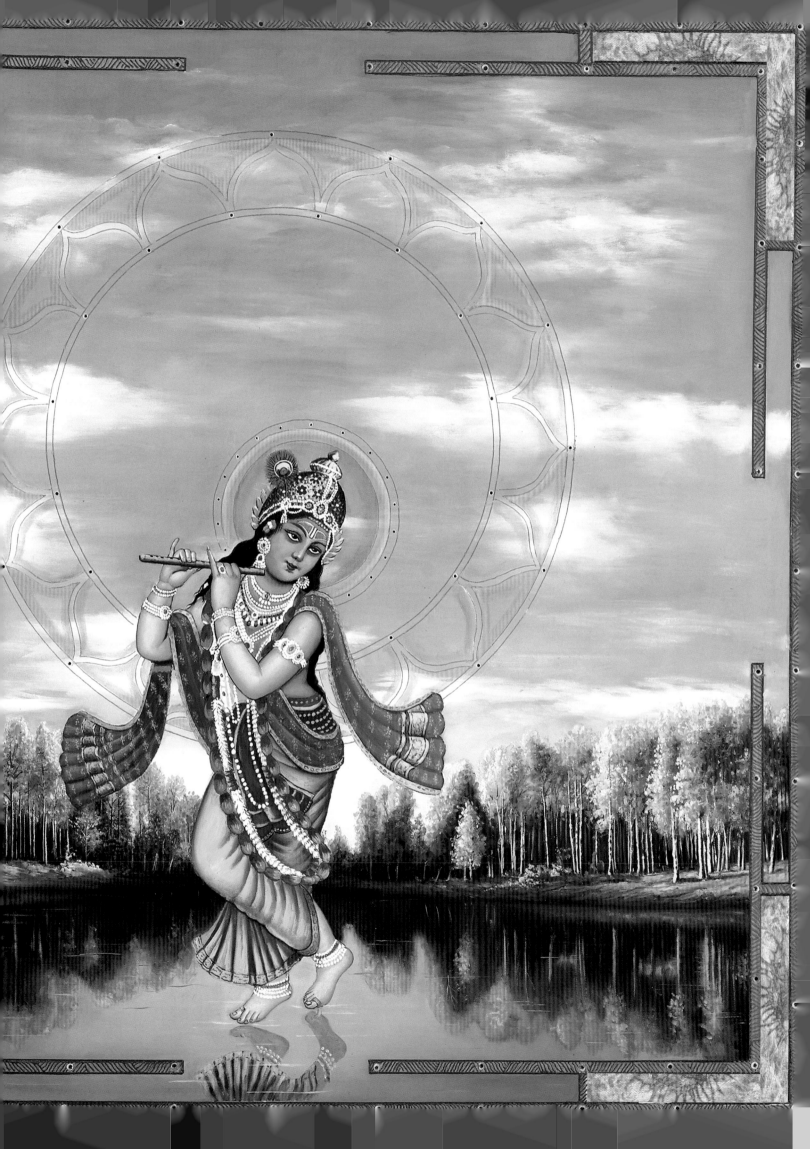

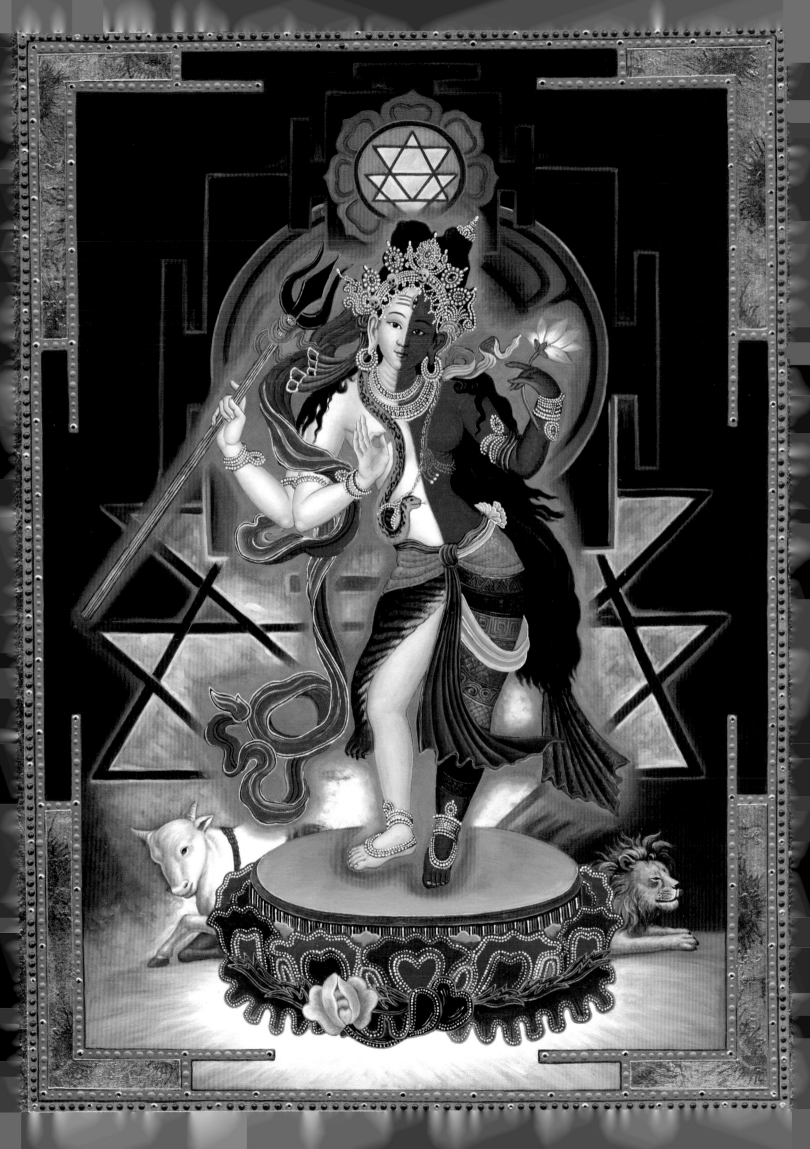

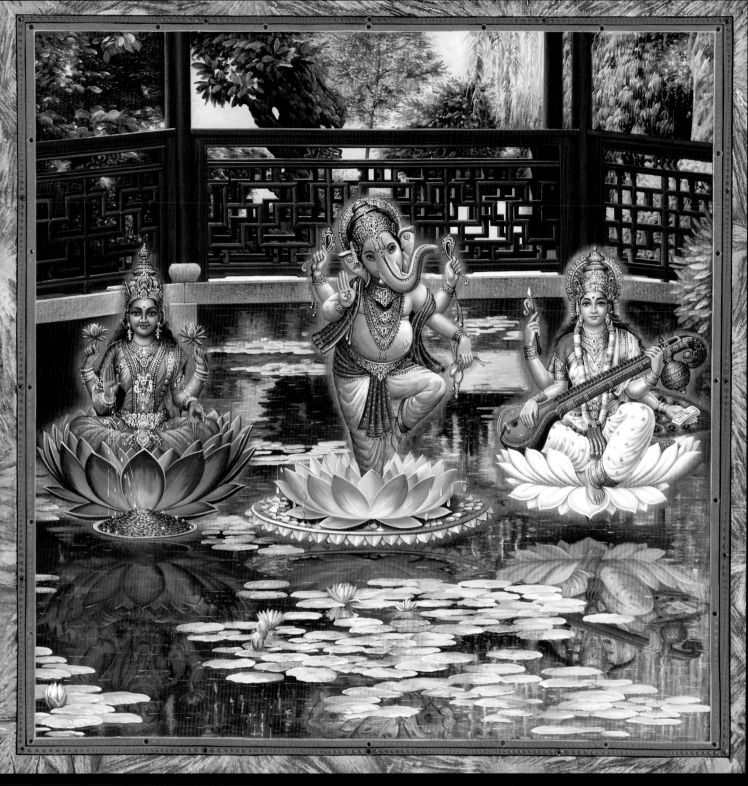

Ganesh Lakshmi Sarasvati

*T*hrough meditation and imagination, Ganesh, the largest animal in the forest, is as light as a feather. He's dancing his eternal dance, signifying Divinity. Along with Ganesh is Saraswati, the Goddess who ends the abyss of ignorance, and Lakshmi who transforms poverty into riches.

Your body is the easel on which your life experiences are painted.

The eternal and indestructible union between Shakti and Shiva gives birth to the entire Universe... both visible – as the Artist reveals it, and invisible– which is the job of the Artist to manifest.

opposite page: Shakti Shiva Orange Aura

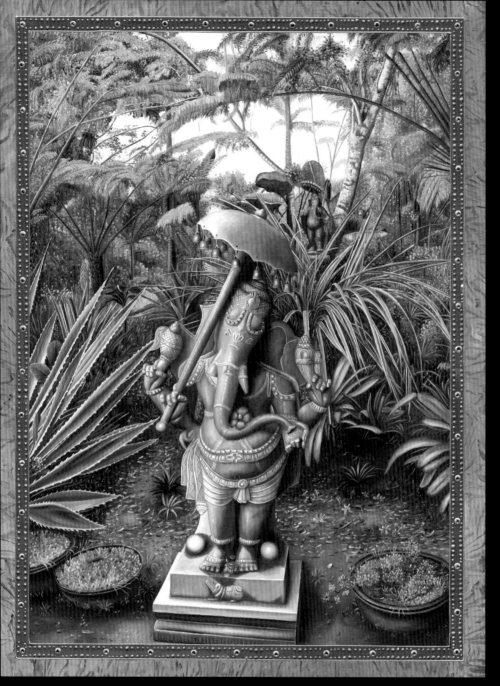

Ganesh in the Garden

The Soul connects all things — everything. Art attempts to describe those connections. As the magnificent French painter Nicolas Poussin said, "Art is not separate from nature, nor can it go beyond nature. For that light of knowledge which by the gift of nature is spread here and there and which manifests itself in different men at different times and places is brought together into one body by art. This light is never found entirely, or even in a large part, in a single man."

One thing we know about Soul is that she creates.

opposite page: Ganesh with Red

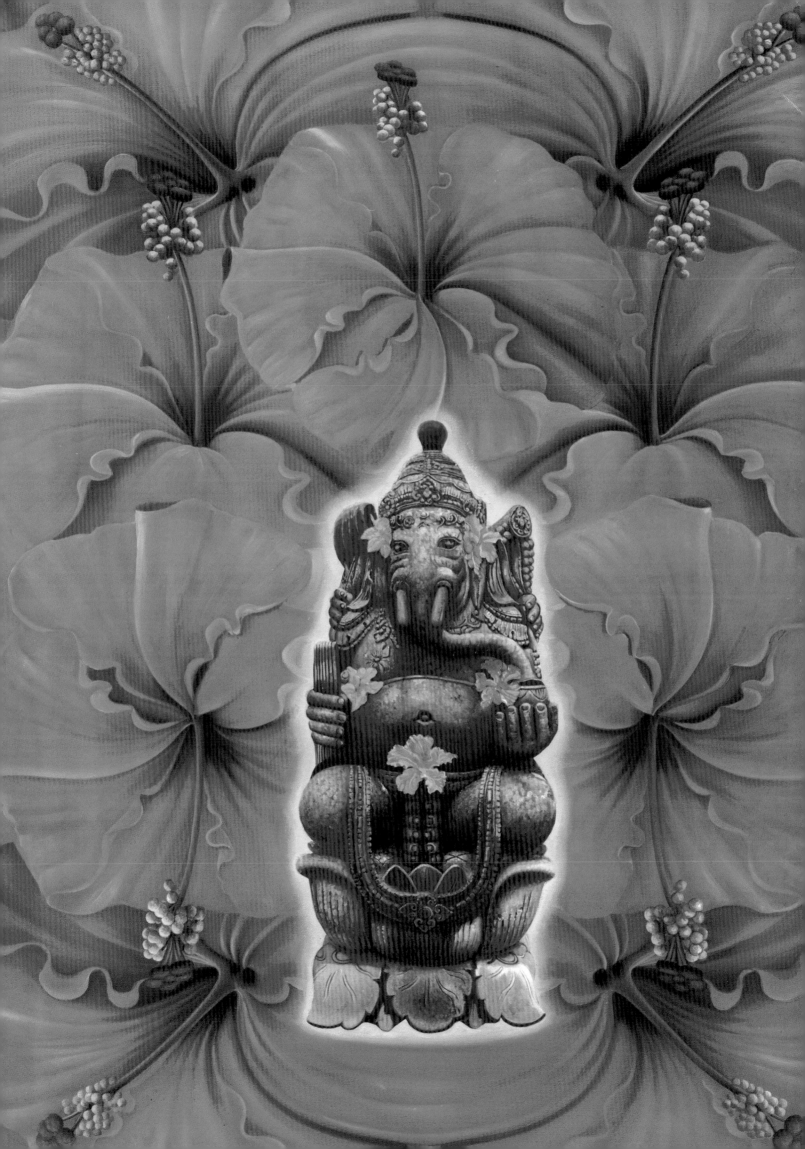

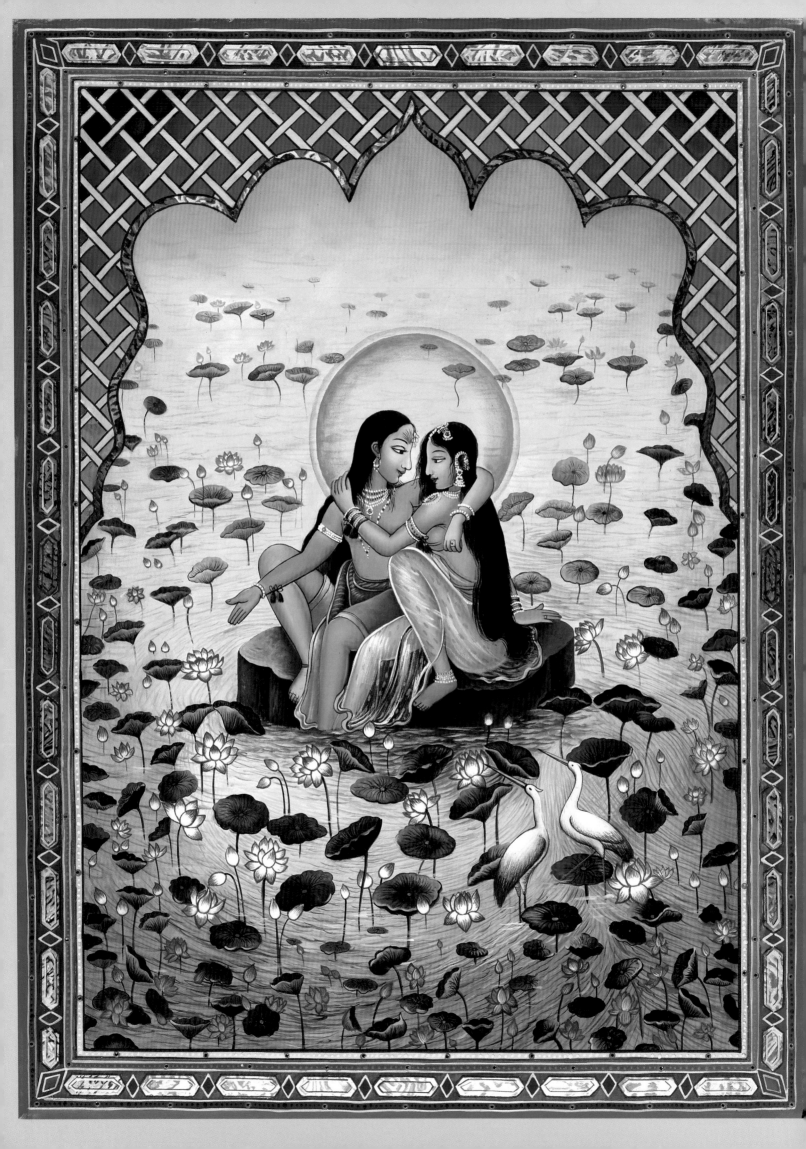

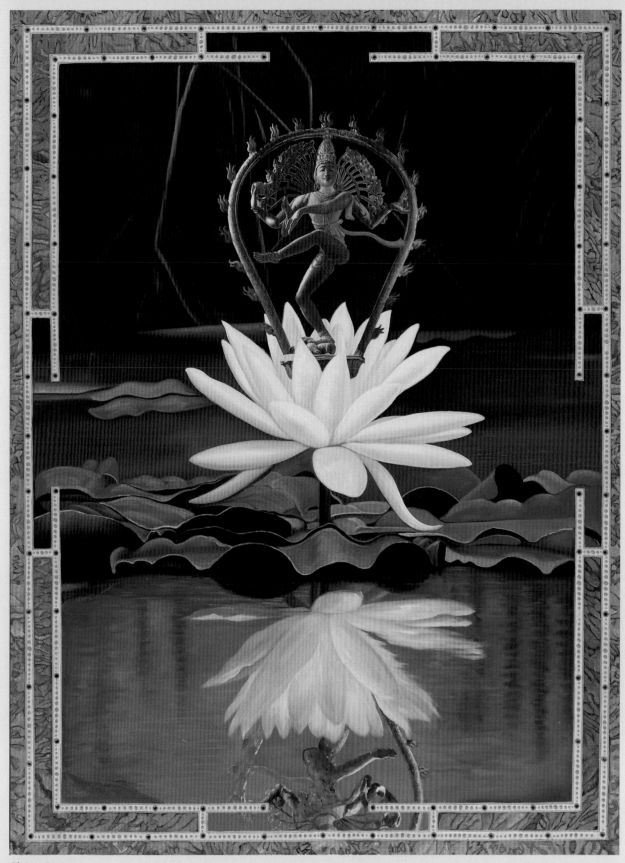

Shiva Lotus

Shiva Nataraj (Dance King) :
The destroyer... the transformer... the creator of the cosmic dance of the Universe. His third eye has the capacity of higher perception; and he is beyond the power of death. Many Artists embody this eternal energy of creative/ destructive. No modern Artist embodied Shiva more than Picasso, who was once heard yelling, "I am God... I am God!"

"For you, Krishna, your duty is first. For me, you are my duty." -Radha

Radha Krishna is like a flower and its fragrance.

"Our bodies may be separated, but we share the same life." -Radha

opposite page: Blue Radha Krishna.... tribute to the painter B.G. Sharma

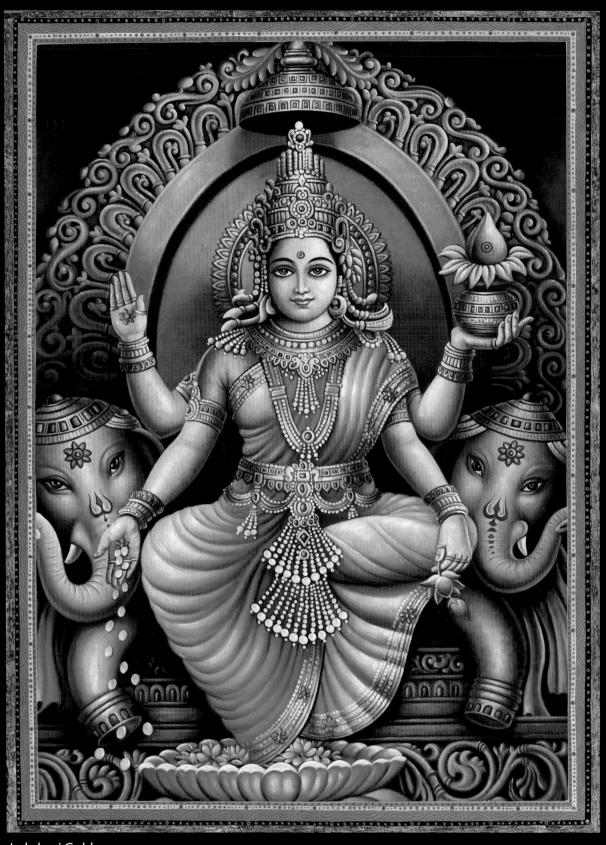

Lakshmi Gold

Lakshmi is the goddess of fortune and wealth, but also the embodiment of loveliness, grace and charm. She grants worldly prosperity as well as liberation from the cycle of life and death.

The Soul and the heart, the true feminine, are the greatest Artists.
They participate in planting truth with the brush of imagination.

True art can be fully appreciated or deeply touched only by "hearts"
that have art in them and a relationship with their Soul.

opposite page: Lakshmi Garden

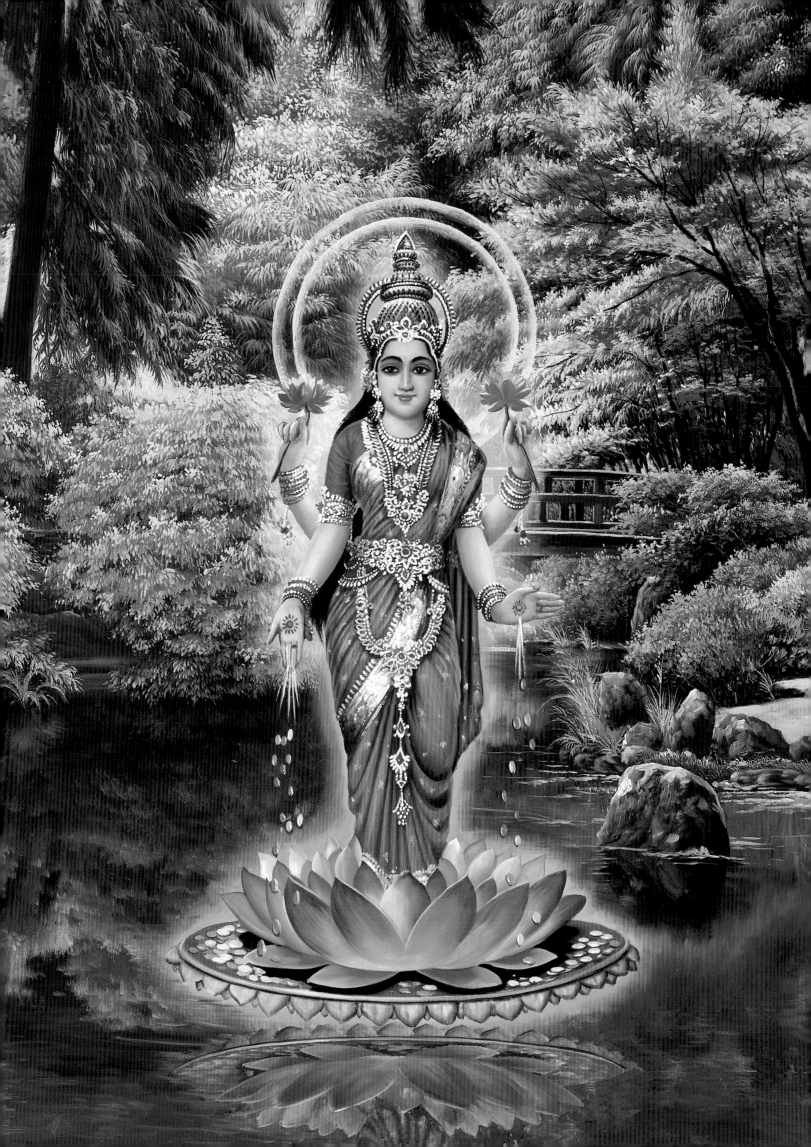

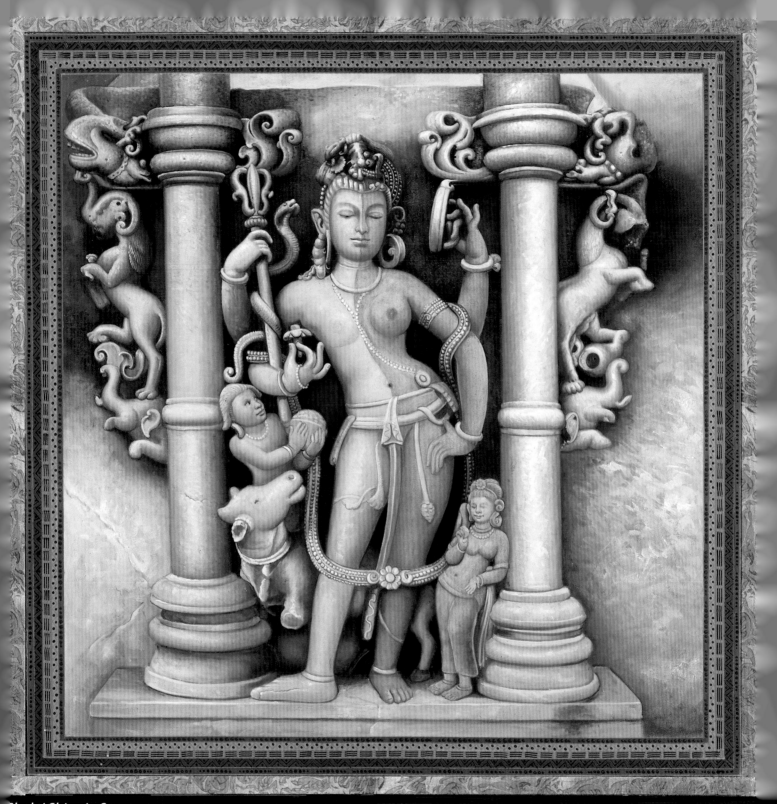

Shakti Shiva in Stone

Shakti Shiva: The amazing deity of the union of masculine and feminine in one body. On the left side is the feminine (often shown in blood red), and on the right side is the masculine (often white, representing sperm).

Ganesha represents a man of perfection who must have a big belly to stomach peacefully all the experiences of life, auspicious and inauspicious.

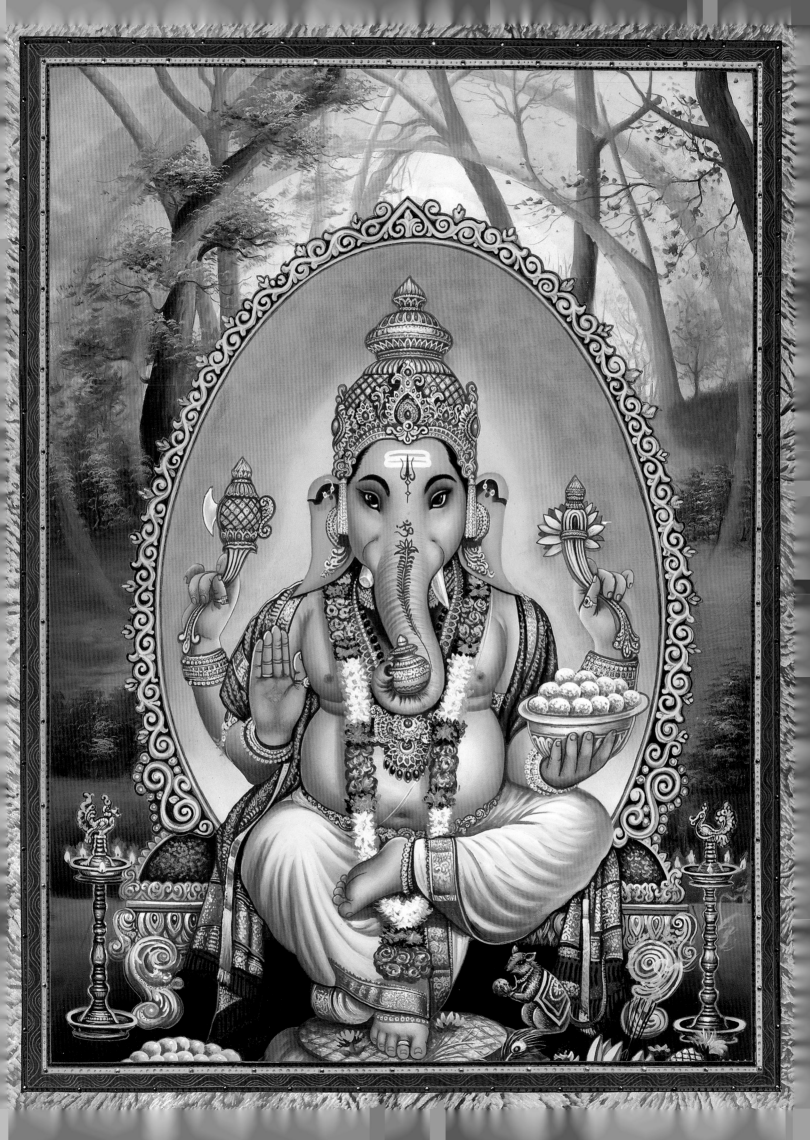

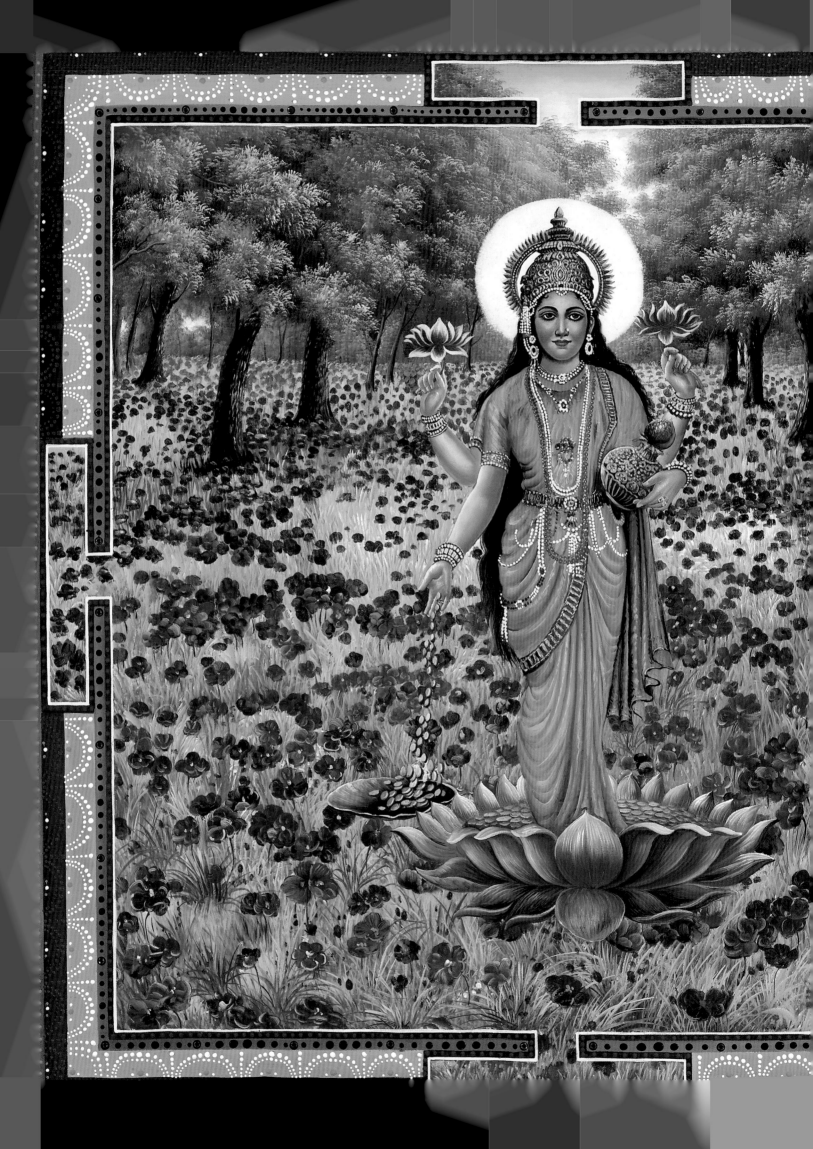

"She's standing on my eyelid, and her hair is in mine," wrote the enigmatic Marcel Duchamp about his relationship with the inner feminine (Soul). "She has the shape of my hands, she has the color of my eyes, she is engulfed in my shadow like a stone against the sky, her eyes are always open. She does not let me sleep, her dreams in broad daylight make suns evaporate, make me laugh, weep, laugh and speak without anything to say."

Women today are exploring the masculine in all respects. They wear men's clothes, do men's jobs; they're in the military. In the colleges, 60 percent of the students are women; 25 years ago it was less than 20 percent. They aren't trying to be men, they're simply exploring domains once exclusively masculine; meanwhile, men are exploring the feminine. In the art world, years ago women like Mette Gauguin (Paul's wife), Frida Kahlo, Rosa Bonheur, and others at times wore men's suits and smoked cigars, exploring the masculine. During the Renaissance, Artemesia Gentileschi, the first famous woman Artist to secretly draw men's penises as a way to explore the masculine from this. As a result she awakened: "My heart lies free in my breast; I serve no one, and I belong only to my self (Soul)."

From the heart view, when we view any sacred text, or our lives, or great Art, or relationships, we will find deep connections. Seeing from Soul eyes reveals the world is seamless. In Hinduism, this is seen as Indra's net — each of us a jewel shining at the intersections of the meshes. Or the web of the Goddess Gaia — each time we move, the whole web moves — another description of complete connectiveness.

The philosopher, Teilhard de Chardin described a sacred envelope of energy surrounding our planet. Within this noosphere, everything and everyone is intimately related. In Kolbenshlag's "Lost in the Land of Oz," she insists that we exist in God and are being breathed by God. Jung said, "We are in the Soul." Monet's paintings are an "envelope of light" about an eternal moment. When we come from the Soul and open her eyes into a Monet painting, we can catch a glimpse of eternity! Monet saw and recorded eternity; this was the motivation and the vision of his life's oeuvre. It's no wonder that Monet has risen to the status of a world treasure, a prophet to all mankind … and he simply revealed the "Soul." When Cézanne was asked about Monet he said, "Monet is only an eye, but Lord what an eye!" And when Monet was asked about Cézanne, at a time when no one understood him; he said, "I have fourteen Cézannes in my bedroom." Monet and Cézanne knew the Soul. A trip to Monet's garden at Giverny can be an experience of an "altar" to the Goddess and is "Heaven" to the Soul.

Lakshmi Blue Poppies

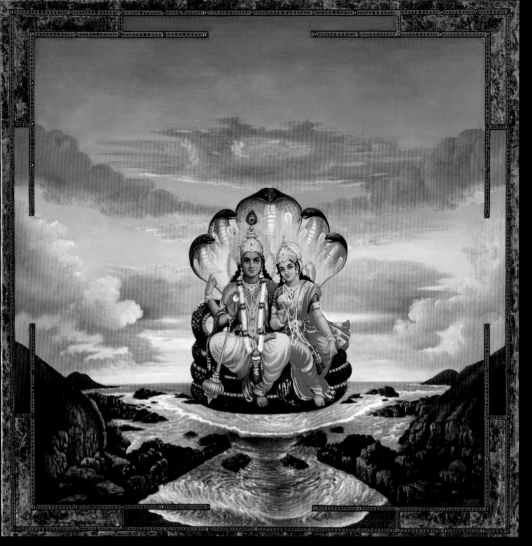

Lakshmi & Vushnu

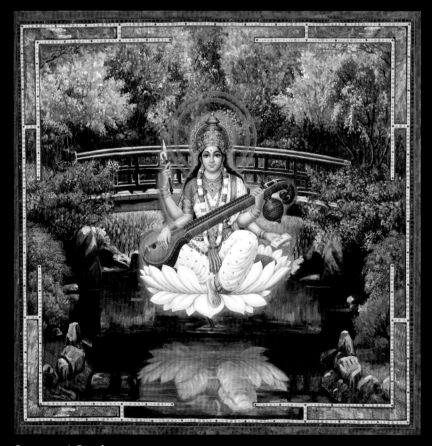

Sarasvati Garden

If we learn how to access the Soul and the language of the Soul, we see a new world we've never seen before. One of the best descriptions was offered by the French Impressionist, Claude Monet, who explained what happened to him when he was young. While working outdoors one day, in a single moment, "the veil parted," and his entire life destiny was laid out before him. Monet pierced the veil of surface reality and clearly saw a vision of the Divine. He was destined to be an Artist, and that vision changed him forever. He learned why he was to be an Artist, and no matter the struggles Monet endured during his life, that vision kept him on his destiny path to becoming a world treasure.

All Artists must have a similar Soul vision to guide them; otherwise they couldn't stay focused for a lifetime. Another French painter, the awesome colorist Eugene Delacroix, pierced the veil and described his vision: "The precious domain of painting, a silent power, that at first speaks only to the eyes, but then wins dominion of the Soul."

The Greek-born Italian painter Giorgio De Chirico also realized the mystery and value of Soul. "Every object has two appearances: one, the current one, which one nearly sees and which is seen by people in general; the other, a spectral or metaphysical appearance beheld only by some rare individuals in moments of clairvoyance and metaphysical abstraction." The rare individuals he is talking about include you! — the Artist in each of us. Any one of us who has learned to use our eyes to view the world from our heart has begun to see the Soul. — and to see with the Soul.

It isn't important that one be an Artist, only that one's journey is begun. The key is learning "to access" the Soul, and Art accesses the Soul of both the creator and the observer. The Artist Marc Chagall discovered this and asked God, "Grant that my Soul be revealed; show me my way; I want to see a new world."

Art is always about the journey.

During my transformation from a business life to an Artistic life, the Soul has shown me the path, guiding me through my paintings. A living relationship with my Soul is the treasure I have sought in my 50 years on the planet, and this is the most valuable relationship in my life.

Suppose we wake up in the middle of the night from a spectacular, mind-changing dream. If we don't get up and record it or write it down, the surface reality will erase it because it's being threatened by something out of its direct control. This is where a creative person must begin on the path of discipline. Art requires tremendous discipline. Having a vision, the discipline to follow it, and a relationship with your Soul is the way of the Artist.

Another way of opening the heart is to visit any art museum. From a Soul level, a visit to an art museum is a visit to the eternal visions of not just the Artists but mankind's consciousness through the ages. In Buddhism, the painter (often a monk) painted to reveal the Spiritual language of his religion as seen through the physical eyes. Likewise, Western Artists have been revealing the language of the Soul from the beginning of time, first in caves, then in churches and temples, and currently in galleries and museums.

Cézanne believed that each Artist was really the same man. "Our canvases are the milestones of Man — from the reindeer on the walls of caves to the cliffs of Dover — from the hunters, the fishermen who inhabit the tombs of Egypt, the comical scenes of Pompeii, the frescoes of Pisa and Siena, the mythological compositions of Veronese and Rubens, from all these the same spirit comes down to us. We are all the same man. I shall add another link to the chain of color. My own blue link." Blue is the color of the throat chakra, which is the energy center responsible for the voice and hands, thus the Spiritual color of the creative Artist. Cézanne knew this!

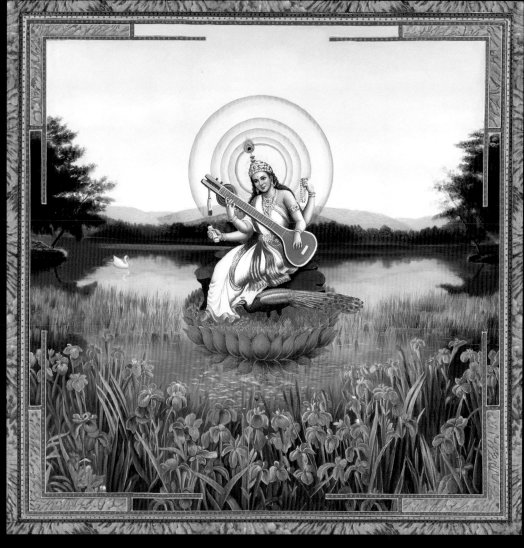

Sarasvati Sunshine

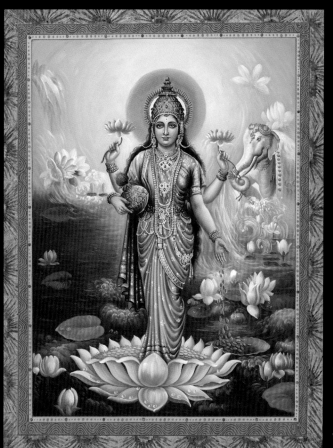

The more you bring out the Goddess in a painting, the more she comes alive in you.

Painting is a path: searching for your self, searching for your Soul, and searching for a glimpse of the Divine Universe.

Violet Lakshmi

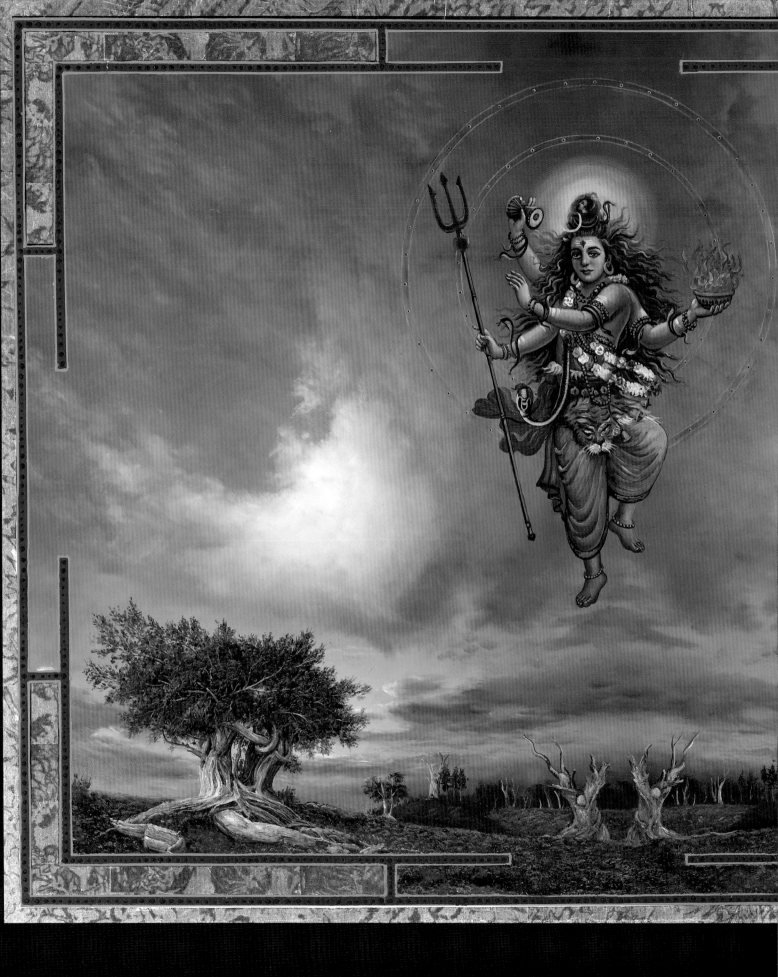

Gauguin wrote: "I dream and paint at the same time and awaken when the painting is finished." Gauguin was clearly out of his everyday mind and, in his own words, creating a "religion of Joy." He painted as if he were in a Spiritual dream. Cézanne asked: "Is art, then, a priesthood demanding pure beings who belong to it completely?" Monet added: "I applied paint to these canvases in the same way the monks of old illuminated their books for hours."

Yes, I experience a true Artist as a Spiritual teacher or, better, a creative Priest. One of the first things for an Artist (novice) to do is to find teachers who have already made the journey of surrendering to Art. Without surrender, we cannot descend into the magnificence of the heart because if we cling to surface reality as if it were total reality, then the deeper we go, the more terrifying it can become. The descent journey is for brave individuals because as we descend into our heart, it opens a new world that is powerful and potent, which means we must "transform" into or be "reborn" into a new life. Here we encounter both pain and fear ... along with quite natural and understandable reasons to continue on with our "normal" lives without transforming.

The Artist must engage in the forces that secretly keep away madness, poverty, destruction and wounds... all transform in the creative process with art work.

As an Artist gets closer to Essence/Source, madness often appears... having a sacred center found in the Mandala balances and heals these forces in the creative process with artwork.

An Artist, through creativity, slips into Cosmic Consciousness and records what her/his eyes have seen.

The cosmic dance of Shiva is called ananda tandava, meaning the Dance of Bliss and symbolizes creation and destruction, as well as birth and death. Painting Shiva is experiencing the five principle manifestations of eternal energy: creation, destruction, preservation, salvation and illusion.

Shiva Descending

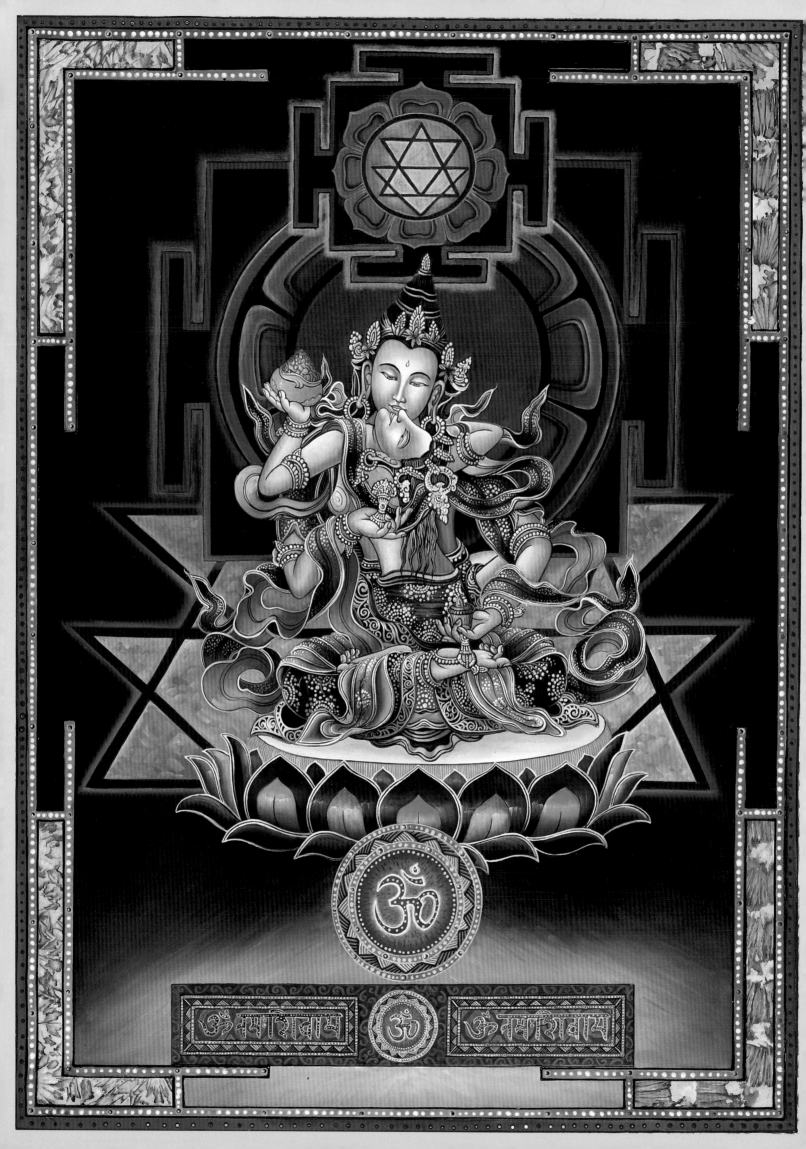

"Let's reflect upon whether we live free and totally as though we were dancing without aim or purpose, as though no one were watching, as though we were making love. Or do we live as actuaries, calculating entire worlds of possibility increment by increment before we make the slightest move?"
— Lama Surya Das

Art is the manifestation of the union of opposites, which ultimately reveals that we are all One.

"Vital Energies generated by inner and outer means are drawn into one's central channel, causing the mystic fires to blaze. Inspire us to gain great insight into the innately produced Great Bliss."
—The Seventh Dalai Lama

Let art become your beautiful, juicy lover.

For a long long time, the Universe has been germinating in your spine;
so pick up your paint brush and unfurl your colors.

Tantra

In Hinduism there's Shiva and Shakti, Krishna and Radha. In Buddhism there's Vajrasattva, Kalachakra and their consorts. Clear images of masculine and feminine joined in a single body symbolizing the tantric mystery of union. Eastern traditions use tools like yoga, tantra, and other symbols (like yin/yang) to represent wholeness. Carl Jung, a student of consciousness, used the term "conniuctio" to signify the internal, conscious "union" of masculine and feminine within ourselves. However, I feel union is possible only from a Soul perspective, as our minds can only "think" about the possibility. The leader of the surrealists, Andre Breton, knew this. "There is a center point (heart) in the spirit (Soul) from which life and death, real and imaginary, communicable and incommunicable, are no longer perceived as contraries." In my experience, only the Heart Chakra can integrate the upper and lower worlds, dark and light, good and bad, feminine and masculine, and the rest of the mind's dualistic opposites.

Tibetan paintings, the great Mandalas, show us the Spiritual ideals of Tibetan Buddhism. There are representations of the yin/yang symbol, depictions of male and female gods in tantric union. In Tantra we have intimations of cosmic or eternal union in our sexual relationships. In moments with our personal beloved, we enact the underlying objective of Spiritual development, the ultimate union of forces within ourselves and with the Beloved Creator of all that exists.

These images are timeless and eternal. If we only apply tantric principles to see Adam and Eve as connected, two parts to a whole. A Soul view, an entirety or timeless archetype, is to see the story in a different light. Adam represents separation in all forms and Eve represents connection to everything.

When Eve bit the red apple it left a little symbolic stain on all women's lips. The Soul strongly reacts to red on lips, and it's Eve's stain, the readiness of awakening to knowledge; which is her legacy to human kind. All women are one eternal woman from a Soul perspective. Every woman (Eve) has the potential to initiate and to help her partner become more conscious.

To the Soul: Eve bit the apple; and the snake, the heart and the tree of knowledge are one and the same. If we look at woman, the snake is in her body. We see the curves. The snake is inside her. The apple she bit was from the tree of eternal truth. I realize this is a radical leap into conscious awareness. From a Soul Artist's perspective the Soul sees reality in patterns. First on the outside, later on the inside. Ultimately, the inside and outside merge into a union that approaches enlightenment. I have learned to use my Soul eyes from the creative life and have applied it here to Adam and Eve, a symbolic story. Applying these same Soul eyes to painting or life radically changes the whole process of experience and consciousness.

opposite page: Yantra Tantra Mantra

Art is, at last, the Awareness of where we are standing, where we are in love, and where we are in relationship to the Divine.

A further example: Women [heart/Soul] are always interested in and searching for the experience of the Truth. But the Soul contains your truth, your destiny, the whole truth of existence. No matter what we think, always tell women the truth, the absolute truth, the whole truth … from any level we can. Whether we realize it or not, a woman knows the truth intuitively because Truth is Eve's essence.

Soul understanding will change a life, and Soul awareness might well alter a way of engaging with women. To know the Soul is to know the essence of woman [the feminine]. In the wider eye, the Soul sees the body entirely differently than does the mind. The eyes reveal the Soul; the mouth, the flesh; the chin stands for purpose. The nose is will power; hair means sensitivity (long hair = more feeling/feminine). Skin color is relationship to the dark and the light; hands are higher creativity and feeling capacity. The throat is language, song, poetry. The feet are sole (connection with the Earth Mother). Crown is the connection with spirit (father). The back is the unconscious; the heart unconditional love and the union of opposites. Learn the Soul's language, and you will see the Soul.

The mystery of Adam and Eve relates to the relationship between men and women, but this mystery is active within each of us as individual men and women. From the point of view of Soul, we don't have an outside and an inside. The inside and the outside are intimately intertwined. The Soul alters reality. The essential work of the Artist is to make visible the deepest feeling and to manifest the Divine. You see this essence running through the lives of all great Artists. "Art doesn't reproduce the visible; rather it makes it visible," said Paul Klee. "Color awakens a corresponding physical sensation, which undoubtedly works upon the Soul," said Kandinsky. In his lifetime, Franc Marc endeavored to create, by his own definitions, "symbols for the altar of a new Spiritual religion." Without a doubt, these Artists were deeply connected with Soul and lived their lives accordingly and have sufficient value to all mankind.

Paul Gauguin was mythic in his descent journey, traveling from Europe (mind) to Tahiti (Soul). In his words, "bit by bit civilization is leaving me." Gauguin realized that by leaving Europe and all of its teachings, he was entering a lower universe (Tahiti) where he journeyed, painted, and lived, and was finally recognized for revealing the mystery of the Tahitian women (dark feminine) to the European world. "Tahiti and its inhabitants," Gauguin found, "seemed to exist at the wavering threshold of the conscious and the unconscious." Virtually all of Gauguin's Soul experiences are to be found in his painting life. While moving through his retrospective in Germany several years ago, I can still feel the eyes of the dark Tahitian women watching me feel into their eternal mystery.

Art is a field of infinite possibilities, a field of uncertainty, spontaneous creativity, and a place where we consecrate the Universe with Divinity.

opposite page: Transparent Tantra

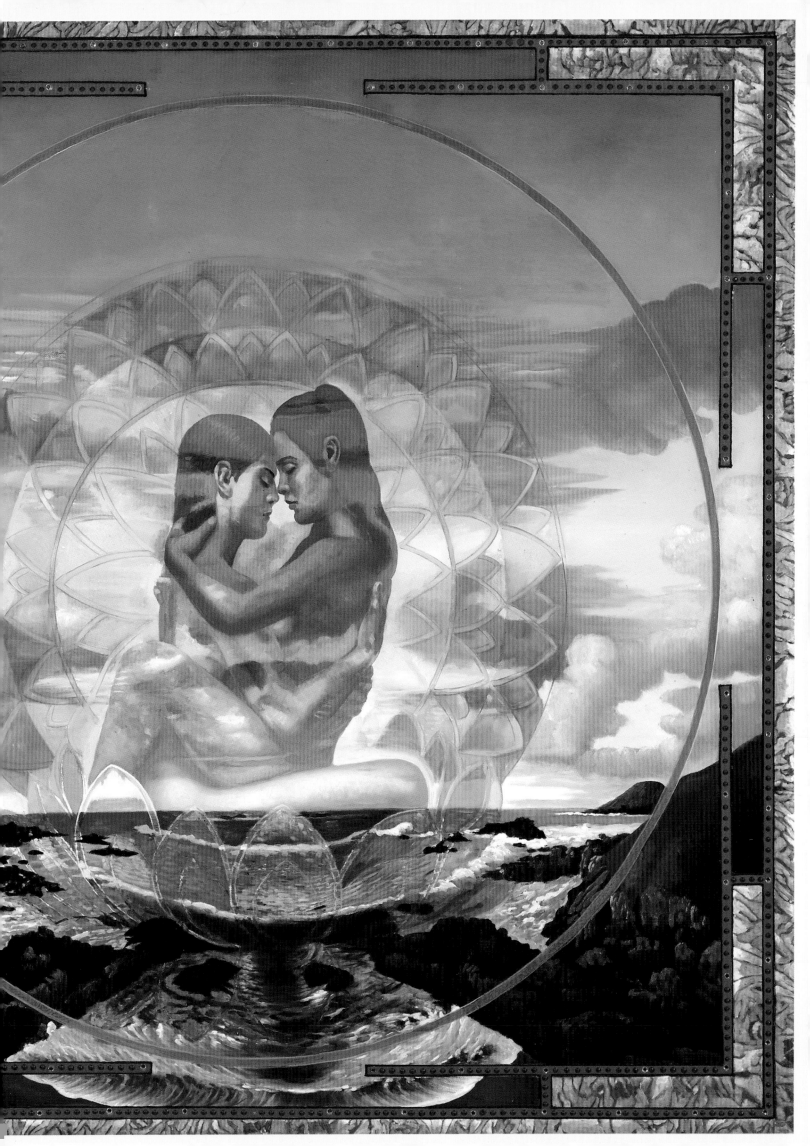

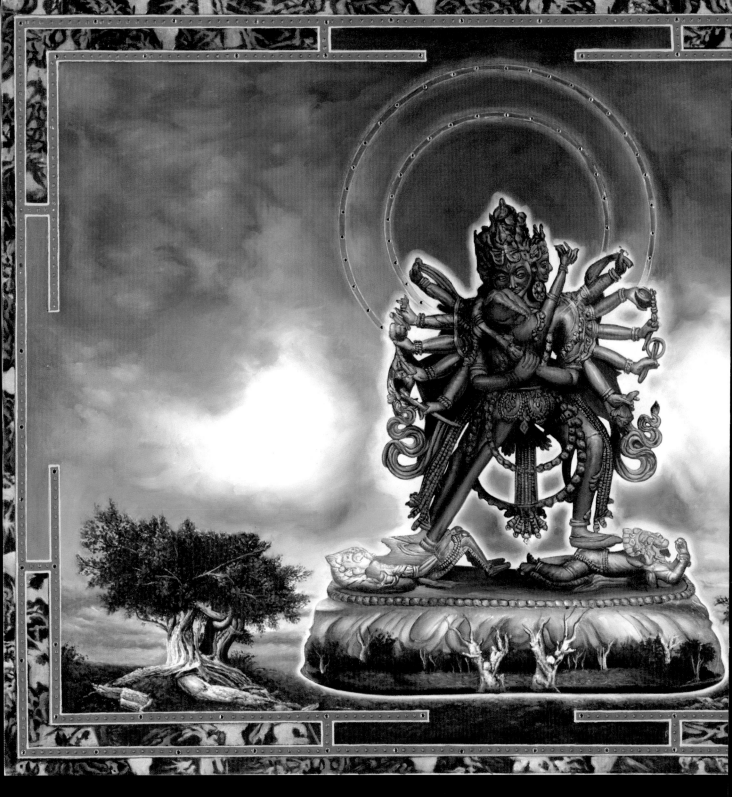

Chakra Samvara

"On the wall surface of whatever appears
I paint the vision of non-duality
With the brush of meditation
Holding the teachings on the inseparability
of emptiness and appearance
I am the master Artist, The Lotus Born"
-Padmasambhava

Art, in essence, is revealing the decisions of the Universe.

*A true Artist is reborn in each painting and
dies between paintings.*

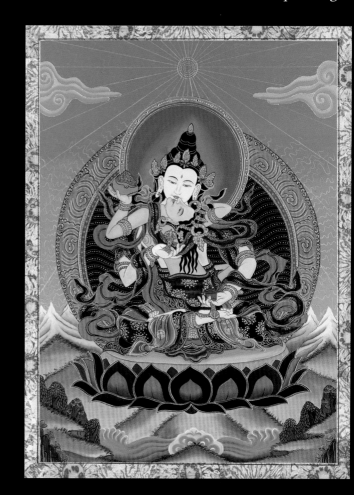

Golden Lovers

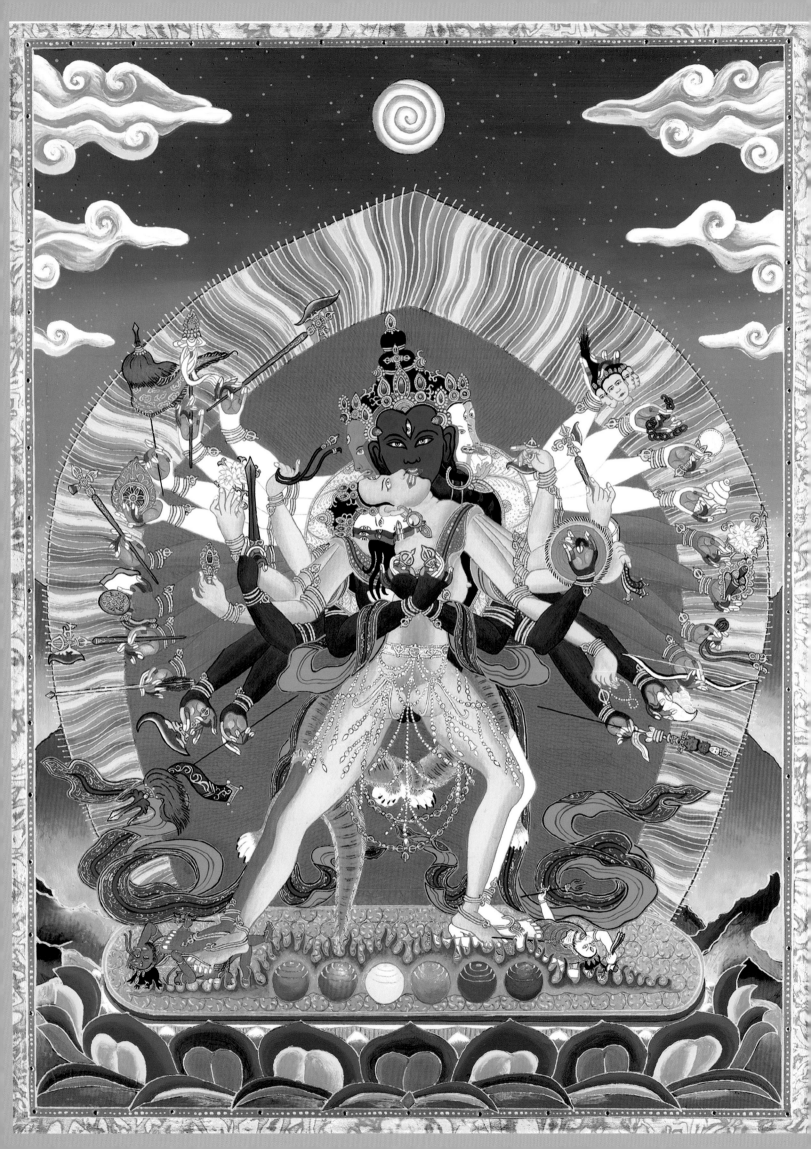

As Artists, when we direct our attention to the colors of creativity, courage, and integrity, we become expressions of those qualities in whatever we do, and whatever we create.

In tantric art, the symbols of union are Divine teachers through whom the mysteries of the Universe are made apparent to the world's perception.

Exploring sexuality has always been the path of Artist, and through enlightented consciousness when entering into sexual union with a consort, gives rise to an ultimate Bliss. The creative vital energies dissolve into a place of union, a place whre two individuals become One... at that moment, you experience what the Buddhist call non-dual consciousness.

How Paul Brought Tantric Deities Into My Life

by Margot Anand, *author of the "Art of Every Day Ecstasy" and the film "The Secret Keys to the Ultimate Love Life."*

One day, unexpectedly, Paul Heussenstamm walked into my life dancing. He was a child of the deities. I quickly noticed that they followed him around. He loved them as a child loves his mother, his aunts, his sisters, and later, his consort(s). But what I loved the most about Paul is what I love the most in me: We both believe in the power of "being the hero of your life." That is: beyond the mundane every- day activities, there is a greater mission to accomplish: awakening Self and Others to the infinite radiance of being alive in this body at this time. Playing the game of this life as an impeccable warrior, a dancing Shiva: creative, joyful, generous and inspired. That is Paul's choice. That is why I feel honored to be his friend.

Paul, I quickly learned, had been in his previous "incarnation" some years ago, a successful businessman, busy with import and export in the garment industry.

One day he went to India, met a Master, was deeply touched, came back, did a retreat in the desert, and during this retreat one could say that "he went crazy."

But madness is the door to what some call "Crazy Wisdom." Paul trusted and stayed put, waiting, living with this crazy energy that took him over, physically and mentally. It lasted days, even weeks. And Paul stayed with it, trusting so deeply; even madness and disintegration became acceptable. That is what happens to one who has taken refuge in the love and presence of a genuine spiritual Master or guide. Such a guide acts like a 'Mother." He/She elicits great trust through his or her compassion and kindness. And when the heart of the disciple or student is open, he/she disintegrates the ego, that in us which stays separate from existence through judgment and contraction. That process is painful, and often feels like one is going mad, certainly, jumping in the unknown. What was known and familiar in the past, no longer stays as a point of reference, because reality has shifted into a world utterly new and mad. Mad because so much energy is available, so many new colors are revealed....

This madness, this initiation into crazy wisdom is often, the way that the deities knock at the door of the mind. Once the door opens, through the grace and blessings of a master, it is as if the top of one's head were lifted, and new, amazing, unpredictable and mad energies were poured into one's being. Creating havoc, chaos, erasing all that is known, and leading one into a formless, primordial innocence, a surrender – there is no choice. The heart opens and becomes the central focus of perception.

At that moment, the chakras, our energy centers, relax. These new and powerful energies burn away their impurities, such as old pains, fears, and contractions. Like a subtle flame burning bright, or a tsunami sweeping everything away, these energies open new doors, through the chakras, to an expanded perception of the universe in which the Gods and the Goddesses can be manifest.

opposite page: Kala Chakra

This, I believe, is what happened to Paul during this time of "Divine Madness". He suddenly started "seeing" the divine archetypes, within his mind's eye. They talked to him. They guided him in a very innocent way.

Paul is not a scholar. He sees, he feels, he makes manifest, and disseminates those visions to turn on the people around him to a concrete vision of their ultimate potential.

Paul asked to be on my team and join my seminars, the Love and Ecstasy Trainings. During the trainings one discovers that Tantra can be a path to awakening, as lust is transformed into bliss through many energetic tantric practices and meditations.

Paul transformed the Conference Center where I teach into a tantric temple of amazing beauty. He hung twenty deities of all sizes and colors on the wall. And I felt I knew them, and invited them to the celebration. They showed up.

They came to represent our divine archetypes, aspects of ourselves that we forget to remember, yet which represent our potential for awakening wisdom and skillful means in our being. There was, for instance, the goddess with a thousand arms, Vajrayogini. Each of her hands held open; and in the palm of each hand — an open eye. Her third eye is open…. She is all seeing. She brings such a powerful impression of awareness in action; right action, aware action that is not limited by two arms, two eyes, etc… but is carried through by the power of an infinite number of arms, hands and eyes. How wonderful.

All of us in the room loved to associate with Vajrayogini, especially during specific Tantric practices which consisted of caressing and arousing one's partner to states of ultimate delight, and then channeling that energy through the chakras – the Inner Flute – all the way to the crown of the head, thus transforming Lust into Bliss. With a thousand arms and eyes and hands!!! Vajrayogini watching. In a moment, looking at her, I became Vajrayogini, and my actions became unbounded, infinitely powerful and aware. How delightful!

I have spent years studying the meaning, the symbolism, the practices represented by these deities. In fact, the central focus, of the Love and Ecstasy Training is the transmission of the Buddhist Meditation on Vajrasattva, which I have named: "Riding the Wave of Bliss." It involves the famous "Hundred-Syllable Mantra" which has great healing power and is symbolized by Samantabhadra and Samantabhadri in Yab Yum Union: she sitting on his lap, he sitting in lotus.

One could write books about them and these practices. They are simply representing an alchemical process of transmutation of base instinctual energy of desire into the light and formlessness of pure consciousness.

The deities in their many forms, as Paul paints them with unending enthusiasm and delight, represent aspects of our beings that awake to teach us how to transcend doubts and limitations and celebrate our aliveness. They inspire us to remember that we are beings of fire, earth, Beyond that: orgasmic beings who ride the wave of bliss as "Sky Dancers" do.

In my association with Paul I felt he brought the pictures and I brought the meaning; the alchemy that expressed their energies in the exquisite marriage between energy, our life force and consciousness – the emptiness that is like the witness of all that happens and reflects it.

When Paul brings the deities — male and female — in the room, we all want to dance and celebrate.

Artists give us a glimpse of eternity. This is why we value their paintings and other vast creations. Museums and collectors seek to purchase the eternal quality that is hidden in paintings. The mind can't see or comprehend it, but the Soul sees it. A painting has the power to join with the heart in an intense relationship. When a great Soul painting is up for sale, museum directors all over the world dream of owning that painting. In Great Britain, museums pool their resources to keep Soul "masterpieces" within their country. The Soul's language is Art. All museums that house and preserve paintings (windows) to Eternity should unterstand the Soul's realms. In my workshops we may visit a Buddhist temple to meditate so as to prepare us to enter the more spiritual realms of a museum.

"We ought not to look past nature, rather through it," Mondrian said. "We ought to see [Soul] more deeply." Franz Marc surely knew this: "Today we seek behind the veil of appearance the hidden things in nature [Soul]."

Art, to a senstive Soul, is a "treasure of happiness."

opposite page: Chocolate Tantra

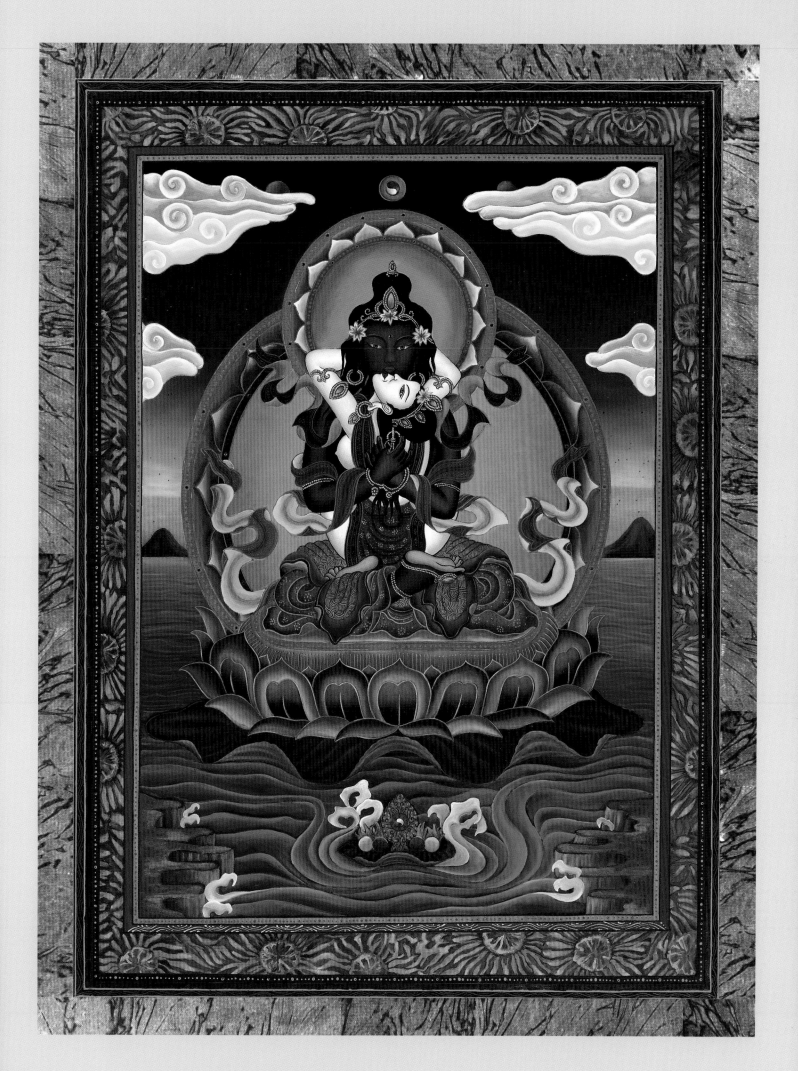

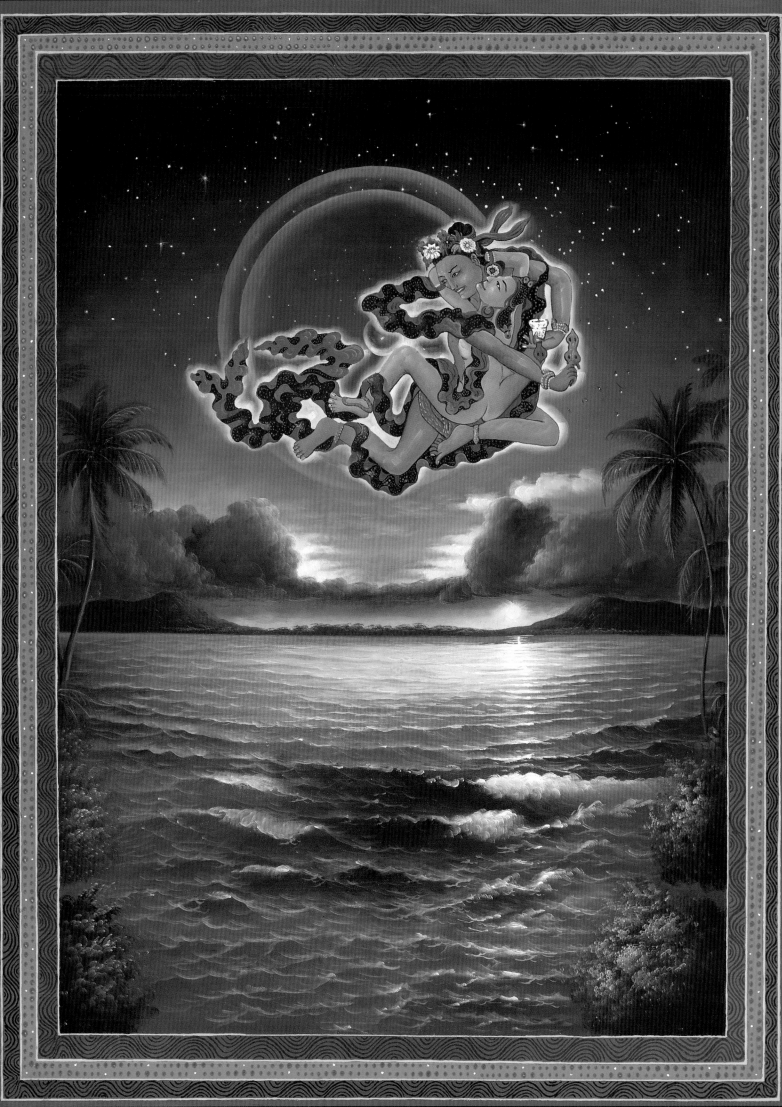

When painting in a group, you begin to feel a 'love' that transcends all feeling.
You feel the essence of your Soul. You feel a different flavor of color in each person.

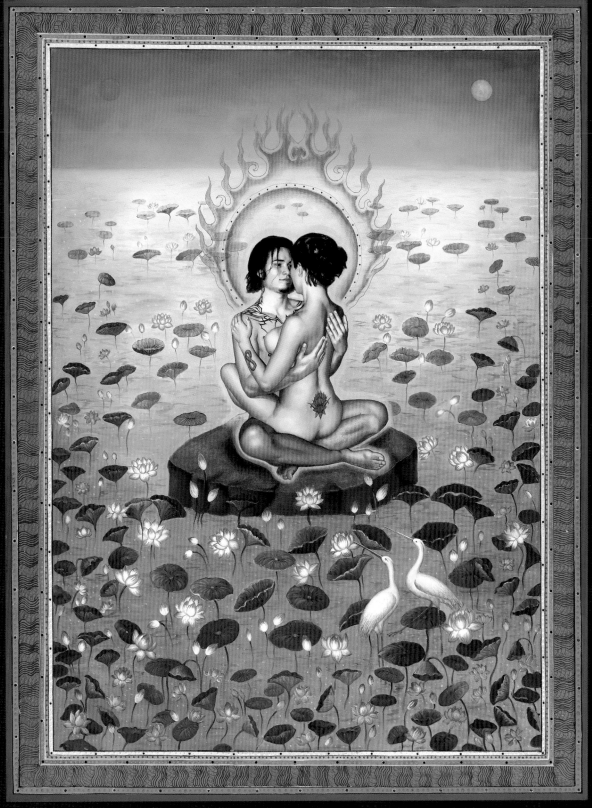

Tattoo Tantra

While painting a tantric image, I imagined Eve eating the apple and sharing it with Adam. They hugged each other, lay down, and made delicious love. Then God said "This is good; this is really good."

opposite page: Sunrise Lovers

As Seen In...

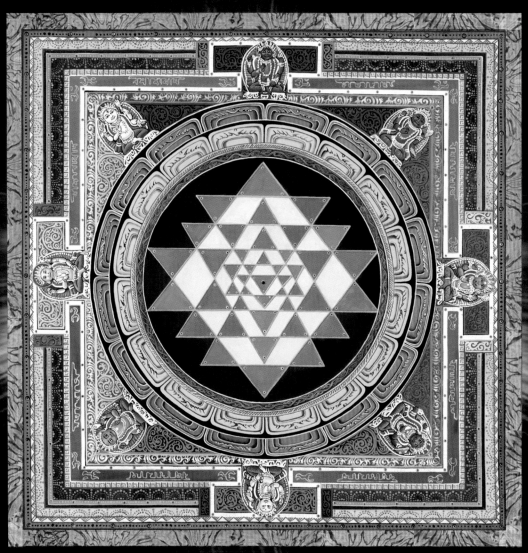

Sri Yantra Magic

All art is vibrating at individual vital frequencies.

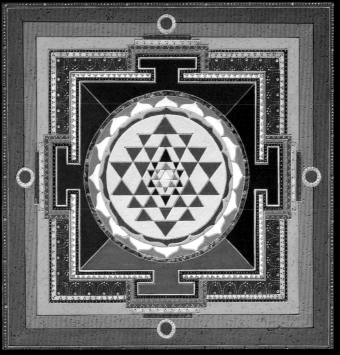

Sri Yantra

An Artist prays that all may be healed when looking at a sacred painting.

Yantra

Art is a religion to a painter that finds her/his Soul through the practice of painting. Art is a mysterious force that guides each painting, while a deep teaching comes through each work of art. In some ways, art has been forgotten, ignored and devalued in our modern society and has been replaced by the computer. Although for the Artist, it is the hand – not only the individual hand, but the divine hand – that becomes all important.

Part of my work has been to explore and create art of Divine Center as if each painting were a synthesized version of a larger whole, far greater than anything I know on a personal level. It is awesome when Presence takes over and I merely watch as the entire energy and frequency of each painting comes into manifestation. The painting's entire being, as clearly seen in Yantras, is aware of the connection to the Source at the center of the painting.

The Artist's spiritual journey from the place of material

existence (everyday life) to higher consciousness, or perhaps enlightenment, is mapped out in the Sri Yantra. The Sri Yanta is the oldest and greatest of Yantras.

The Artist's path is more or less a pilgrimage in which every step is an ascent to the center, a movement beyond one's limited existence.

Painting a Yantra at every level brings one nearer to the goal, an affirmation of the unity of existence. Pissaro once stated, "At fifty, I formulated the idea of unity without being able to render it. At sixty, I began to see the possibility of doing so."

There's no doubt that Art is a Spiritual Path. When one studies the Yantra, it is as if every part has knowledge of each and every other part.

In art there's a possible way to experience the equality of opposites.

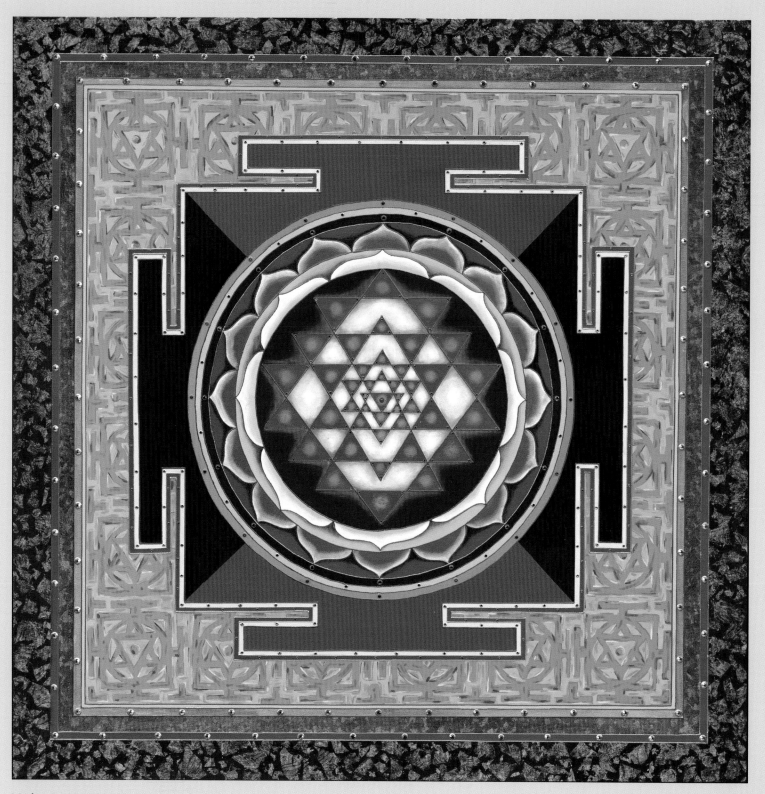

Maha Sri Yantra

Art is a journey into painting, a journey into each painting, and a journey into life.

All true works of art point toward the truth.

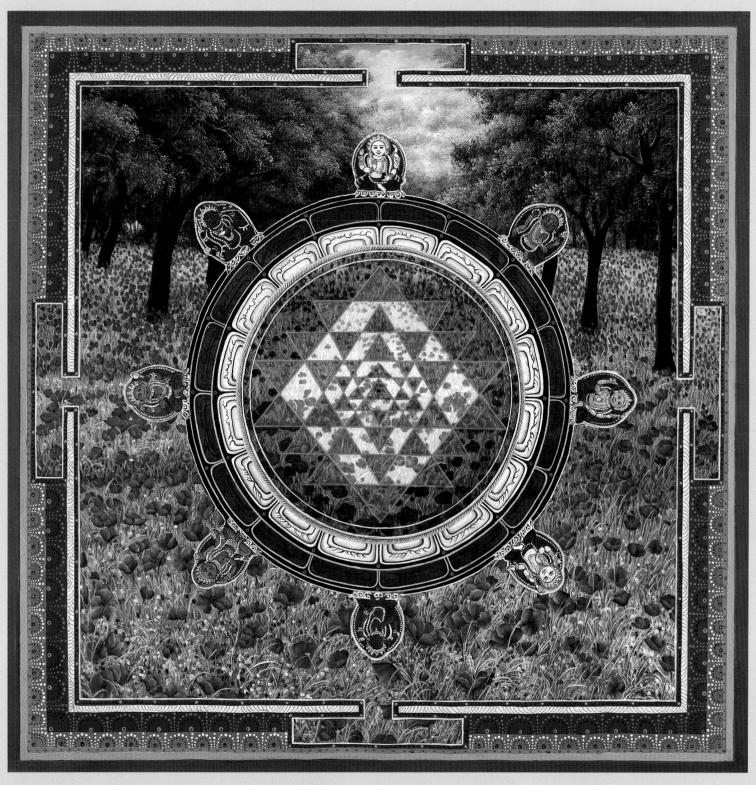

Yantra is Up

The only reason to be an Artist is that the Universe is using your voice.
When the Universe is finished with that person as an Artist, she/he dies.

Paintings are sent by Goddess/God.

In the body, the physical body, the mind has a positive bioelectricity while the heart has a negative bioelectricity. In life, this is why opposite sexes attract each other. In Art, the enlightened Artist radiates a tremendous energy for the heart of all seekers. In the path of the Artist, the creations will both be created from a place of enlightenment and open a door for each individual spiritual seeker to awaken into the current of the deeper forces of life. When you find the right painting or the right Artists, you must surrender completely. To surrender to the forces is the only way to reach a unity, wholeness with the creation or the Artist. Never pass up an opportunity when it is there because it may not happen again and you will be haunted by your decision to stay in the mind.

The mind tries in every way to be closed because to open is in a way to die. For the mind it feels like death; so it will try; it will argue; it will find many reasons to stay closed. It will even make up absurd things rather than surrender its place of dominance. Once you have found the key to open, you will probably be amazed at the things that made you doubt, these meaningless things that made you skeptical. And if by grace you open; you find the Soul of a painting; then the chain of feelings, the transmission will be possible.

If this happens, your life will never be the same… fortunately.

When an opening occurs, either for an Artist or for a lover of art, then nothing will seem the same. The day will not be the same, sounds will not be the same, and especially what the eyes are seeing through the heart will never be the same. With your day dreaming Soul and your heart eyes, the whole of life takes on new colors. When it is said that the world is an illusion (maya), it does not mean that the world doesn't exist. Rather the seeing of the world is no longer an illusion.

Art is the interior consciousness of mankind.

opposite page: Sri Yantra Goddess

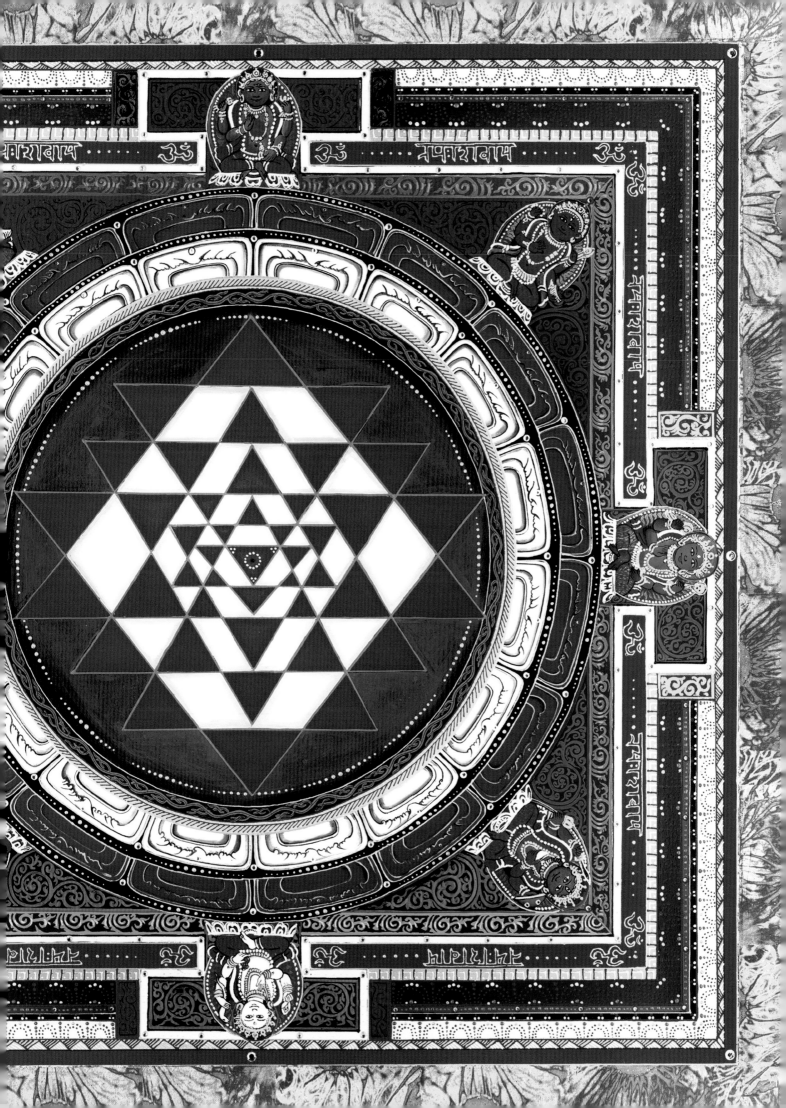

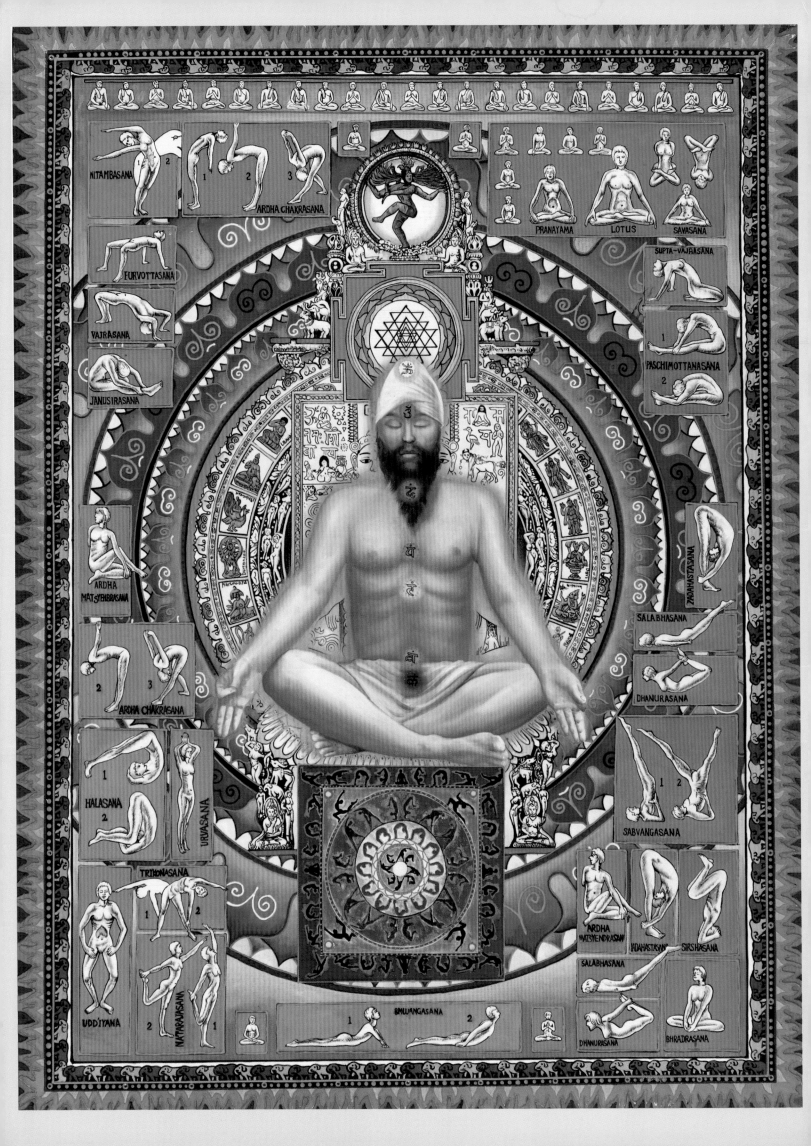

Art is an instrument of Soul's power.

The Artist's power is that he can create in every home, school or yoga center. Art should therefore hold a place of honor.

Yoga

I was fortunate indeed to grow up in a household where meditation was practiced regularly all through my formative years. Meditation along with yoga are two assets that have followed me through life and have been lifesavers during times of change and transformation. As an Artist, my experience is that 'discipline' is of primary importance and the practice of yoga, yoking with the mind of God, is key for that Artist who must handle manic periods of riding the highest highs when his creative output is flowing and suffering through the lowest of lows when nothing is working (or selling).

At its best, yoga balances and attunes the forces of the unconscious, a valuable tool for all explorers of the interior

worlds. It would only be natural then for signs of yoga, a true love for life, to appear in some form in the area of my painting life.

As Matisse said about being original: "The hardest thing for a creative Artist to paint is a rose because first he must forget about every rose that has ever been painted...." So in time, especially when practicing a more Eastern Spiritual Path of Sacred Image, one must first learn by using the images passed down by the Masters; then only later discover, really by listening to your own Soul, to become original and find the way to your original essence.

opposite page: Yogi Bhajan

The Artist transforms energy (different frequencies) into matter through color, shape and form.

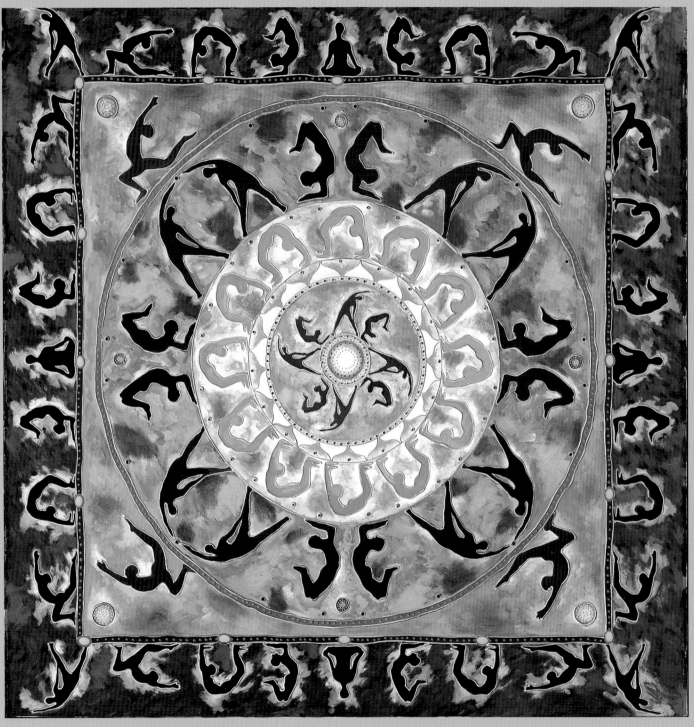

Art of Yoga

The mandala is a description of an existing energy field.

Art teaches us that a true work of art lasts forever.

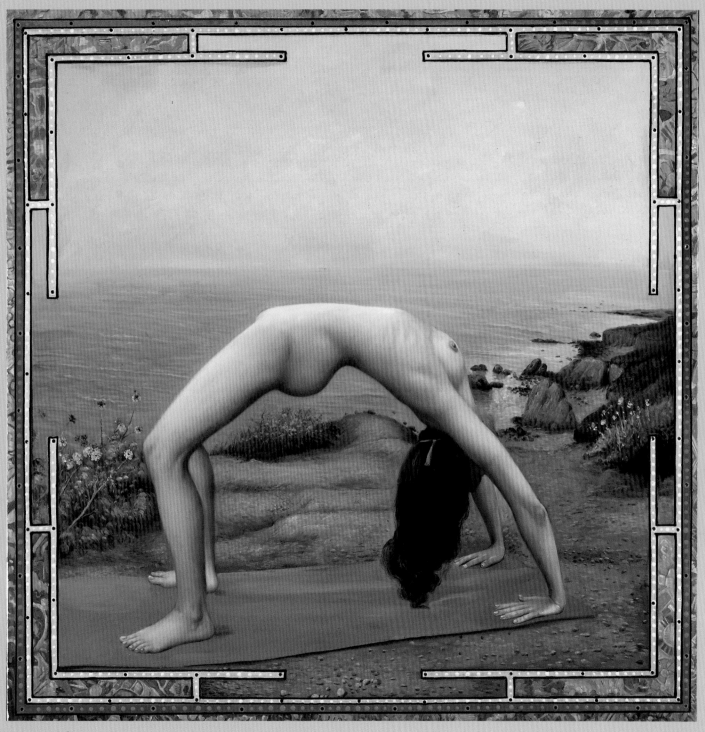

Yoga Nude

The most important moment of an artist's life is when her/his heart wins out over the head.

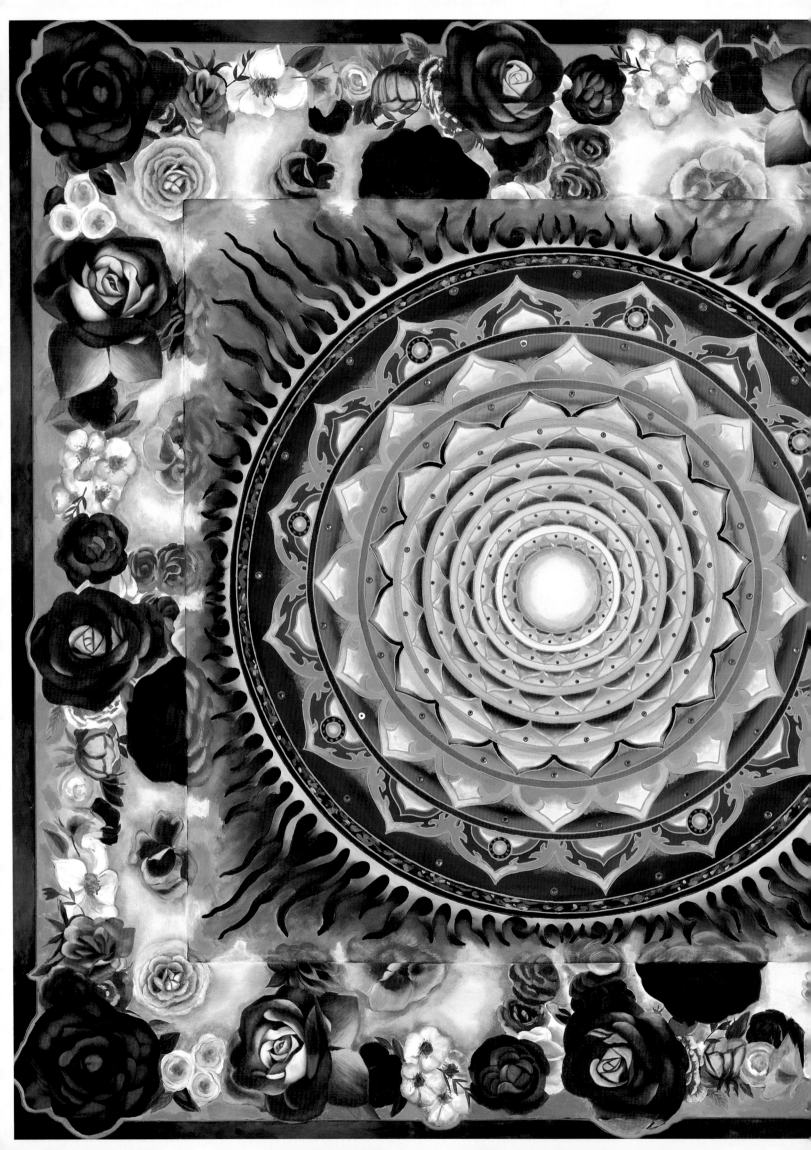

Art has the infinite capacity to deepen consciousness.

Flowers

As I began painting, I began to experience the mysteries of the universe. The Soul sees reality as a vast, colorful, seamless web connected to all reality, including the past, present, and future (mind). One glimpse of this mystery will alter your painting life forever! "I felt Spirit descend on me, which filled me with a fire of great beauty of the highest feeling," said the Mexican Master Diego Rivera.

Soon I realized that Art is a Spiritual path that leads to the deeper truths of the universe. John F. Kennedy suggested that Art was one of the noble paths to truth, along with religion, science, and philosophy; and it is so. When we begin to paint, new eyes open and we see a world of feelings and colors with all mysteries connected. It's no wonder that, on his deathbed, a Japanese billionaire paid $85 million for a single Van Gogh painting. Who wouldn't want to see the "Divine"? Certainly $85 million is a symbol of the pricelessness of experiencing Eternity.

We hear a lot about Van Gogh's suffering, and surely he did suffer but in many of his paintings I feel him to be one of the most ecstatic, joyful painters of all time. The energy and experience of "God" clearly brought complete joy to Vincent's Soul; and this is carried forward to us in many of his moving, dancing, energized, and utterly cosmic paintings. I read somewhere that Van Gogh's paintings are "God's fingerprints." This is an example of how the Soul works through the Artist, who must experience both joy and suffering to be the translator of this Divine Energy. We know well that Michelangelo experienced great agony and ecstasy in his Artistic life. This is the price of gaining the Soul — life is different when we identify less with the mind that is thinking than with our heart that is feeling.

People in the West want to overcome their feelings of separation, to experience the Divine or God. Art can do this for them. If we're reading about great Spiritual teaching, visiting a museum, taking a Spiritual workshop, or watching a great film, yet we feel no connection, we're coming to the moment from the mind. The mind's reality is separation — "you and me," for example. As a businessman my reality was based on "me," however, as an Artist my reality became the experience (through my heart) of the universe, the Divine (God). William Blake said that the universe could be seen in a grain of sand, something which can only be truly understood from a heart or Soul perspective. From a transformation from an individual Artist to "Ourtist" (collective) serving humanity is the spiritual path of art.

Once we learn to approach life from the Heart Connection, we are in the world in a new way, not merely observing it. We are "in" a movie, "in" a painting, "in" life. Have you ever felt a movie was so real that you were frightened or moved or erotically stimulated? That moment was a glimpse of how an Artist, or anyone who has his or her heart open, connects to the world much of the time. We enter our reality filled with mystery, open-hearted, living moment to moment.

Floral Ecstasy

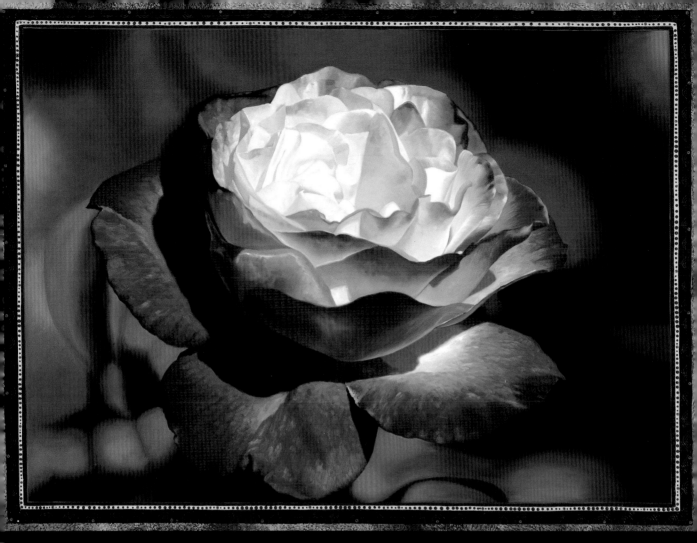

Rose Shades

Art comes from the Soul's journey through cosmic time.

When we look at the paintings of the Impressionists, we can see that they connect the sky and the earth, the background and the foreground, the person in the painting to the flower. The entirety is connected and fully colored. "If I make one stroke on the painting," said Cézanne, "the whole painting is affected by that one stroke." This is Soul. The Soul paints your life one awakening stroke at a time, animating the possibility of your self-realization.

Feeling with the heart, you see that each stroke, experience, dream, or realization in your life, provided by the Soul, is all connected. The marvelous poet Rainer Maria Rilke once said of Cézanne 's paintings, "It is as if every spot had a knowledge of every other brush stroke." Soul!

Indeed Cézanne had recognized that each individual stroke is connected to every other one. This is why paintings that we term "classical" appeal to generation after generation Camille Pissarro discovered that there was a total "unity in painting without being able to paint it, although at sixty I began to see the possibility of doing so." Edgar Degas observed that, "An Artist can say more with one stroke than a writer can in volumes."

The generations-old aphorism, "A picture is worth a thousand words," is a "Soul statement." This is also seen in Zen brush strokes, as well. An Artist's brush strokes are an authentic expression of the Soul of the Artist. They literally speak "Soul," and the Soul of the viewer responds. The esthetic response is a heart-based reaction to any masterpiece. All great masterpieces are always true expressions of the Soul.

Flowers so reveal the feminine side. Georgia O'Keefe was a modern painter, and she practiced the Eastern art of not signing any painting. The flower is beautiful in itself, she realized; and painting was so powerful for her she understood 'that all life was a necessary aggravation between paintings'.

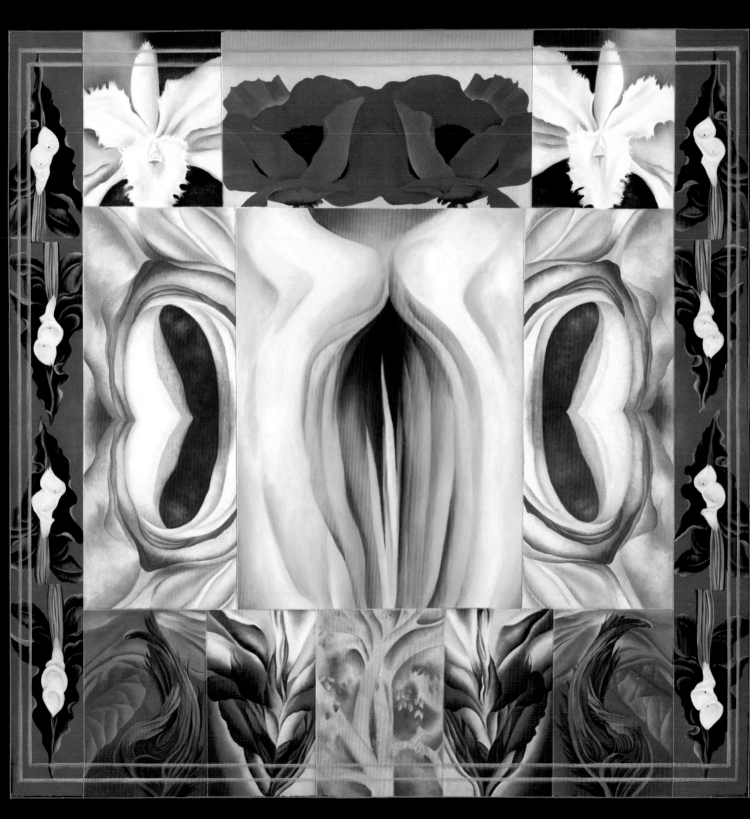

Georgia O'Keefe Mandala

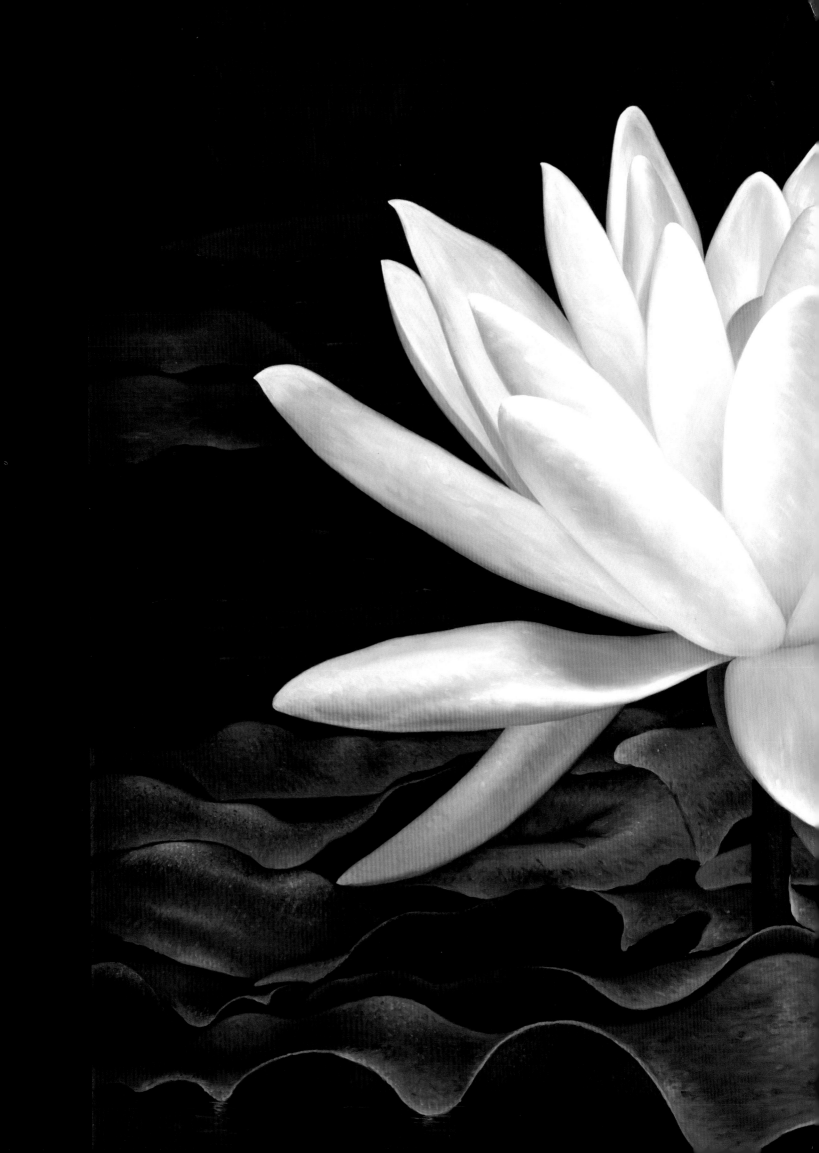

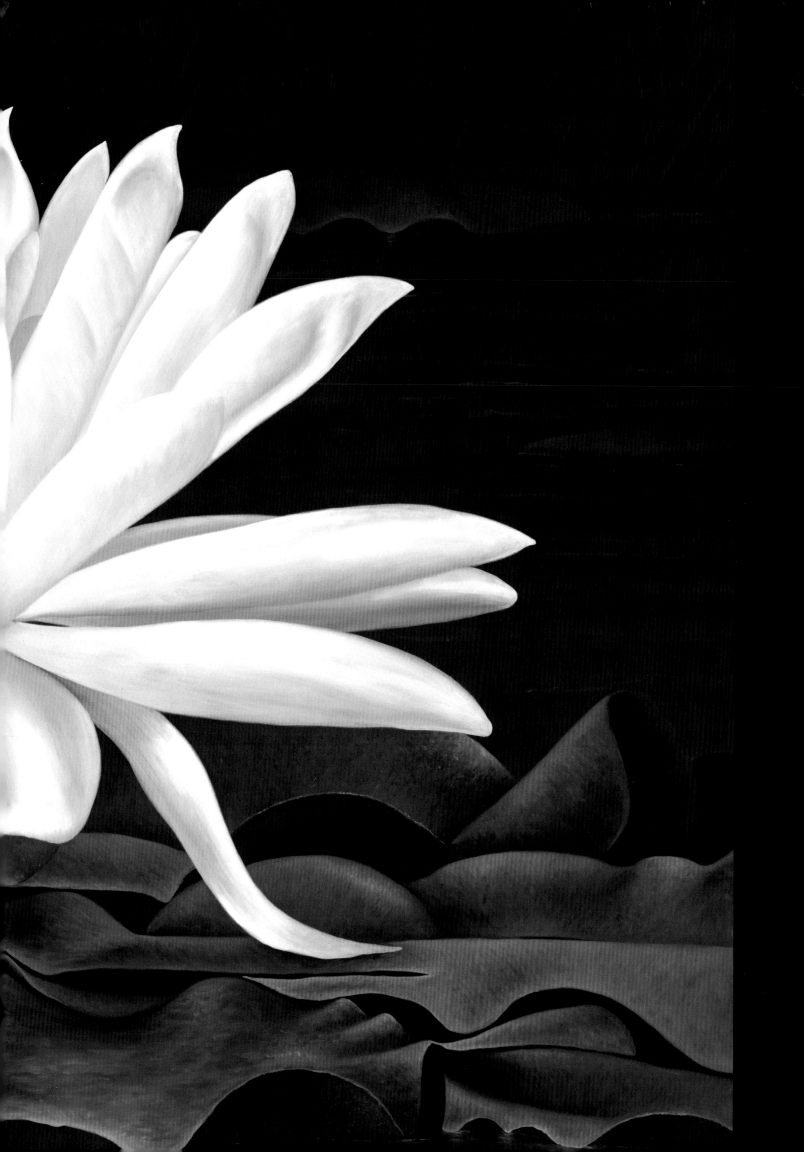

I can paint an open lotus only with an open heart.

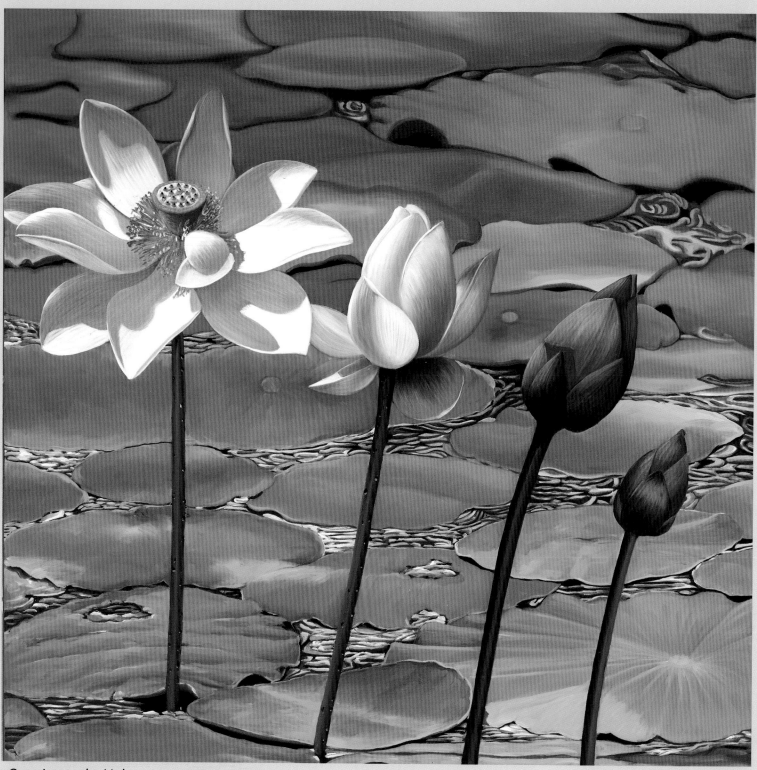

Opening to the Light

A painting of a flower is where Earth greets Heaven and Heaven touches Earth. A painter indulges in this place of Divine love and captures it so it becomes eternal.

You don't need a definition of what is sacred to a painter, for what is being painted is the sacred.

opposite page: Orange Lotus

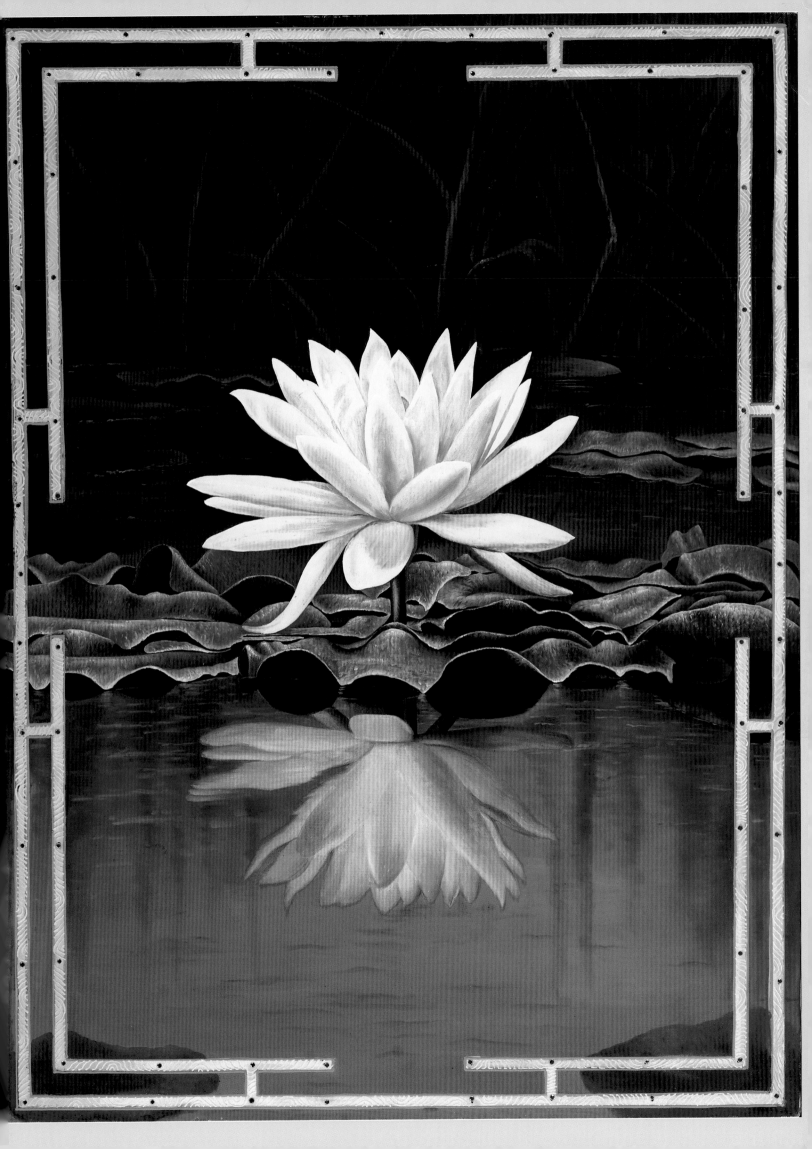

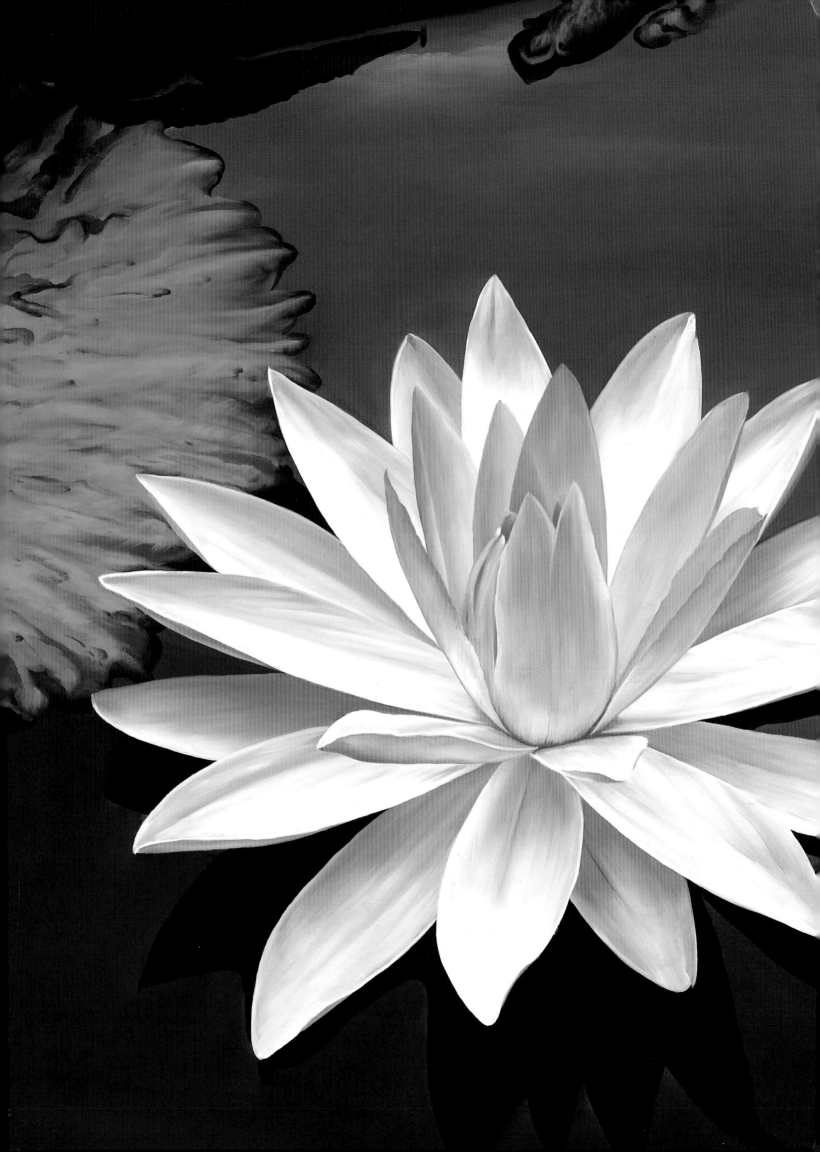

Art is an orgasm waiting to happen.

A painter learns to see the world through the eyes of the heart.

Square Lotus Reflection

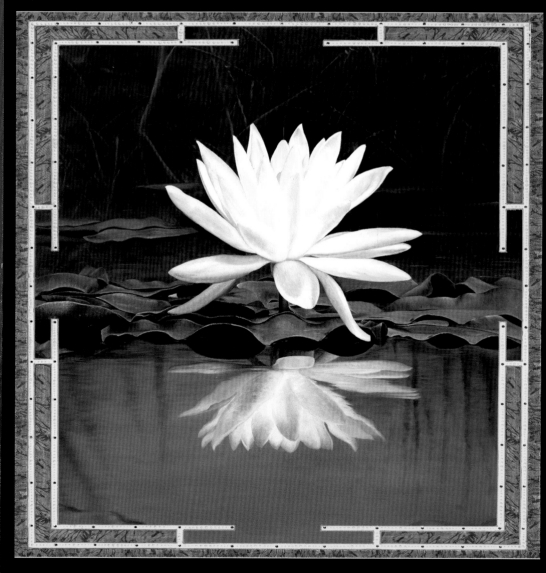

opposite page: White Lotus on Blue Water

next page: Purple Lotus

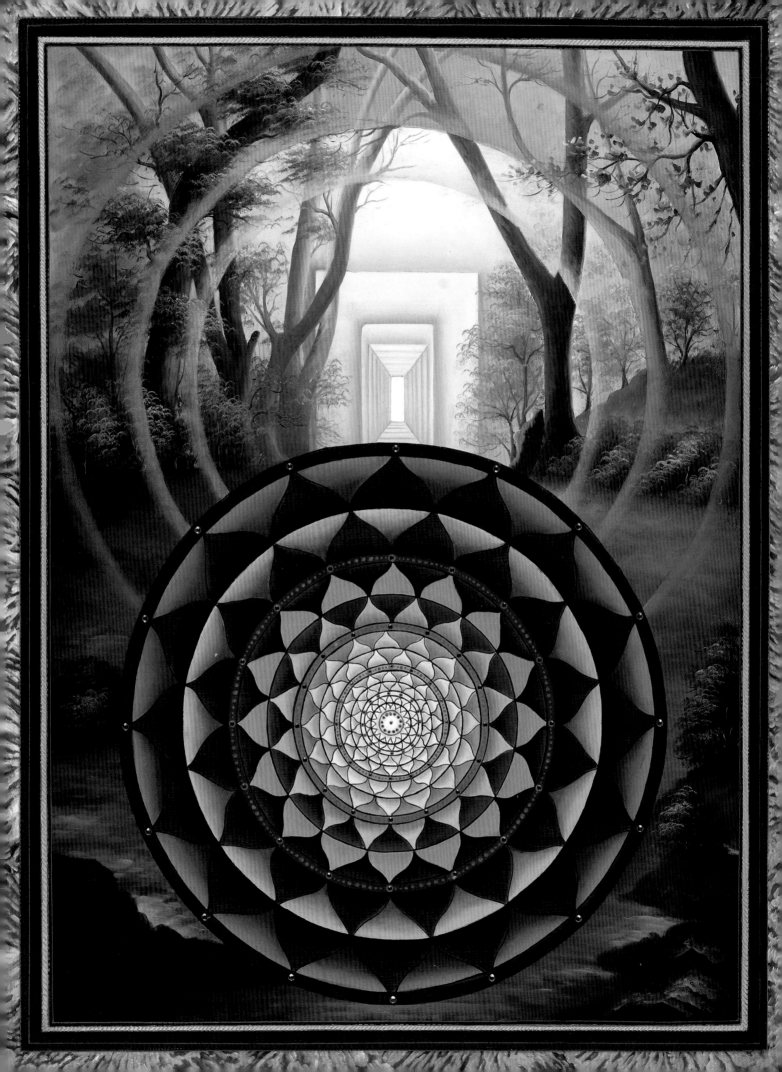

Art is a bridge between the mind and the Soul.
Creativity is the optimal function of the sensitive Soul.
Cultivate the Soul, and creativity and art will take care of themselves.

"When one's own vision is pure, the entire Universe is seen as a Divine Mandala and everything in it as ambrosial nectars."

—*The Dalai Lama*

Nature

One way to understand the relationship of the Soul to the heart is through surrender. To surrender (or to undertake a descent journey) means shifting away from the mind as the primary focus of our consciousness to the heart, letting it act as the center of our consciousness. You feel, as opposed to think. Then, when you feel the moment strongly, open your heart and engage the Soul. "What is important in a great man above all the nature, is the strength of Soul," said Odilon Redon, the mystical French painter, whose work led to a "small door opened to the mystery." The Soul is fundamental to the Artist, and Redon changed the way we looked at our world. The Soul gives us new eyes to see nature and a fresh understanding of our cosmic planet. The beauty that a true Artist creates on a canvas is immortal.

In our culture we mistake the surface reality of the mind for all that there is of reality. This is not the case. In Hinduism, Buddhism, or any of the Eastern cultures, there is a much broader understanding of a wider range of reality that is not illusion or Maya or Samsara. This understanding and experience becomes available to us as we descend from mind down into heart.

Seeing the world with the heart as source, and the mind as filter through which the Soul expresses, is very different from being mind-based. When our heart begins to open, the effect is transformational, and it deepens and accelerates the journey on our path to self realization. Cézanne said, "If I think while I am painting ... everything collapses and all is lost." Chagall realized, "If create from the heart, nearly everything works; if from the head almost nothing." This is also true in life and we have to learn how to listen to our heart. This is the key to the creative life. The open heart is the entrance into the creative life and union with the Divine.

As my heart began to open, the Soul was increasingly revealed. I want to quote a Buddhist teacher in northern California, Tarthang Tulku, concerning the truth that when you have beauty, and when you nourish that beauty, eventually your heart opens. In his words "The heart begins to open like the petals of a flower unfolding." It's the heart that connects us with life and with our own mysteries. In other words, we feel connected — we experience a profound connection to nature and to all of life. We enter into this profound mystery of life through the heart to the Soul. As this happens, you begin to understand that opening creatively to the Soul will radically change your life. Physically, it is less than a foot-and-a-half from the mind to the heart, but it is a lifetime journey to move from one to the other — to explore the creative life based on the heart.

opposite page: Gateway to Enlightenment

next page: Essence of Esalen

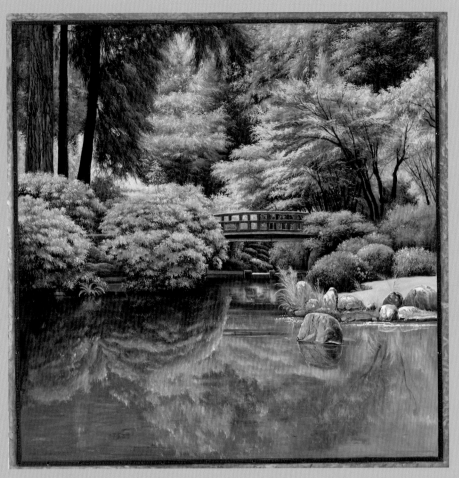

Green Garden

Sedona Mountains Mandala

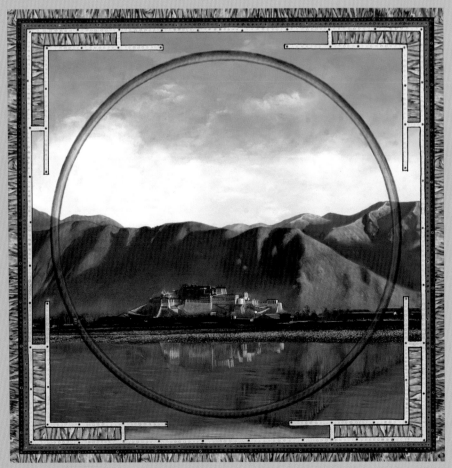

Portola Rainbow

As we begin to cultivate a relationship with our heart, we discover that the heart is feminine-based. It sees everything as infinitely connected. That little refrain that we hear in religious credos, Spiritual teachings, and prophecies — "we are one" — is basic Soul 101, fundamental reality to the heart and, therefore, to the Soul. My heart sees and feels connections, unity, and synthesis, an integral universe. It's an entirely new and vast realm! Cézanne discovered this when he stated that Art "should give us a taste of nature's eternity." Chagall declared, "Art seems to me to be above all a State of Soul."

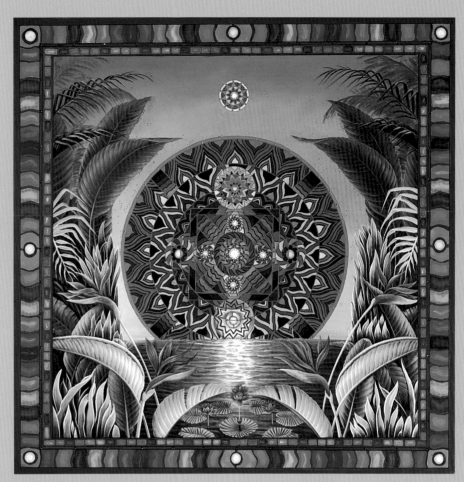

Mandala Paradise

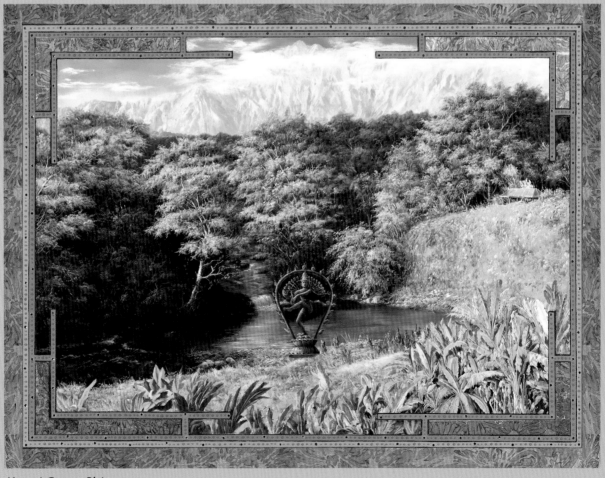

Kauai Green Shiva

In my own life, the onset of these experiences created such an internal uproar that, as I began to paint, I felt I had no choice but to leave my business career after 25 years. I felt it was a calling from my own Soul, and realized it must be so for all true Artists. Soul calls us to be Artists, and we must learn to listen to her guidance. Edouard Manet realized this when he said, "Each time I begin a picture, I plunge headlong into it … like [throwing myself] into the water."

Auguste Renoir said, "I am like a cork thrown into a stream and tossed about on the current. When I paint, I let myself go completely." Even so, my painting experiences opened my heart to a transformation from a superficially real business life (masculine mind) to the deeper flow or a "bohemian" creative life (feminine, heart-centered) of the Soul.

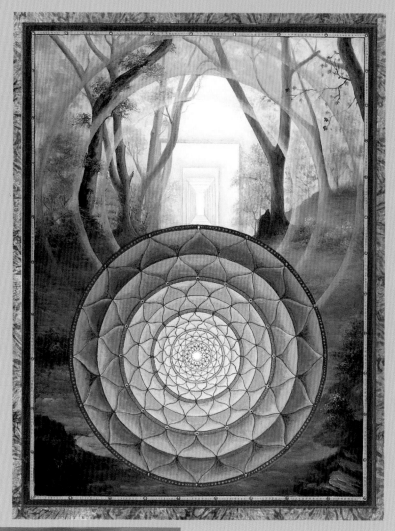

Inner Light

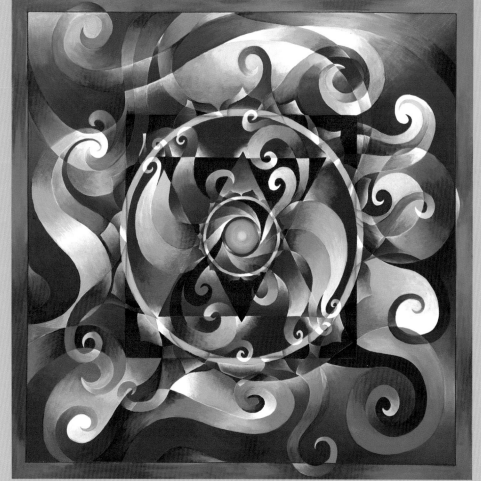

Your Soul is the ultimate river within you that has more information about esistence than you have ever imagined.

Artemis

Waves

*The antidote for
sadness or boredom
is creativity.
No matter what,
it is within us
waiting to be born.*

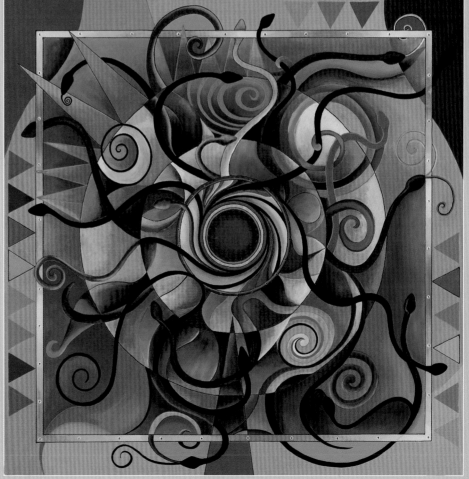

Serpentine Fire

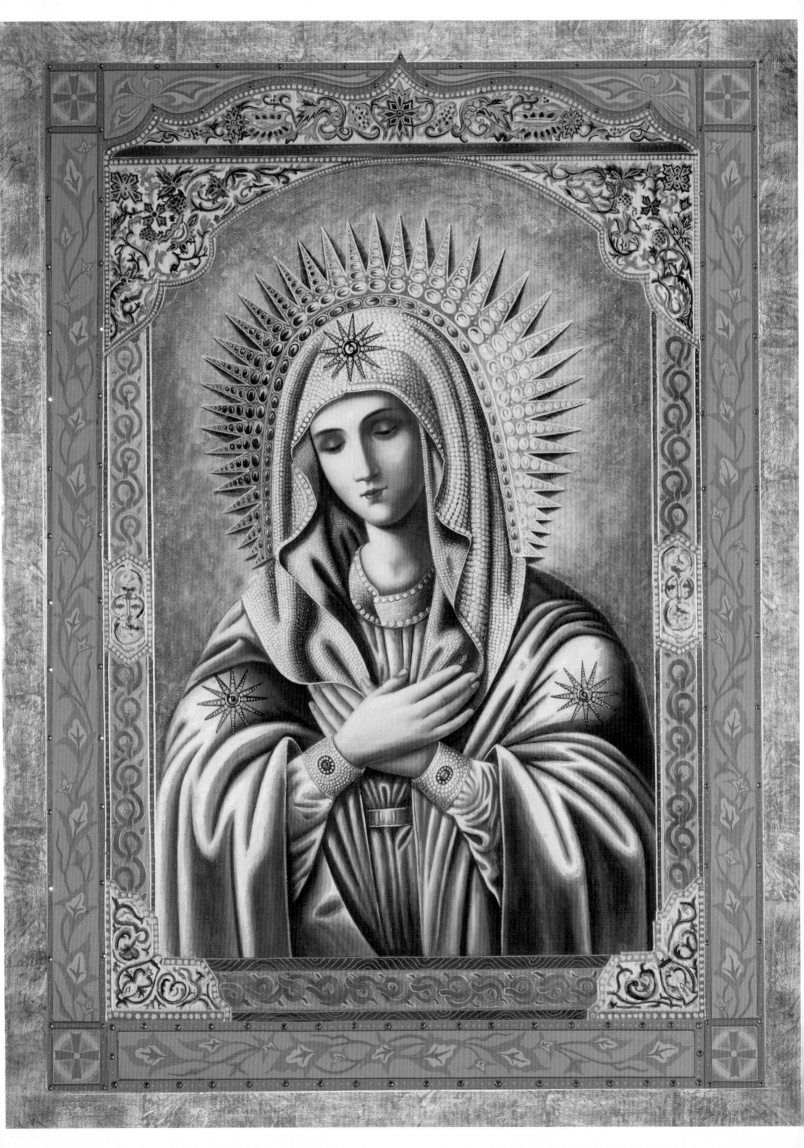

An Artist must get out of the way of the forces, trust the process, and allow it to happen.

As an Artist, I learned very early to yield to the paint, to allow the process to be my guide.
I surrendered... all paintings are from my Soul, through my heart.

Christianity

A descent journey powerfully changes life and eventually means being out of your mind's control. Learning how to transform and integrate Artistic expression into one's life accelerates the developmental process. There are many ways to begin experiencing the wisdom of the heart, and any individual who undertakes the descent journey (either of his own volition or by unexpected or unanticipated life events) can learn how to come back to the Heart Center over and over again, whenever she/he feels knocked off balance.

Years before I began to paint, one of my primary Spiritual teachers, Brugh Joy, was teaching the daily practice of centering your being in the heart and Heart Chakra. I have practiced this continually since 1978 — using the heart as an anchor to balance and attune awareness, especially during disruptive or difficult times

The descent journey leads to the symbolic death of the old ways of being in the world, and can be very painful. Courage is the critical virtue at this point; one must be brave enough to continue on the Spiritual journey. Virtually all our movies and novels are based on the courage of the heart. The descent journey and concomitant life transformations are well-revealed by studying the lives of recognized Artists such as Picasso, Matisse, Dali, Delacroix, and Diego Rivera and in the more extreme cases of Van Gogh, Kahlo, Maccahio, Modigliani, Munch, Pollock, and Soutine, to mention only a few. Each of these Artists had deep struggles with this question and found that art was the life path to express this descent into the heart. An Artist must develop both courage and discipline to handle the forces of being highly creative.

It is important that we not be naive here. Opening the heart leads to "enormous" feelings and fundamentally alters one's life.

opposite page: Mother Mary Through Time

The descent is not something one does in an afternoon; as I said, it is a life-long journey. Let's begin with the idea of what it means to descend. In a negative cultural perspective, from a so-called Christian prejudice, "down" might imply or conjure images of hell. From an earth, Native American shamanic perspective, the descending journey is toward the Mother; and the Mother is the earth.

The surface mind is masculine-based. It sees everything as separate. Separate countries, separate towns, separate cities, separate houses, separate cars, separate bank accounts. It sees a painting separated just as it sees life. The ruler of this surface mind is the self-based ego. This ego thrives in separation, and it judges and evaluates and experiences reality through its thinking, reacting capacity. Our society mirrors this reality.

Thus there is a direct relationship between the heart of a painting and the heart of a viewer. Once your heart is opened, paintings, museums, temples, and so on take on a new, bright, "cosmic" appearance. You begin to see life through the eyes of the Soul. Gauguin said, "Use your eyes," and "Why should I hesitate to make all this gold and all this joy of the sun flow onto my canvas?" And his friend Van Gogh said, "I want to paint men and women with that element of the eternal ... by the actual radiance and vibration of our colors." These two true Artists, as well as so many others, walked through life with their Soul-eyes wide open; and this is easily visible in their explosive paintings.

When we look at the content of Eastern Art, we find that nothing is superfluous. Every inch means something. In all Tibetan paintings, all shamanic paintings, all Native American paintings, all Aboriginal paintings every square inch has meaning; every "stroke" connects to the whole. These, too, are views of the Soul. Paintings reveal what Nature hides; but to see, we must access the Soul through the heart.

Through art, we see the faces and the forces of the Soul.

The intelligent Artist quickly learns the importance of the Soul.

*An Artist must learn to deal with
Divine discontent in
order to create
a new reality.*

*An Artist holds great power in his creations,
yet can be powerless against his own destruction.*

Celtic Christ

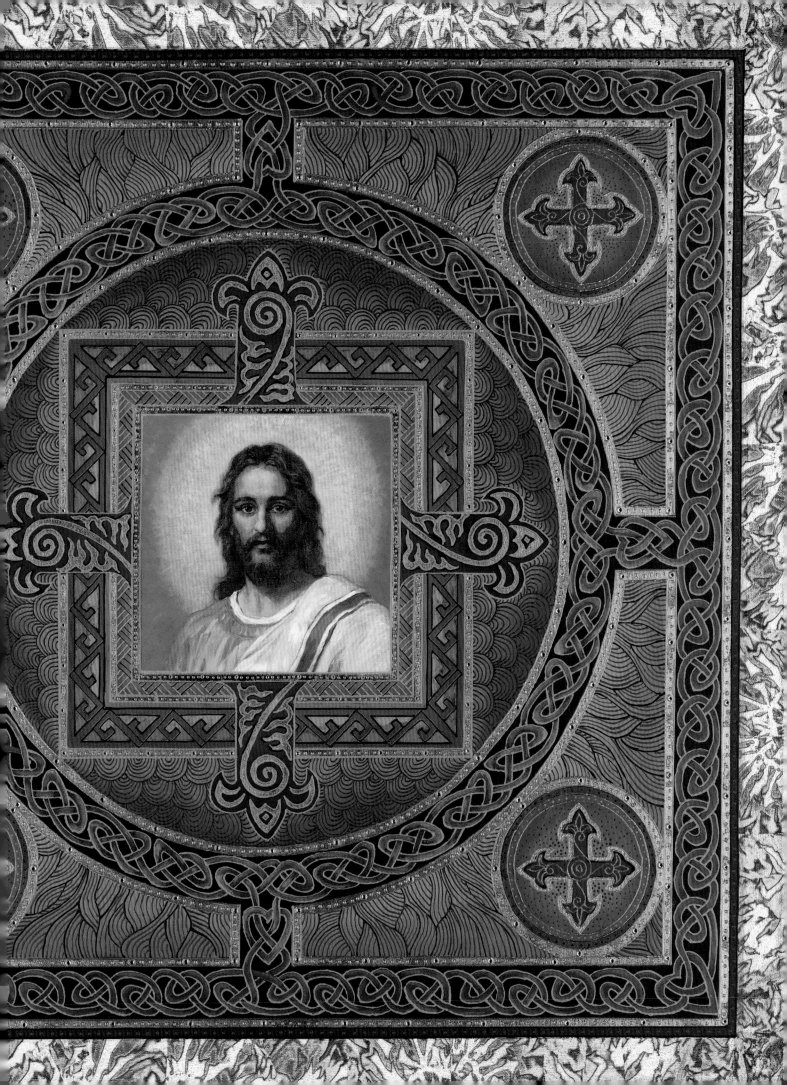

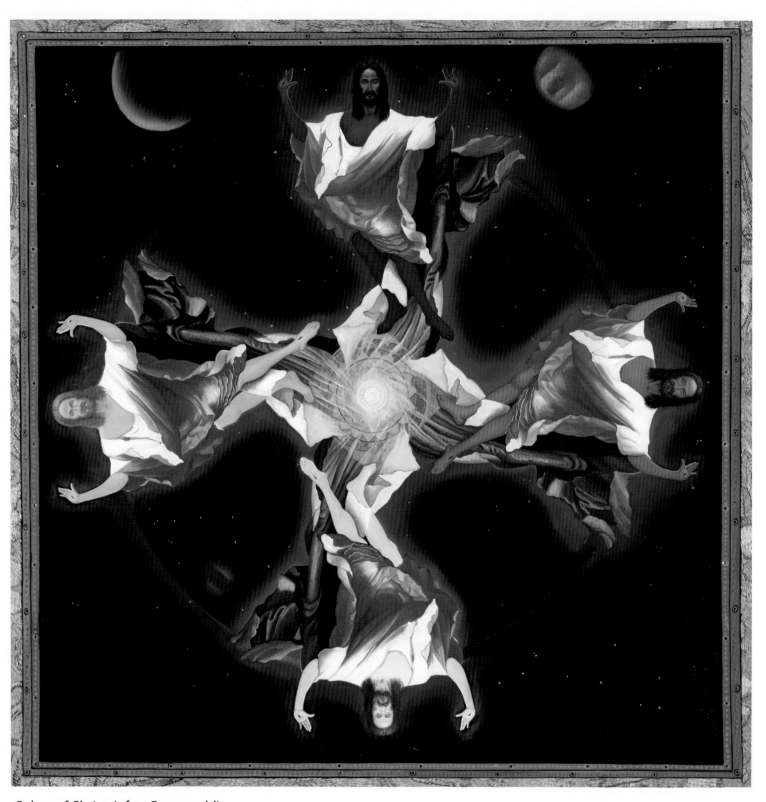

Colors of Christ (after Grunewald)

When an Artist passes away, it's up to all Artists to continue her/his vision. In the future, we'll see colors that are now only within consciousness.... later they will be available to the eyes. May all be healed when looking upon this painting.

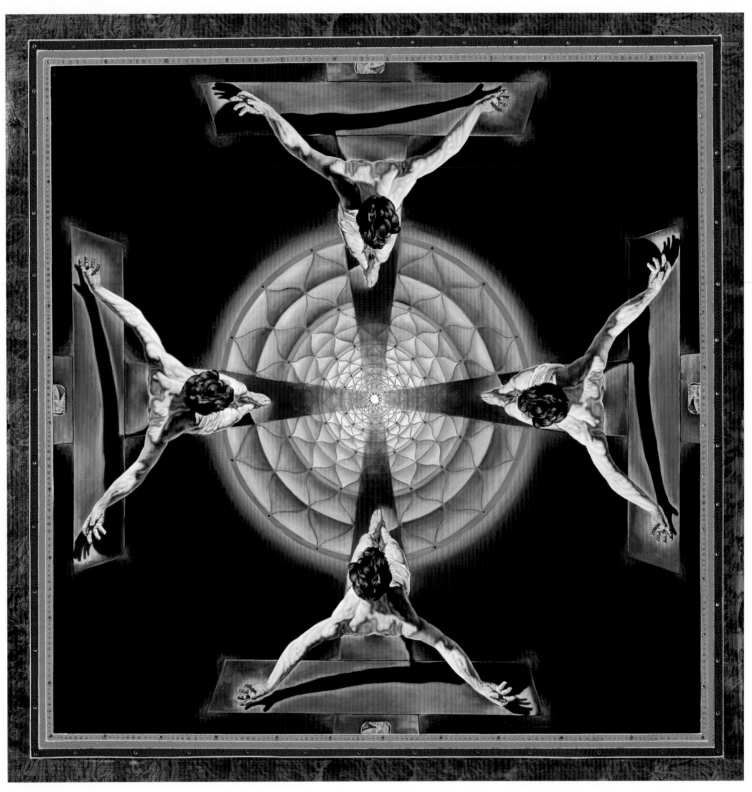

Dali Christ

Meditation is prayer to the Savior... Art is the medicine of prayer... for an Artist, a masterpiece is a gift from Goddess/God..
Thank you, Dali....

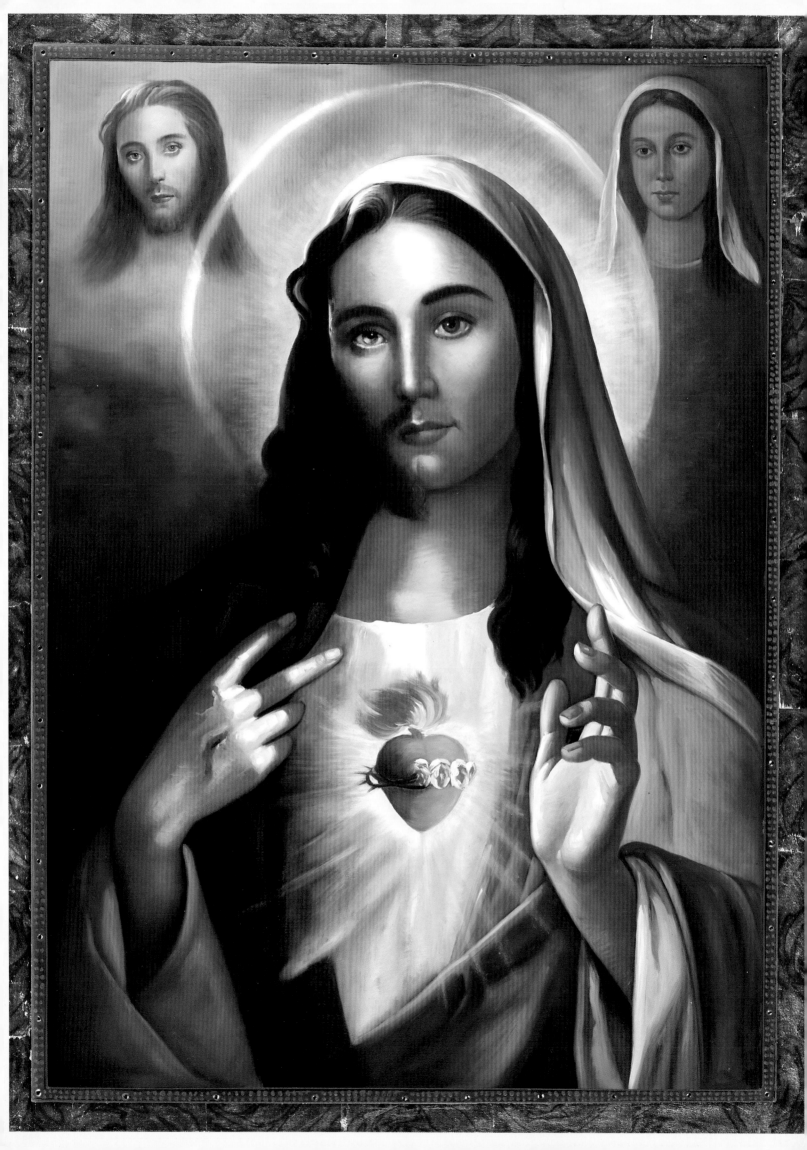

Through art there is a big "Ah Hah!" where you realize you have passed through the center and gained a knowing of your true essence.

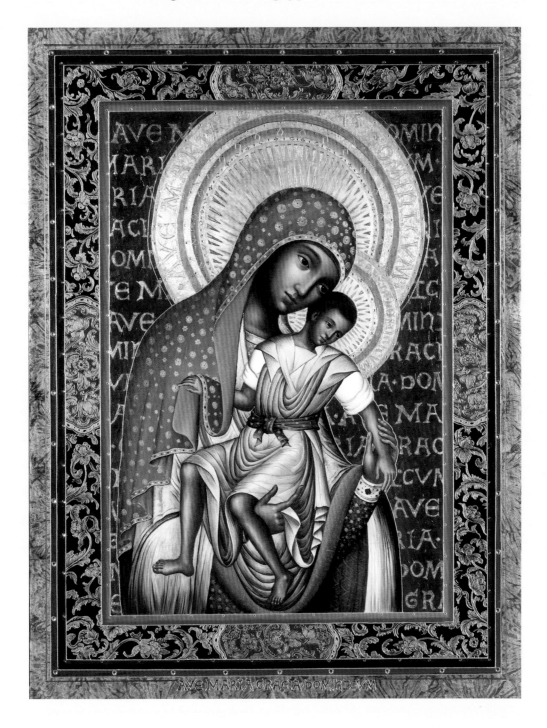

Black Madonna

True art is our collective spiritual inheritance that is outside of time and space and is orchestrated by the deep forces of the Soul.

opposite page: *Jesus and Mary as One*

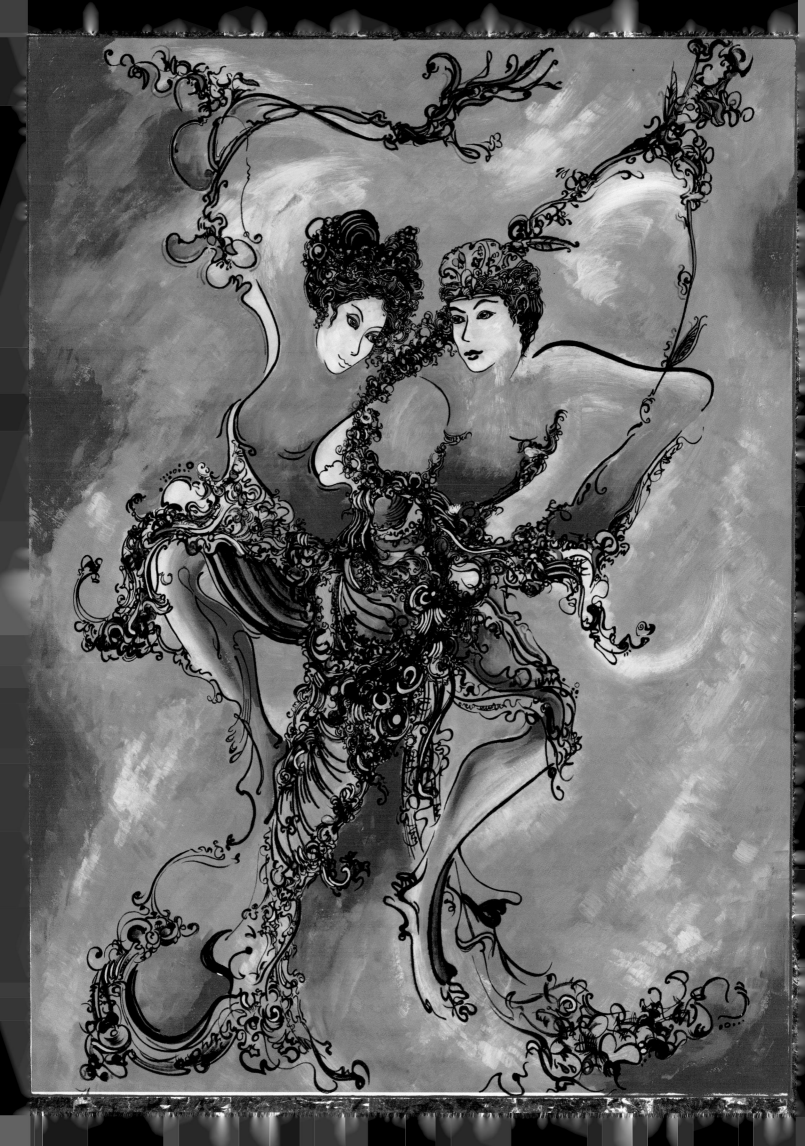

*When the Artist enters Unity Consciousness,
his Spirit and the subject of his experience
merge to become One.*

*When you paint, like throwing yourself into a
river, you have to let go completely.*

*The answer to: What is true art?
is where the Artist disappears into
the ocean of consciousness.*

*The highest moments in my life were when my
heart won out over my mind.*

The Soul's creative capacity is unmeasurable.

Dancers

Water Dancer

After awakening your heart, ultimately by grace, the heart opens, and you begin to feel the cosmic forces of the universe, a true epiphany. This was the magic moment, the validation of my relentless search for the meaning of my life.

"I believe in the sanctity of the Soul and in the truth of Art, one and indivisible," Gauguin said. "I believe that this Art has a Divine source and lives in the hearts of all men who have been touched by the heavenly light; I believe that having once tasted the delights of this great Art, one is inescapably and forever dedicated to it and can never renounce it." Gauguin truly understood the Soul and her connection to life and the Divine.

This is the moment in one's life wherein, without a vision or a teacher, the tendency is to turn and run. After all, what really can prepare you for the moment when you experience the mystery … the Divine? When the door opened, when my Soul called … I responded. This is the moment in the film "The Matrix" at which Keanu Reeves was offered to choose between the blue pill and the red pill. Take the blue pill, and you wake up the next morning as if nothing had happened. The red pill leads "down the rabbit hole" — to the truth and the inner workings of "the matrix," in other words, to your Destiny, your connection to the ancestors, and your beginning of service (Soul) to nature through your own heart. Painting opened my heart, transformed my life, and changed my path to one of following my heart in service to the feminine (the heart is feminine).

During this time I had a revealing dream: It was night and a Persian woman took me by the hand and said, "Come along." We drove a few miles in her orange Volkswagen bug and then stopped by a stream. She told me to take off my shoes and then took me by the hand and guided me skillfully upstream. My feet could feel the smooth rocks and the cool water. Moonlight shone down through large trees lighting our way. As we rounded a bend, I said, "Look at all those glow worms." She answered, "Those are the stars that live in the Earth." She guided me to a very large tree that appeared to reach up into the night sky forever. As I turned around and looked up, feeling the water on my bare feet, the tree reached out and put her branches around me. I relaxed into the tree, and I heard the voices of the world speak out. It was an eternal moment, when I was simply a deep-feeling being listening to the sounds of the connected cosmos dancing. These dancers are the magic of that moment when the voices of the world spoke out, and the vibrations continue to touch my Soul through the paintings.

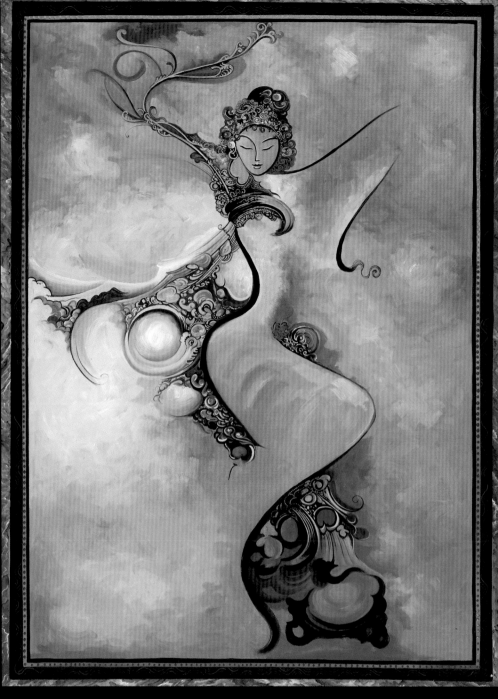

Green Dancer

Blue Flowing Dancer

When an Artist reaches his essential flow, she/he realizes there is a level in the Universe of Omniscience where everything flows and is connected to everything else.

An Artist is a living, dynamic, evolving system of consciousness, comprised of all forms of relationship.

Painting is like riding a wild horse, surfing a tropical wave, or dancing a passionate tango.

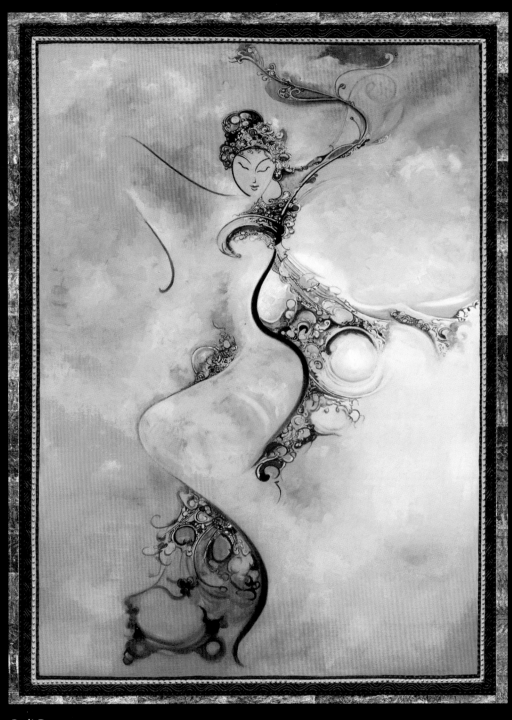

Bali Dancer

An Artist learns to reveal beauty and the elegance of nature. A creative Soul needs no definition of what sacred art is because his Soul, his life and his creations are the sacred.

Painting is being in love with Goddess/God.

Art is like a river's nourishing the fields of consciousness.

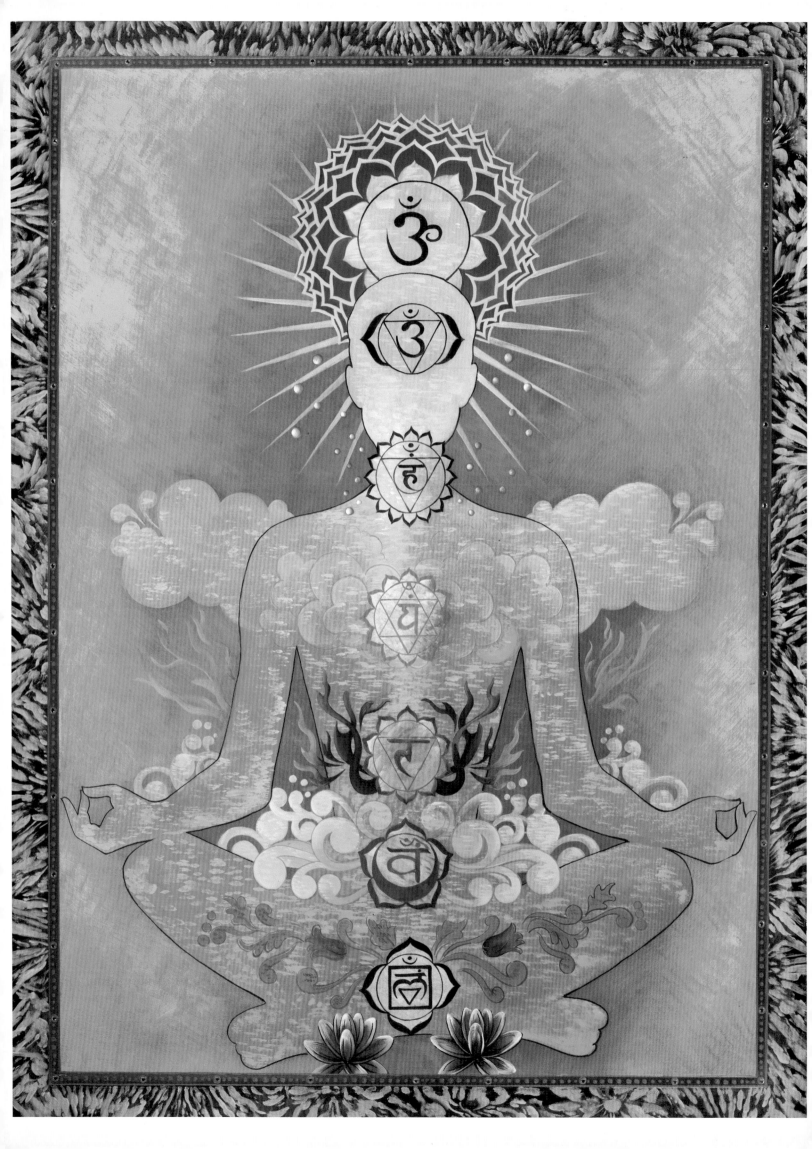

A painter is far more religious than most religious people.

An Artist who paints in the Eastern way of sacred creativity assumes credit for his creation externally, but consciously knows he has no claim internally.

An Artist is like a rose bush that must grow roses to continue a life of vitality.

As a sensitive Soul, unless your innermost core has become creative, you will feel a big gap in your life.

Paint a painting to reveal a hidden frequency that wants to assert itself — that will be your moksha (liberation)

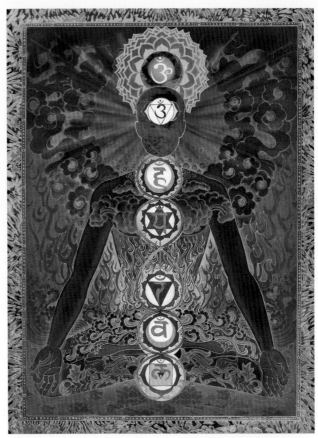

Chocolate Chakra

Chakras

For a painter, there is no greater "feeling symbol" than the "hand," and to see the world as an infinite interconnection of red and blue hands reveals the awesome feeling levels experienced when the descent journey is embodied. Applying this to our lives, when we experience others as separate from ourselves, we're looking at the world through "Western eyes," or through Western thought-forms in which we appear separated. That's how the mind functions.

As we learn to descend to the heart, to open to the Soul, our capacity to "see" expands radically, forever. For instance, you're interviewing me. There's a woman sitting there and a man sitting here. This is a Western experience of the mind. However, if we can see both of us as Self, we begin to experience a whole. I'm not speaking of personal boundary dissolution; rather we're exploring what it's like to be simultaneously individual and collective, or mind-based and Soul-based, at the same time. Two separate "realities" appear. At this point the Artist is learning to see the universe from another vantage point.

opposite page: Chakra Gold

Cézanne was amazed to find that "the landscape was thinking itself in me. I am the consciousness of the landscape." He had transcended the boundary of self-based experience and moved to a new realm where he connected directly to nature … ultimately seeing the Divine.

All paintings are images of the "State of the Soul," according to Chagall, an instance where the Artist has "fallen in love with a view of nature" (or reality), according to the impressionist Artist Alfred Sisley. As a Spiritual path, Art creates energy and as the energy resonates at higher octaves or frequencies a perception shift occurs, leading to transformation. Leonardo said, "The mind of the painter is transformed into a copy of the Divine Mind." Art opens the heart, the Soul awakens, and the resultant energy transforms consciousness in the eyes and to the mind. "Painting is an art. Art is not a vague production, transitory and isolated, but a power which must be directed to the improvement and refinement of the human Soul." Wassily Kandinsky understood Art's relationship with Soul.

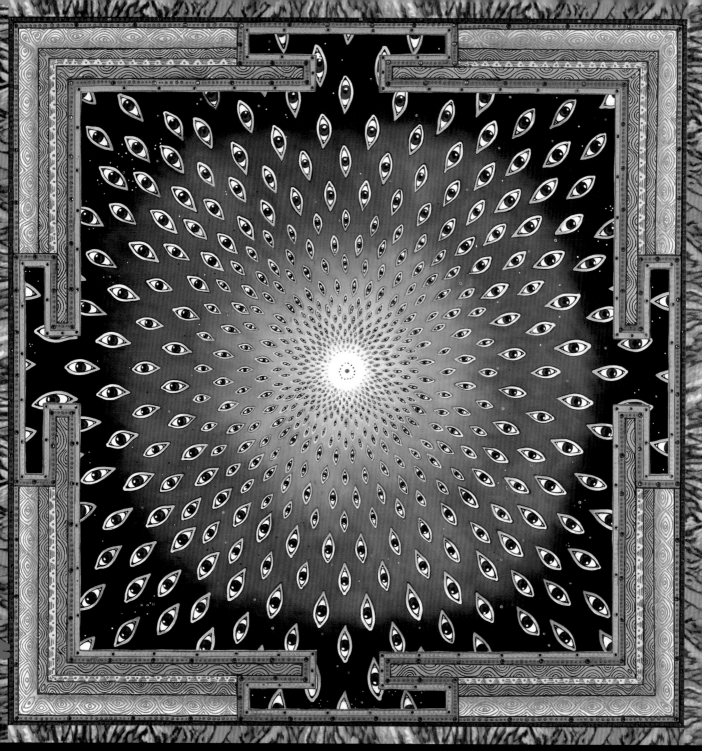

Mystical Green Eyes

Art is a thorough journey of discovery and consists of not seeking another landscape; rather, of learning to use new eyes.

An Artist's eyes first see conventional truth, but eventually see ultimate truth.

Mysticism

We must each find a way to access our own heart and Soul. Fortunately, many paths are available: dancing and drumming, brilliant music, shamanic groups, vision quests, dream interpretations, fasting, meditation, prayer, creating Art, making poetry, hospice work, and many others. I have experienced the Dance Master, Gabrielle Roth's finding Soul in dancing the prayers of the body and the Poet, David Whyte's embodying Soul as he delivers his mystical poetry. Once we consciously invite our own heart to open, we have to expand our awareness, which can be very disruptive to the mind. This is a life-long journey, the path of all dedicated Artists. All aspects of our life, all relationships and interrelationships, are eventually restructured to connect the physical, mental, emotional, and Spiritual to the heart.

Hands of Color

*Paul with painter Alex Grey
in his New York Studio*

"We live in a time of unprecedented global culture. From cave art to the latest in contemporary art fashion, Artists have vast access to the legacy of visual art. The art of every continent has been published in some form. Without too much effort one our part, the strange gods of all cultures can inhabit our imaginations, not by our actually trekking the world, at least by viewing their images in museums, books, magazines, on television, or the World Wide Web. What lessons can we derive from this unique perspective? Lesson number one is that for nearly every culture, art has been a relatively spirtual and unifying force in the human community."

—Alex Grey

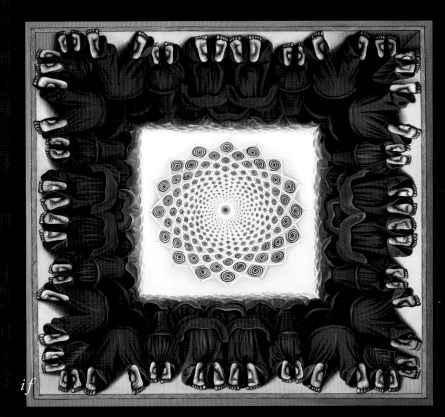

542 West 27th Street - - 4th Floor New York, NY 10001
212-594-8841 www.microcosmgallery.com

Blood Mystery Mandala

Dreams Balancing Heaven and Earth

Paul's Dream: Cosmic Forces Initiating The Artist

Time and place: 2:00am, February 1990, in my meditation room, Laguna Beach, California

Becoming an Artist and leaving my business life behind after 25 years

I'm in a room with lots of flowers and plants around and a large bed and I'm sitting at a wood table. I am listening to two spirits talk. I say to myself 'This is going to be a valuable dream because I am fully conscious at this moment in time.' The two spirits are discussing what to do with me and I realize that one is an older spirit, feminine, giving a younger spirit directions. I am thinking 'I can hear spirits now.' Then the younger spirit manifests as a fully naked woman with long, red hair (She reminds me of the woman in Bottecelli's Birth of Venus). She beckons me to come to bed and make love to her. So I follow her to bed and I'm feeling how wonderful it is to make love to this beautiful woman spirit. As I start to make love to her, I witness a radical transformation: for she becomes Little Red Riding Hood. I am astonished as I look into the eyes of this beautiful young girl. And then she changes into the Big Bad Wolf. As I try to catch my breath, the scene changes again! I'm sitting in a Japanese temple with transparent walls in nature. I am sitting at a bar drinking pure water and seeing through clear-looking glasses in four directions. I can see for miles and miles and miles crystal clear. Almost like a vision. And I begin to cry and cry because everything in this nature scene is profoundly beautiful. I hear thunder in the sky; and all of a sudden I am lifted up and placed down on the Earth like a big "X." I look into the sky as it opens into heaven in a large spiral vortex. A hand comes down and lifts me up into the opening heavens; and I hear tremendous thunder as I go up and up. Suddenly, I turn from the heavens; and I look down and see the Earth below. Now I am taken towards Earth. I can see that the Earth is made up of a moving sea of red and blue hands. And as I start to go under this sea of hands, I enter the matrix where everything in the universe is connected by a lattice of light energy. And finally I pass into the realm of the unsayable. I remember everything so perfectly clear, but I have no words to share the rest of the dream.

Dream Interpretation by Robert Johnson (author of Balancing Heaven & Earth)

A dream of this magnitude is public domain, belonging to all of mankind. It touches me profoundly just to hear it, and I take the liberty of borrowing it from you. The alchemists said that one could take a chip from the philosopher's stone and watch it grow full size, without the original stone being diminished in any way. So I (and many others as well) 'chip' your stone to their great benefit.

The dream is a rapid evolution laid out before you – out of time, but begging to be brought into time. I am glad you are an Artist, for that is virtually the only language with which one can cope with this process.

The process goes Downward and into some startling dimensions. God is no longer 'up,' but is now 'down.' This is such a shock to a people and language and tradition that has always looked for God in an 'up' dimension. Few people comprehend this and one is lonely for company or support in this new direction.

Can you take it as an evolution that your beloved goes from gorgeous woman to girl or wolf? That is required to take us back* to roots and instinct and the origin of things.

You are safe and capable of taking in the often incinerating splendor of God.

The word repent (as in the Scripture "Repent, for the Kingdom of Heaven is at hand") means to walk backward, that is, to return to one's roots. The word means "to be sorry for, or guilty" to most people but its original meaning was "to return." The Greek is Mentanoia "to turn around." This requires the ultimate of courage for a modern person of our culture.

Paul's Dream: Left-Hand Path

Time and place: 3:00am, May 2002, island of Mallorca, Spain

The Descent Journey to the Heart Begins

I am standing on the world looking across a body of water and seeing millions of people on the other side moving towards the right horizon. My consciousness moves way high in the sky, and I can see over the horizon. From the heavens I see major dark clouds, a massive storm, in the direction they are headed. As I put my hands on my heart, I'm thrown back into my body on Earth. There is a woman with long strawberry blonde hair standing on my right side. I put my hands on my heart and run to the left. The long-haired woman follows me very close and never leaves throughout the dream. I notice a few other people running to the left with their hands on their heart also. A huge wave is coming toward us, carrying society's message, "Don't go in this direction! Turn back with the others!" We hold our hands on our hearts as we run into the wave and as it passes; some of the people don't make it through. I notice on the other side, new people with their hands on their hearts, and they are also running to the left with us. Another gigantic and menacing wave comes toward us, carrying another message from society saying, "Stop! Turn around! Don't continue this way!" And we hold our hands over our hearts as we pass through the wave. It's almost magical, as the wave feels transparent. Each time some individuals don't make it, and others come forward to continue the journey. This goes on seven times. And as the seventh wave approaches, I notice that I am also in a very large house going through all the rooms. And as the wave approaches and passes, I am on a spiral staircase in the attic of the house. With my hands on my heart, as I look up, I see the room transform into heaven. And as I am about to enter the sky, I realize that I am to give up all my power. And I look down at the longhaired woman. I tell her, "This is as far as I can go; take the rest of the people and enter heaven." As I surrender my power and die, I awaken outdoors holding a small, green vase over my heart. In this vase is a spoon. I know it is filled with nectar that sustains life. I first feed the longhaired woman who is still at my side. There is an elderly man sitting on a chair alongside an elderly woman with white, long hair sitting on a rocking chair. I give them both the nectar as well. And we are telling stories about existence and the trials and tribulations through life. We are laughing. Then I awaken from the dream.

Dream Interpretation by Robert Johnson (author of <u>He, She and We</u>)

A magnificent dream! There are legends from many places and times in history that there is a "Hermetic circle" of people, a very few, drawn from all levels of society, all ages, who, though their number is few, hold the safety of mankind in their hands. These are the conscious few who are the hope of mankind. Your dream is of this nature.

The dream is saying that the vast multitude of people is going to the right (the 'doing,' extroverted side of life) and going into dark storm clouds. Certainly our society is caught up in a mad rush in that direction. But a few are going to the left (the introverted, in-turned side of life). This is difficult, and they are assailed by great waves of collective opinion, which keep trying to turn those few people back into collectively 'right' behavior. The waves are dangerous and kill some of the brave Souls who defy public opinion. But you, with your feminine companion, are safe. Just at the last moment of the left-hand journey, it is required that the masculine side of you gives up your ego identity – which at first looks like total defeat. But the defeat turns into a spiral into heaven and you end up giving the nectar of immortality to the few people who can hear you.

The dream is indeed a magnificent confirmation of your life.

Your book is a confirmation of your dream and immensely valuable. You have a rare art of making the inner world comprehensible, of bringing the archetypal world into a form that can be assimilated. This is the task of the Hermetic Character.

My profound respect, Robert

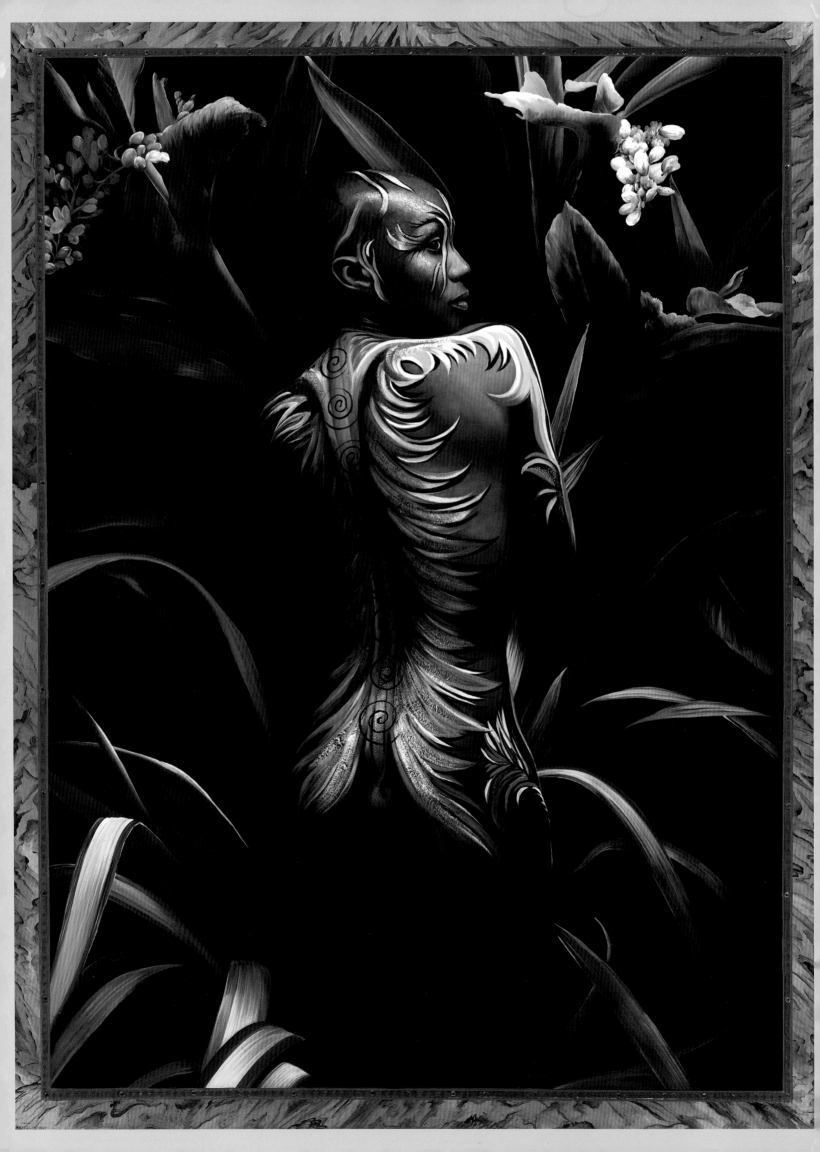

The Artist life is a manifestation of the full range of feeling in each brushstroke... every new color. The laughter and pain, the meals with friends, and the loving support of fellow Artists allows the Soul to create a life of transformation that mirrors somehow the Divine creative act.

"A creation of art is the same as the creation of the world."

—Kandinsky

In a portrait painting, the Artist allows for the singing of the color which reveals the Soul.

A portrait is the clothing of Spiritual revelation.

Portraits

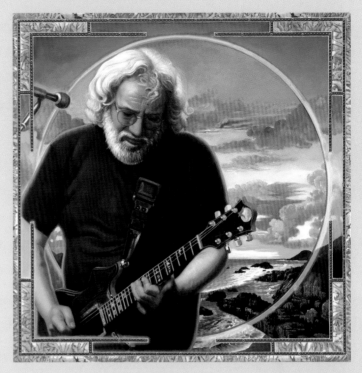

Jerry Garcia

The mind can't see an aura. The Soul sees an aura. The mind cannot do the "distant viewing," in which the Russians are so heavily invested, or even Divine simple Tarot cards. It is a different dimension of our selves that "reads" these patterns. There are authentic psychics who use astrology or palmistry or Tarot cards, who intuit and who understand something about how the Soul works; and they begin to connect to layers of hidden information. The palm of a person contains a language that has patterns of the Soul.

A chosen Tarot card and the chooser are the same, but each presents different aspects of material reality. The eyes of the Soul penetrate into the mysteries of the palm, the Tarot card, a great painting, life itself. When we study a Pissarro landscape, we see the Soul of the land; in a Van Gogh face, we see the Soul of the person; in a Chagall stained-glass window, we see the Soul bathed in light; in a Frida Kahlo self-portrait, we see her own feeling-Soul; in a Matisse collage, we see the Soul of color; in a Rousseau Jungle, we see the Soul of the dark feminine. And so it goes, on and on.

opposite page: Jungle Goddess

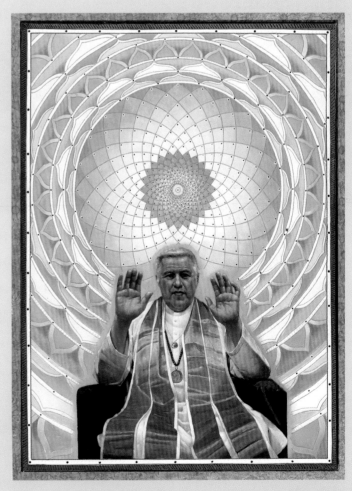

Ron Roth

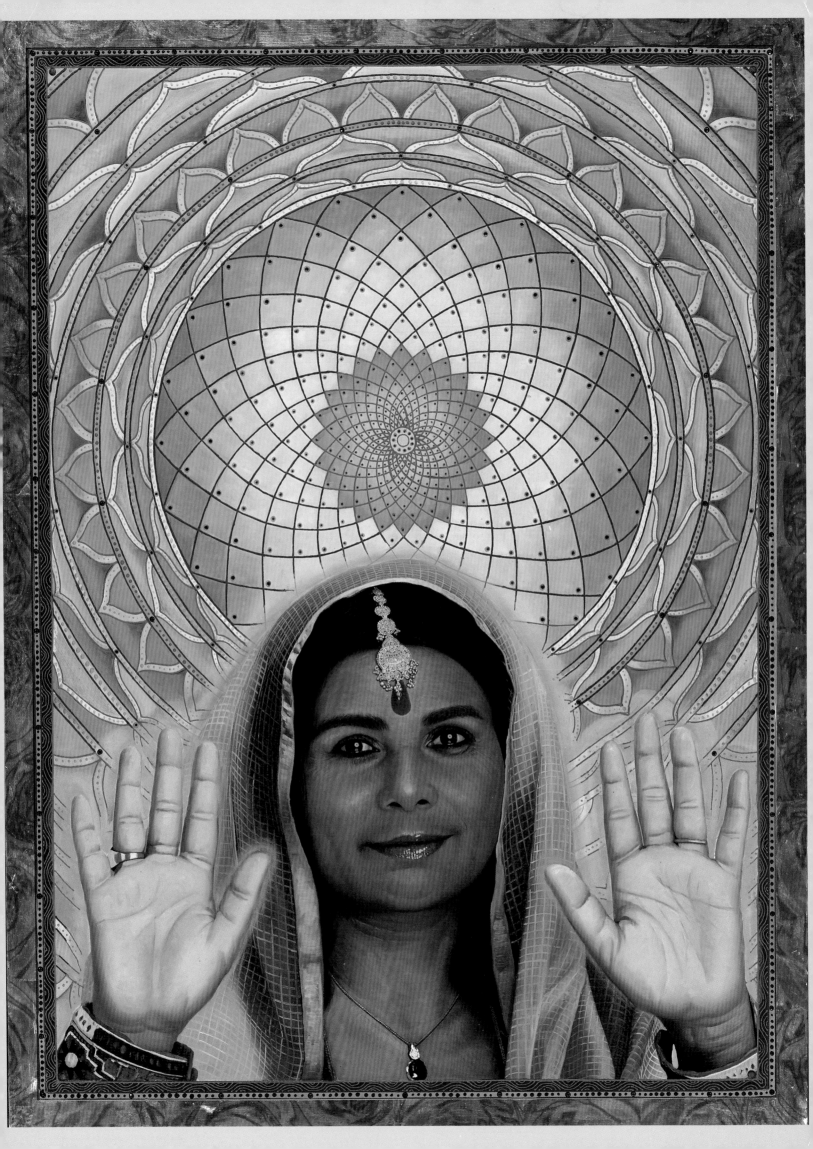

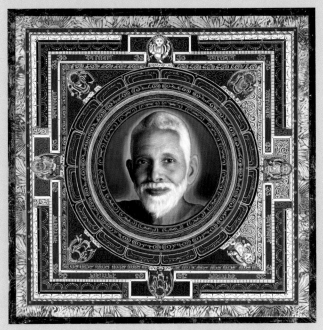

Ramana Marharshi

Osho 2

Sai Maa Pink Poppies

Ammachi with Blue Aura

Spiritual Teachers

When I was a young man, my spiritual, meditating, vegetarian father had several teachers as friends. My first meeting with a spiritual teacher was with his teacher,s Kuthumi, Swami Satchidananda, and Gobi Krishnan. Even today, his lifelong best friend, now 85, talks of them walking with Paramahansa Yogananda, Ernest Holmes and Manley Hall.

The component of the spiritual teacher has been with me my entire adult life and has played a significant role in my own transformation and development. As a seeker, the teachings of Brugh Joy, Richard Moss, Osho, Adyashanti, Sai Maa, Ammachi, Mother Meera, and Caroline Conger have all been instrumental in the awakening of consciousness that has dominated my spiritual life... likewise, understanding the true Artist also as a spiritual teacher from Massacio to Picasso has been a valuable, rewarding and eye-opening addition to the traditional teachers. Picasso chose his mother's name because he felt that there have been a lot of Artists that had the "double-"s in their name. At that moment, I realized I was on that list along with Pissaro, Rosseau, Poussin and others. Painting these teachers became a natural progression. As my path deepens, the spiritual teachers and true Artists have been coming closer and closer. For my own relationship with my Soul, they have become one and the same.

opposite page: Maha Sri Lakshmi

All human beings are paths to Goddess/God. As an Artist creates art, she/he reaches for the Divine. Creativity becomes a deeply transformative Spiritual Path.

Art is the hidden meaning behind all consciousness.

An Artist, like a Saint or great leader, works with Love.

Art As A Spiritual Path: Teachings from My Soul

Dalai Lama Kalachakra

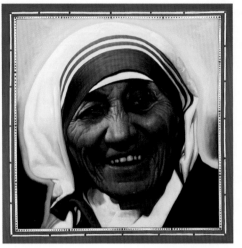
Mother Teresa

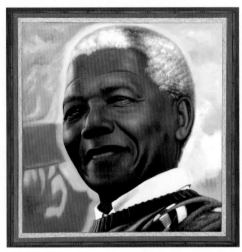
Nelson Mandela

Ultimately life itself is not very serious, and life is just an overflowing energy that seems to have no purpose. An Artist is to lead life purposefully and spiritually. Likewise, an Artist is living life as play and not as work. The so-called serious mind of our society, will in fact turn play into work and art into business. An Artist lives his life as a dream and has more or less renounced the society's serious mind. An Artist struggles with the seed that lives inside him, which can grow into such heights that outward nonsense will automatically fall away. Once you have experienced through Art your creative inner riches, there will be nothing in life that is comparable. Once an Artist finds his creative bliss, the usual forms of enjoyment, entertainment, and possessions seem foolish, and also begin to fall away as you connect with your inner ecstasy.

Ultimately, through the heart, an Artist has communicated something that cannot be communicated through words. The message is hidden in all works of art. Here are the keys to Art as a Spiritual Path; a painting is a visual mantra that is seen over and over in a particular way and felt over and over again in a feeling way; and an Artist has emphasized in his own way a heightened frequency that can transform your consciousness. An Artist creates a wavelength painting through time. Having a relationship with a painting creates waves that go deep into the psyche and penetrate into consciousness.

The mind exists only when there is past or future. To enter a painting, you must not think because you can't think in the present. The moment you think, it has become the past. The mind cannot exist in the present. It exists only in the memory of the past, or it projects into the future. It never comes into direct contact with the present; it is impossible. Without thought there is no mind, and no-mindness means a new awareness and an expanded consciousness. So many of the great paintings both in the West and in the East come from an essence that isn't from the mind. There you have a chance, a moment of possibility, to enter the here and now of the painting. Then you begin to explore the reality of the painting, which may lead to an inner realization; or that reality may explode through your eyes into your heart.

When you realize that paintings have an existence, you can create a bridge between you and the painting. When you see the life, the Soul, of a painting, there can be a dialogue with all existence and you can have an intimate, loving relationship with the painting and with life. Art as a Spiritual Path opens the possibility of being in love, in dialogue with the Divine.

When one is studying a painting, the mind goes on and on. The mind will continue unless you become very aware. When entering a painting, there can be a miracle. The moment you become aware, there will be no past. Now you can enter the moment fresh, ultra-sensitive, alert, and alive. In a painting you can truly be reborn into the current of the painting. The Upanishads called this "the inner space of the heart." This space; I can only describe as a space of consciousness — the expression of awareness. Through art, the mind transcends above thinking, above the past, opens the vulnerability of your heart to depths of feelings and new dimensions.

Art is a metamorphosis, a transformation of your own mind, an awakening transformation of the surface reality into an eternally living consciousness. Art as a Spiritual Path transforms and changes your attitudes toward existence and opens you to the sky of consciousness. The whole of existence found in a painting becomes a flow of love, great feelings, compassion, and the experience of grace through the Divine. A celebrated Artist is loved and will be throughout time, through thousands of eyes and hearts. The Artist opens each viewer to a joyous celebration.

In India, the Hindu religion has created deities with a thousand hands in every direction. This means that everywhere there is a hand. Nowhere can you go where the divine hand will not be upon you. There is an embrace of the Divine everywhere. When you see the whole of the Art World through time, you will see a thousand armed deity in our world — the Artist as a hand of the Divine in all times, in all places, and extending out to one who has opened her/his heart through art, a painting, or thousands of other keys that unlock the direct experience of the Divine.

When you become meditative through art, your body will become so sensitive. When the heart is opened, your eyes see deeper; you feel more; even your organs feel deeply. Ordinarily, we never really see, hear, or feel fully — just so-so. When your heart is opened — painting, like passing through a garden — awakens you to the glory of the moment. In Western life, our eyes have become insensitive, just like our feelings and our intuition... the body has also become this way. Our whole culture is against the Heart Awakening. The Artist gives us an opportunity to reawaken to our birthrights — our true gifts — where we are reborn into a life that connects us with the Divine and we have a powerful, moment-to-moment relationship with our Soul.

Our society knows very little about the Soul and true art. It's a miracle when an Artist creates a visual landscape of the mysteries of life. Our culture has interfered with our true nature. Opening the heart connects us with the wisdom of our body's vast realms of experiences. We spend enormous amounts of money renovating and building museums ($4.5 billion in the past few years) and very little on the development of the Artist to fill the museums. The National Edowment for the Arts (NEA) has been severely stripped of both its freedom to create and the collective means of supporting the Artist.

Our way of seeing and understanding art is old, and the mystery isn't there. Art can penetrate into your innermost depths. Unless we transcend our present form of relating to art, there will be no direct Spirituality. Unless the Artist knows how to explode into the Soul of the viewer, then both the Artist and the viewer will not be reborn into the dimension of the Divine. If you can meditate on a painting and open to its mystery, then you are opening your own Soul to life's hidden mysteries. Each day great change happens, and each day we are present for these changes in the body, in the mind, in the emotions, and in the heart. Without this meditation, civilization has a way of making us unconscious. This is the way we try to create or enter art. We must move to our Heart Center and open our hearts in order to awaken into the Divine quality of paintings and life.

My experience is that Artist must be initiated either from a teacher or from life. In Buddhism, the term for initiation and for the one who is being initiated is Srotapanna, one who has come into the current. Great Art is flowering just like an enlightened Buddha and carries the same form of currents or energies. One who has been initiated and surrenders fully to it, falls into the current and starts flowering. You have only to find a favorite Artist, such as Monet, and you can easily see through your heart that he carried unquestionably this current. I recommend spending a day at Giverny where Monet created his true alter to the Divine goddess of beauty.

Art is outside of time and space and always will be. One of the great problems and really diseases of our modern society is a mind that is in a hurry. The new phenomenon of our society is time-consciousness, which has changed radically changed our awareness and our lives. We have become so time-conscious that not for a single moment can we wait, stay in the moment. It seems impossible these days. Therefore, art that is timeless is separated from our world, it is out of reach.

This isn't so when you go to an ancient temple in India for example where the art has been meditated on and prayed to for 1000's of years. For example, in the Ellora temples, just a few kilometers from Bombay, you can experience sacred paintings and stone carvings, meditated and preyed for over 1,500. The whole place is consecrated to the Divine through the Spiritual values of beauty and Artistic creations

Visit *mandalas.com* to learn more about Paul's Art As A Spiritual Path Workshops

Buddhism and many other religions believe that sacred art has the supernatural ability to awaken the Divine within us. In particular, Tibetans believe that mandalas — sacred geometry, intricate in detail and infused with prayer — are the highest form of spiritual art and have the ability to heal and realign our minds, emotions and bodies.

As a renowned teacher and fourth generation artist, Paul has been sharing his unique gift of helping people discover their Soul through his paintings and Art As A Spiritual Path workshops worldwide. Paul has created over 1000 unique and spiritual paintings while passionately sharing his artistic capacity to explore and create Sacred Art from many traditions such as Buddhism, Hinduism and Christianity.

What participants have said about Paul's workshops:

The workshop is a circle of love. I felt love transcend all feelings. *I felt essence.* Painting is heaven to me. I loved the time we spent

painting together. *I found out that this was my path.* Your heart vibrates from the painting. *I wanted to paint outside come rain or*

shine. Thank you for making my dream come true. *I came out of my cage of darkness in the painting. I learned to surrender.*

I was definately guided here. *There is no way to tell someone what a mandala is until you have experienced one.*

In art, I have an incredible new life. *Wow!!* The workshop is a ceremony. *Seeing all the beauty, I am unable to deny my own beauty.*

In the workshop, each day feels like a year. *I can hear the painting sing... I hear it's song.*